S0-BYL-135

Building on the Past

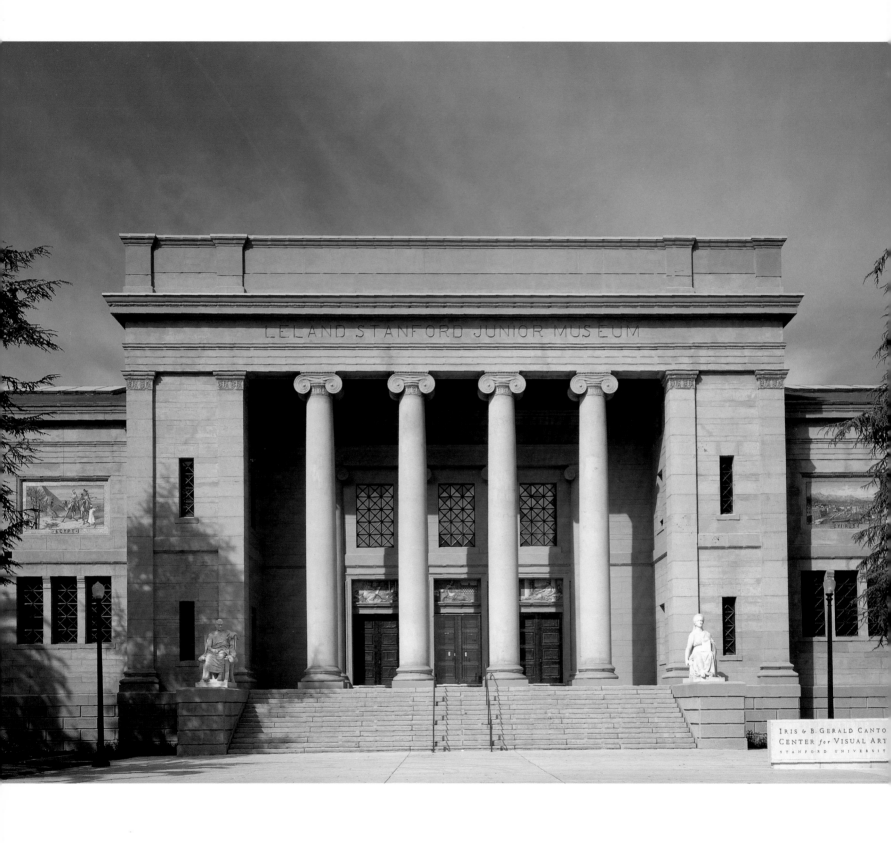

Building on the Past

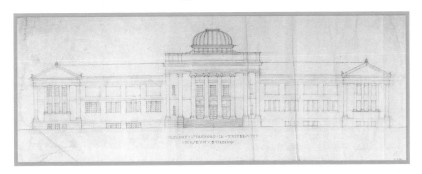

The Making of the Iris & B. Gerald Cantor Center for Visual Arts

at
Stanford University

Richard Joncas

with contributions by
Gerhard Casper
Thomas K. Seligman
James Stewart Polshek
Richard Olcott
Richard Barnes

Printed in Hong Kong

Copyright © 1999 by the Board of Trustees of the Leland Stanford Junior University.

All rights reserved. No part of this book may be reproduced or transmitted in any form or by any means, electronic or mechanical, including photocopying and recording, or by any information storage and retrieval system, without the written permission of the publisher.

This catalogue is published in conjunction with the opening of the Iris & B. Gerald Cantor Center for Visual Arts at Stanford University.

Library of Congress Cataloging-in-Publication Data

Joncas, Richard, 1953-
 Building on the past: the making of the Iris & B. Gerald Cantor Center for
 Visual Arts at Stanford University/Richard Joncas, with contributions by
 Gerhard Casper... [et al.]. — 1st ed.

 p. cm.
 Exhibition catalog.
 Includes bibliographical refernces.
 ISBN 0-937031-14-3 (hardback); 0-937031-15-1 (paperback)
 1. Iris & B. Gerald Cantor Center for Visual Arts at Stanford University-History.
 2. Stanford family-Art collections.
 3. Art-Private collections-California-Stanford.
I. Casper, Gerhard. II. Iris & B. Gerald Cantor Center for Visual Arts at Stanford University.
III. Title.
N781.J66 1998
727'.7'0979473—dc21 98-26180
 CIP

Library of Congress Catalog Card Number: 98-072926

Iris & B. Gerald Cantor Center for Visual Arts at Stanford University
Stanford, CA 94305-5060

2 1

Editor: **Mitch Tuchman,** Los Angeles
Book Design: **Tenazas Design,** San Francisco
Principal Photography: **Richard Barnes,** San Francisco

Contents

Acknowledgments

I am indebted to Mona Duggan, who first proposed the idea and found support for it, and Tom Seligman, who provided invaluable insights into the museum's operation and rebuilding as well as the history and program of the competition and its designs. Many other people assisted with the research. Mary Griffin and Eric Haesloop of Turnbull, Griffin & Haesloop, Architects, Yasuku Imamura of Arata Isozaki & Associates, and James Stewart Polshek, Richard Olcott, and David Robinson of Polshek and Partners, discussed their design approaches with me; David Neuman, Ruth Todd, and Margaret Burgett in the Planning Office, and Richard Kosheluk of Polshek and Partners, helped clarify the technical peculiarities of Ernest Ransome's experimental use of reinforced concrete in the museum; and Professors Lorenz Eitner and John LaPlante, shed light on the history of the museum during the 1950s and 1960s. My research was also greatly aided by the writings of Paul V. Turner and Carol M. Osborne, whose histories of the Stanfords and the early years of the Stanford Museum are indispensable. Margaret Kimball, Pat White, Peter Whidden, Polly Armstrong, and Sara Timby of the University Archives, Alex Ross, Peter Blank, Linda Treffinger, and Arturo Villasenor of the Art Library, Liz Martin and Sylvia Wohlmut of the Art Department, and Bernard Barryte, Jeff Fairbairn, Laura Janku, Donald Larsen, and Susan Roberts-Manganelli of the Museum offered generous research and technical support. I am especially grateful to Elizabeth Buchanan, my wife, who juggled a busy work schedule to allow me the time to research and write this essay.

Richard Joncas

President's Statement

May 1, 1998

In founding Stanford University, the Stanfords believed in the special capacity that art and artifacts have to inform. In an era when few universities had museums, the Stanfords built a truly huge museum to house their ever-expanding collections. Like the library and the laboratory, the museum should be a vital resource for inquiry, scholarship, and enjoyment. Studying works of art can enrich the understanding of different epochs, cultures, and human experiences and can enoble the minds and spirits of members of our community. Thus, it has been important among my objectives to rebuild and expand this unique resource.

When I came to Stanford in 1992, one of the facility-related challenges was to repair and renew all of the physical plant that had suffered in the 1989 earthquake as well as to move forward with much-needed new buildings to allow our faculty, staff, and students appropriate facilities for the next century. In collaboration with University Architect David Neuman, I instituted formal architectural design competitions for all of our new buildings. The Museum project was the second such competition following the Allen Center for Integrated Systems.

April 27, 1994, was a special day for the museum selection committee as we reviewed models and proposals from three architectural teams: William Turnbull with Hartman and Cox of San Francisco, Arata Isozaki of Tokyo, and James Stewart Polshek of New York. Each had a unique approach, providing innovative solutions to the sensitive aesthetic and historical concerns of relating a new wing to the existing building. After lively discussion we selected the Polshek firm to be our architect, and design began in earnest.

In the years since the museum competition we have undertaken four other competitions retaining distinguished architects including Pei, Cobb, Freed of New York City; Tanner, Leddy, Maytum & Stacy of San Francisco; Ricardo Legorretta Arquitectos of Mexico City; and Sir Norman Foster and Partners of London.

It is indeed my hope and intention that we will continue to strengthen the Olmsted campus plan at Stanford while creating architecturally distinguished buildings. A great university should do nothing less.

The museum project has turned out extremely well despite many challenges. Our confidence in Polshek and Partners has been well rewarded. I want to thank our architects, engineers, museum and university staff, and general contractors Rudolph & Sletten for a job well done. And to all our supporters who made it happen, I am very appreciative.

Gerhard Casper
President
Stanford University

Starting Over…Again

PLAN FOR THE IRIS & B. GERALD CANTOR CENTER FOR VISUAL ARTS
at Stanford University

Thomas K. Seligman
John and Jill Freidenrich Director

The Leland Stanfords planned the Leland Stanford Junior Museum, at the university they founded in memory of their son, to be on a scale with the great urban museums of the East Coast and Europe.[1] The Stanfords believed that collections of all kinds, including art, were integral to the proper education of youth and that their son, Leland Jr., had directly benefited from collecting and studying objects from many historical epochs. With their pursuit of an ever expanding collection of various kinds of objects from around the globe, spanning many periods and cultures, they intended the Leland Stanford Junior Museum to be an additional monument to their precocious son's avid interest in archaeology, history, and collecting. Conceived for greatness, the museum grew to encompass about 300,000 square feet of floor space during its first decade.

Having built a railroad through the Sierra Nevada, Leland Stanford was accustomed to overcoming the forces of nature. He was very aware of earthquakes and chose to build the original museum structure of reinforced concrete, but even he never anticipated the devastation of the 1906 earthquake that destroyed much of the fledgling university and most of the museum, except that first building, the adjacent brick rotundas, and the west annex. The museum never fully recovered from the catastrophe, losing much of its facility, collections, and energy. Progress toward recovery only began in the 1950s and in earnest during the tenure of my distinguished predecessor, Lorenz Eitner, who was chair of the department of art and director of the museum from 1963 to 1989. Eitner's museum was much smaller than the original but was developed and refocused as a collection of works of art. It filled a significant role in the life of the community and was a teaching resource both for the art department and university. No one imagined that the museum would be closed again on October 17, 1989, immediately following the Loma Prieta earthquake.

In early 1989, just before Eitner retired, a new position of full-time director of the museum was endowed. Recruitment for the position progressed slowly, and Wanda Corn, art department chair, was asked to serve as acting director. After the October earthquake Professor Corn and a few colleagues were able to convince university officers and some key trustees and supporters that the museum ought to be saved. In 1990 the university retained William Turnbull and Associates, Architects and Planners, to help prepare a master plan for the building, and initial fundraising commenced. At the May 1991 centennial of the laying of the cornerstone for the original building, I was appointed director with a mandate to rebuild and reshape the museum. This was a unique opportunity—challenging to be sure—and it has been a privilege to return to my alma mater.

1 See Carol M. Osborne et al., *Museum Builders in the West: The Stanfords as Collectors and Patrons of the Arts* (Stanford: Stanford University Museum of Art, Department of Art, 1986), and Paul V. Turner et al., *The Founders and the Architects: The Design of Stanford University*, (Stanford: Stanford University Department of Art, 1976).

A "ONE HUNDRED-YEAR-OLD START-UP"

In 1991 the museum was virtually starting over. I began to see the museum as analogous to the start-up high-tech companies so common in this region. For me the characteristics similar to a start-up's were the prospect of growth, building for a future, a new identity, and a new reality. We needed generous investors (donors) to finance the project; unlike investors in start-up companies, however, supporters would get no financial rewards if we "made it," but they would get the pleasure of seeing the museum resume its valuable role in the life of the region.

The museum's one-hundred-year history at Stanford provides a strong basis for a start-up through the variety of its collections, the prestige and importance of the university, and the commitment and resilience of supporters, friends, and staff. The earthquake presented these people a significant opportunity to recreate the institution while rebuilding it. We had been given the chance to transform the museum's vision and goals, its collections, exhibitions, base of support, and relationship to teaching and research at Stanford.

Dr. Eitner had changed the name of the museum from the Leland Stanford Junior Museum to the Stanford University Museum of Art. We decided to change the name again to recognize our most significant contemporary benefactors and to reflect a new reality. Now the Iris & B. Gerald Cantor Center for Visual Arts at Stanford University, the name reflects our enlarged ambitions. Deciding no longer to use the word *museum* in the name was difficult and controversial, yet we intend to enlarge upon the concept of a traditional nineteenth-century institution that collects, preserves, and interprets its collections. *Center* embodies the ideas of "a place at which an activity or complex of activities is carried on, from which ideas, influences, etc. emanate, or to which many people are attracted."[2] With our renewed facility, improved collections, enhanced university resources, and community support we can be a museum as well as a visual studies and art historical laboratory. If our aspirations are achieved, this describes our role as we enter the twenty-first century.

VALUES FOR PLANNING THE BUILDING

Architects Mary Griffin and her late husband, William Turnbull, helped the museum staff, volunteers, and friends articulate a master plan and define our programmatic objectives. In 1993, after more than a year of intense planning—considering the size and shape of spaces, the relationship of functions, visitor circulation, and systems requirements—we collectively agreed upon values for the facility and the way it should function.

- The historic character of the existing building is of value and should be maintained as much as possible, especially the exterior, the public lobbies, and major galleries. We should at the same time fully upgrade the building structurally and mechanically.
- A new addition should accommodate programmatic needs, including special-exhibition galleries, a cafe, an auditorium, and a conservation laboratory.

2 *Webster's New World Dictionary of the American Language*, 2d college ed. (New York: Simon and Schuster, 1982).

Acknowledging that it would be more than a century newer than the original, the addition should be of contemporary design yet sensitive to the original building in scale, mass, profiles, and materials. "Distinct yet compatible" was the phrase we used to summarize this objective.

- The facility and its institutional attitude should be accessible, welcoming, friendly, and comfortable, with amenities for the visitor. Visitors should find their way around the facility easily.
- The plan should maximize indoor/outdoor relationships. Given the temperate climate, expansive site, the existing Rodin Sculpture Garden, and a collection strength in sculpture, we wanted to create outdoor galleries and expanded sculpture gardens. There also should be numerous views to the outside.
- Spaces for the display of art should be designed to enhance the presentation of the objects.
- The building should take advantage of the region's remarkable light by allowing filtered natural light to mix with a flexible artificial lighting system. In addition, natural light through windows should help articulate the building's spatial organization and orient the visitor.
- The plan would capitalize on the building's location at the edge of the built campus.
- The Cantor Arts Center's role as a multifaceted educational institution ought to be recognized through facilities dedicated to learning; it should be flexible enough to function as a laboratory for experimentation.
- The new wing must be beautifully conceived, detailed, and fabricated.

In addition to these broad goals, there were also a number of more predictable and specific objectives:

- The building and nearby parking should be accessible to both the university and the surrounding community.
- The facility should be secure for visitors, staff, and collections. Behind-the-scenes circulation should be easy.
- Spaces should be flexible to accommodate expansion of the collections, programs, and attendance.
- All systems, including climate control, wiring, communications, fire detection and prevention, security, and storage should be modernized.

All of these objectives were to be met by a relatively modest construction budget to improve the site, upgrade the 1891 building, and add a new wing.

We intended these ideals to establish the guiding principles for the architects, who would be chosen after an international architectural competition (described in the following essay by Richard Joncas). I heartily endorsed a competition because I felt we needed new and different approaches to the plan for the building. All of us involved in the planning had gotten too close

to the programmatic issues, which inhibited creative architectural solutions. The competition yielded two important results: (1) we were able to see three very different architectural solutions, which opened our eyes to alternate possibilities; and (2) we selected James Polshek, Richard Olcott, David Robinson, Stefan Hastrup, and Richard Kosheluk of Polshek and Partners, Architects to be the architects with whom we would develop the building.

As we moved into the design phase, I was gratified by our choice of architects. We developed a rapport conducive to the clear communication of abstract ideas and specific requirements. We worked very closely throughout the development of the design and the myriad of details during construction. The architects even tolerated my drawing on their plans to articulate my thoughts more precisely. There were many such drawings as I was determined that the Center be beautiful and highly functional. The architects had strong views about all of the significant design issues yet were flexible in seeking alternate solutions to improve functioning.

The entire design process was engaging and time consuming for everyone involved. We were enthusiastic about devoting the time and energy necessary to the effort. I believe firmly in the adage that excellent buildings result from a talented and skilled architectectural team working with an experienced and engaged client.

When the bids for construction came in 30 percent over two independent estimators' figures, we faced a most daunting challenge. We had to "value engineer" the plans, a euphemism for budget cutting. I argued that we must preserve the overall square footage, allocation of space, and basic form of the new wing. To accomplish that we had to cut, trim, and simplify. I believe that on several occasions we actually added value while cutting costs. We also eliminated some things that the architects or museum had wanted, such as some of the skylights in the new wing.

After six years of planning and fundraising the project moved into construction in February 1997, and we were really going forward. I drove by the site every morning and evening and walked through at least twice a week with camera in hand. I will never forget when the old basement was excavated, when the rotundas were braced, and the east and west walls were taken apart brick by brick, when the first steel of the new wing began to rise from the ground, and when I could walk through and see the three-dimensional relationships, the sightlines, and views. I remember thinking then that the finished building would be better than I had envisioned from plans and models. I was also delighted by the quality of craftsmanship and the dedication and intelligence of the numerous contractors who built the building. Our project manager, Maggie Burgett, amid great uncertainty about her future at Stanford when the entire project management group was eliminated in mid-1997, determined to complete this project because of the team spirit that had developed among all the players. I believe this sense of collective dedication will remain embedded in the Center long after we have all gone our different ways. The architects, builders, and managers involved in creating the Center will always be able to feel pride in a job well done. The staff, volunteers, and visitors will have the pleasure of being in this extraordinary place.

VALUES GUIDING THE CENTER'S PROGRAM

It is very difficult during a major capital-fundraising and construction project not to be consumed by what some have termed the "edifice complex." We had to remember, however, that the facility is only the stage for the artistic and educational program. For the Cantor Arts Center at Stanford to flourish, its staff and users must remain open to diverse ideas, create accessible presentations, and take advantage of changing opportunities. The Center will be a place where important issues can be explored and debated and where human creativity can flourish and be appreciated. We intend to serve the broad university community and local schools as a resource and catalyst for exploration and learning in the visual arts.

Exploring the age-old relationship between art and technology is more vital today than ever before. By placing increased emphasis on what I term "in-reach," meaning developing new relationships throughout the university—especially with departments involved with technology, science, and medicine—great potential exists for collaborative projects that enlarge our conception of *visual* and *art*.

The Center's programs will be ever changing. Its future will be determined as much by others as by ourselves. For the institution to endure and thrive, it must continue to evolve, grow, and make contributions to inquiry and learning. With a creative, engaging, and enjoyable program the Center will fulfill its potential.

A NEW BEGINNING

How will the Cantor Arts Center at Stanford evolve in the new century and millenium? We trust it will endure, but will it remain diverse in its collections, ideas, people, and programs? Will it remain a cherished place and forum for dialogue within this great university? We look to our future with great optimism in the realization that the stage has been set by our wonderful buildings.

ACKNOWLEDGMENTS

Bringing the museum rebuilding project to completion has taken nine years, during which literally thousands of people made important contributions. Although many are listed in the appendices, it is impossible to acknowledge them all by name. Nevertheless my thanks go to each and every person who contributed to the successful realization of this building.

Past and current university leaders who have been involved in making this project possible include Presidents Donald Kennedy and Gerhard Casper; Provosts James Rosse, Gerald Lieberman, and Condoleezza Rice; Deans of the School of Humanities and Sciences Ewart Thomas and John Shoven, and Associate Deans Carolyn Lougee and Susan Stephens; Vice President for Development John Ford and Director of Principal Gifts David Glen; and Vice Provost Geoffrey Cox. I also want to acknowledge former Museum Director Lorenz Eitner and Acting Director Wanda Corn, former Associate Director Carol Osborne, and the late Professor of Art Albert Elsen.

Vital leadership and support was provided by a number of Stanford University trustees, especially Robert Bass, Peter Bing, Irv Deal, Doris Fisher, John Freidenrich, Ruth Halperin, Burton McMurtry, and Charles Pigott.

Of course, we would never have been able to realize this project and the development of all the other areas of the museum without the generous support of many benefactors. We received gifts totaling over $40 million for the relocation of the staff and collections; the planning, design, and construction of the facility; the furniture and equipment for the building; the design and costs of installing the collections and special exhibitions; the publication of several exhibition and permanent collection catalogues; and the design of signage and related graphics for the Iris & B. Gerald Cantor Center for Visual Arts at Stanford University. All donors to the building fund are listed in this book, but I wish to express my heartfelt thanks to several who have been especially significant because of the extraordinary generosity of their contributions and the help they provided in getting others to support us. With Carmen M. Christensen's splendid lead gift we were able to launch the campaign effectively. Jill and John Freidenrich and an anonymous donor, followed by Don and Doris Fisher, Jack and Mary Lois Wheatley, Madeleine Russell, Joan Corley, and John D. Leland, kept the momentum going. At a crucial period when fundraising had slowed, Iris and Bernie Cantor, with their magnificent commitment, made it clear to all that the project would succeed. Then, very close to groundbreaking, gifts from Charles Pigott and his family, Deedee and Burton McMurtry, and Robert Halperin (in honor of his wife, Ruth) took us near the top.

The Federal Emergency Management Agency (FEMA) contributed substantially to the reconstruction of the old museum building. The leadership of the Committee for Art at Stanford, the membership group of the museum, raised more than $1,500,000 from over five hundred donors. This organization, which has done so much for the development of the museum, was our partner throughout the long rebuilding process. Former university trustee Linda Meier and a committee of volunteers did an outstanding job of planning the opening events to launch the new Center.

I want to thank the late William Turnbull and Mary Griffin for working so effectively with our staff to develop the program for the facility. James Polshek, Richard Olcott, David Robinson, Richard Kosheluk, and Stefan Hastrup from Polshek and Partners, Architects designed our beautiful new wing and the restoration of the old museum. Their consultants and the team from our contractor, Rudolph & Sletten, gave so much to realize our vision. Stanford's project team, led by Maggie Burgett, David Neuman, Olivier Pieron, and Ruth Todd, made our work so much more efficient and effective. Our graphic designer, Madeleine Corson, and installation designer, Mindy Lehrman Cameron, helped develop our elegant new look in an intelligent way. Richard Joncas provided an insightful history and evaluation of our institution and new building for this publication, which was designed by Lucille Tenazas, edited by Mitch Tuchman, coordinated by Laura Janku, and which includes both documentary and interpretive photographs by Richard Barnes. Very generous support for this publication has been provided by the Committee for Art at Stanford, Rudolph & Sletten, Inc., and Polshek and Partners.

My deepest gratitude goes to the many staff, colleagues, and volunteers who worked with good humor in difficult conditions for a long time while always striving for excellence. They were led by Bernard Barryte, Marty Drickey, Mona Duggan, Susan Roberts-Manganelli, and Patience Young, all of whom worked selflessly to recreate this institution.

Finally I would like to thank my wife, Rita Barela, and my three sons for their love and support during these past seven and one-half years of late nights, long meetings, and many, too many, hours away.

T.K.S.

Multiple Histories as Generators of Architectural Form

James Stewart Polshek, FAIA

Multiple histories have influenced the formal conception of the Iris & B. Gerald Cantor Center for Visual Arts at Stanford University. First is the Leland Stanford family history, which accounted for the creation of what was, upon its completion in 1905, one of the largest museums in the United States. This 300,000-square-foot memorial to Leland Stanford Jr. was developed principally by his mother, Jane, after his tragically premature death at the age of fifteen.

The second history derives from the unpredictable geological phenomena of northern California. The new museum survived intact even fewer years than did young Leland. In 1906, an earthquake destroyed most of the building, which had been built primarily of unreinforced brick. After the dust had literally settled, only the ornate entry pavilion on the east, the galleries to the north and south, and two octagonal rotundas remained usable. Eighty-three years later, in 1989, the Loma Prieta earthquake essentially completed the museum's demolition. It was so weakened that it was officially declared uninhabitable.

The third history centers on a great university and its commitment to the rebirth of its museum. Leland Stanford's poignant declaration to his wife on the morning after their son's death—"The children of California shall be our children"[1]—clearly established his conviction that despite personal loss his dream must be realized. Similarly, after the 1989 earthquake the university administration decided that a new museum had to rise from the debris of the old. In 1991 Thomas K. Seligman was appointed director of the museum. His primary goal was to create an expanded and renewed home for the museum's unhoused collections and for future gifts. The project had the enthusiastic support of the new university president, Gerhard Casper; the chair of the board of trustees, John Freidenrich; and the campus architect, David Neuman. Armed with a master plan prepared by William Turnbull and extremely generous gifts from Iris and B. Gerald Cantor and many other donors, Stanford announced an invitational design competition for the new museum. Polshek and Partners, Architects of New York created the winning concept.

The last of the four histories arises from our design philosophy and its affinity with the spirit of Stanford University and the director's vision for the project. As with past projects of a comparable nature, our intention was to develop a design strategy for the new addition that would subordinate its formal expression to the human activities the building would contain and nurture. The purpose was not to deny the importance of affect but rather to diminish the temptation for architectural self-aggrandizement so as better to satisfy the demands of user and place. This is not a case of architectural false modesty but rather a

1 Paul V. Turner et al., *The Founders and the Architects: The Design of Stanford University* (Stanford: Stanford University Department of Art, 1971), 19.

rationale that has emerged from a long-held interest in anthropological and archeological art—that is, objects designed for functional and symbolic use—and a preference for the architecture of vernacular buildings of preindustrial cultures, such as the Cistercian abbeys of southern France and northern Italy from the late Middle Ages and the great man-made landscapes and temple structures of pre-Meiji Japan. What these architectures have in common are their anonymous creators, silent interpreters of deeply felt cultural and religious forces in their societies, seemingly free from market forces and the arrogance of celebrity that shape so many contemporary American buildings. It is in this spirit that we aspire to a social and physical contextualism that requires the submersion of stylistic identity as an end in itself so that institutional and community needs can be more effectively and creatively served.

The specific architectural principles reflected in the design support the values and beliefs expressed in the last of the four histories. They include the fusion of old and new without resorting to historic pastiche; respect for the proportions and scale of the existing fragments; the renewal of the existing building both by restoration of its historic entry pavilion and by the interior reconstruction of its rectilinear galleries and octagonal rotundas; the creation of a new rotunda on an east-west axis with the abandoned remains of a precursor; homage to both the nineteenth and twentieth centuries by the restoration of the southern Rodin garden and the creation of a new contemporary-sculpture lawn and terrace on the north; and the juxtaposition of both fine and common materials as in the original building.

We recognize that while the Iris & B. Gerald Cantor Center for Visual Arts is, first, a *university* art museum, it is also a public museum; thus our planning strategy disposed the museum's new public spaces so as to integrate academic and social functions within and without the building. The cafe, bookstore, and student entry were located to the south side, closer to the campus proper, and the special-programs room within the new rotunda was placed to the north, adjacent to the Stanford Family Room. In addition, we satisfied the need to create accessibility for students, staff, alumni, and public by providing a variety of entries, ramps, lifts, and vertical circulation routes that are logically and predictably interrelated, and we created new state-of-the-art galleries whose modern neutrality will, for years to come, accommodate the museum's eclectic holdings. Finally we chose to celebrate Palo Alto's hospitable climate through the arrangement of a private courtyard and public gardens for the use of both visitors and the university population.

Major works by others influenced our design. Paramount among them are Louis Kahn's Yale University Art Gallery, whose windowless street facade respects the adjacent existing gallery but whose north side opens to a courtyard; James Stirling's Neues Staatsgalerie in Stuttgart, with its verdant rotunda courtyard; Carlo Scarpa's Stampalia in Venice, which is comprised of both an opaque facade on the public way and a transparent wall facing its private garden; and most recently Henning Larsen's uncompromisingly modern addition to the Glyptotek in Copenhagen, which occupies a void in the existing historic museum.

In addition, the museum evolved naturally from our own work. Our New York State Bar Center in Albany, New York (1968), preserved the integrity of the nineteenth-century streetscape on a major city park. Designed jointly with Arata Isosaki, the 1989 Brooklyn Museum of Art Master Plan, like the Cantor Center for Visual Arts, involved the completion of a fragment. Three recent projects involving modern additions to historic buildings, on which Richard Olcott played a major design role, are Sulzberger Hall at Barnard College (1989), Seamen's Church Institute (1991), and Jerome Greene Hall at Columbia University Law School (1997). Two projects currently under construction that add contemporary additions to historic buildings are the Plant Studies Center of the New York Botanical Garden and the Frederick Phineas and Sandra Priest Rose Center for Earth and Space at the American Museum of Natural History.

The heretofore described multiple histories—familial, geological, institutional, and philosophical—informed our approach to the creation of the museum at Stanford. However, the realization of a formal design is not a literary exercise but rather a three-dimensional, constructed artifact whose ultimate affect depends upon the elegance of its proportions, the logical expression of its structural and mechanical systems, the variety of its spatial volumes, and the quality of its materials. Stanford University provided the first three histories and invited us to contribute the fourth. Together they formed the background for the design's realization. These histories are acutely interactive: the memory of the original building complex—which was a "ruin" requiring renewal and expansion—and the mission of a great research university seeking an architectural solution that would fulfill its progressive vision and its reputation for integrity and excellence.

The Design as Palimpsest of Multiple Histories

Richard M. Olcott, FAIA

Serenity: Any work of architecture which does not express serenity is a mistake. That is why it has been an error to replace the protection of walls with today's intemperate use of enormous glass windows.[1]

Serenity is the great and true antidote against anguish and fear, and today, more than ever, it is the architect's duty to make it a permanent guest in the home, no matter how sumptuous or humble....But one must be on guard not to destroy it with the use of an indiscriminate palette.[2]

Silence: I have always tried to allow for the interior placid murmur of silence, and in my fountains, silence sings.[3]

Luis Barragán

I do not believe that beauty can be created overnight. It must start with the archaic first. The archaic begins like Paestum. Paestum is beautiful to me because it is less beautiful than the Parthenon. Paestum is dumpy, it has unsure, scared proportions. But it is infinitely more beautiful to me because to me it represents the beginning of architecture. It is a time when the walls parted and the columns became and when music entered architecture. It was a beautiful time and we are still living in it.[4]

I thought of the beauty of ruins the absence of frames of things which nothing lives behind and so I thought of wrapping ruins around buildings.[5]

Louis Kahn

An art museum should above all be a serene place—contemplative, peaceful, and beautiful—which will allow the many different interpretations that individuals bring to the experience of art. In particular a university art museum must be an open-ended and accessible place, especially at an institution like Stanford, where it can serve as a reflective counterpoint to the intensity of the computer science culture surrounding it. Such a building can be simultaneously a learning space, gathering space, introspective space, communal space, relaxing space, a fundamental part of the learning experience that Stanford offers, and common ground for its extremely diverse population.

Additions to fine-arts museums are a particularly difficult building type. This is probably because they cannot really be typified. Extant conditions, institutional memories, political considerations, mysteries of structure and soil, and the philosophical "wars" between modernism and historicism provide the types of challenges with which we are most experienced. The Iris & B. Gerald Cantor Center for Visual Arts at Stanford University exemplified all these challenges.

1 Emilio Ambasz, *The Architecture of Luis Barragán*, exh. cat. (New York: Museum of Modern Art, 1976), 8.

2 Luis Barragán, official address, 1980 Pritzker Architecture Prize, quoted in *Barragán: The Complete Works* (Princeton, N.J.: Princeton University Press, 1996), 205.

3 Ibid., 204.

4 Jan C. Rowan, "Wanting to Be: The Philadelphia School," *Progressive Architecture* 42 (April 1961), 161.

5 Louis Kahn, "Kahn," transcribed discussion in Kahn's office, February 1961. Published in *Perspecta No. 7* (1961), 9.

To this day the museum retains the independent, aloof quality of the original. The museum, library, gymnasium, and science buildings had been given honored places on the new campus; these four structures flanked Palm Drive and preceded one's experience of the Main Quad with its mix of liberal arts. With its classical formality and axiality the museum was always intended to impress and to remain a place apart through its site design and approaches. Once having penetrated its hermetic exterior, an enormous self-contained world of classical antiquity revealed itself, in a way its own ivory tower within the university. One imagines a very different Stanford in curriculum and physical makeup had not the earthquakes intervened.

Today the situation is reversed. The Main Quad remains the central anchor, but the four flanking buildings are now peripheral to the campus, and all either have been destroyed or transformed beyond recognition. Our challenge, above all, was to reestablish their previous connection, and, in fact, strengthen it, meeting the needs of our time and knitting the campus together for the future.

THE SITE: LAYERS AND EDGES

Our first visit to the site provided an extraordinary first impression: a classical, templelike structure in ruinous condition, set amidst a landscape and light of Mediterranean quality. The entry from the east, through an almost wild California vegetation, provided an unforgettable image: that of the fragments of the ruined balustrade scattered in the long grass in a scene reminiscent of classical Greece or Rome. The south side of the museum, with its cypress trees and Rodin sculpture, reinforces this impression. In fact, the Rodin garden's form is derived from the footprint of the 1905 museum's foundation walls, upon which it is built.

More remnants, both below and above ground, exist to the north and west, where the old anatomy building turned out to be a portion of the 1905 addition. It was thus apparent to us that any addition would be completely surrounded by the ruins and fragments of the original. Acknowledging these layers of history and archaeology and their potential resonance with the present and future became a major determinant of the design.

Another dominant factor in the parti (i.e. the initial diagrammatic sketch), development was the realization that the museum actually forms an edge to the campus, a border between the campus proper to the south and the virtual wilderness of the arboretum to the north and the meadows to the east. The creation of a new, visually accessible entrance to the south, where the student constituency will come from, became an imperative. Such an element could then be a counterpoint to the forbidding monumental east portico, facing as it does the unpopulated meadows and Palm Drive. In addition, it could provide a new identity in concert with the campus of today.

PHILOSOPHY AND INTENTIONS IN THE DEVELOPMENT OF THE DESIGN

Balance

Paramount in the formation of this design, and indeed in all our work that deals with existing and historic buildings, is the notion of balance. Balance cannot be achieved by placing the new building apart and allowing it to indulge in a language all its own. The new addition must be carefully calibrated to enter into a dialogue with the original, neither overwhelming nor being subsumed by it. Shared relationships of scale, proportions, rhythms, and materials can facilitate this interaction. Both structures will be the richer for such a coexistence.

Legibility

Such a balance likewise cannot depend on the adoption of the vocabulary and forms of the old in the composition of the new. While sympathetic to the old, the new construction must be easily readable and distinct from the original. In this way the history of a building and indeed the place itself become legible to the observer. The 1891, 1899, 1905, 1989, and 1998 incarnations of the Stanford Museum all have meaning, overlapping and influencing each other. The ability to decipher this palimpsest is fundamental to the understanding of the place and will greatly enrich the experience of the art within it.

THE PARTI: TYPOLOGY AND FORMAL RELATIONSHIPS

The initial parti of the museum project was developed with these ideas as guides. The basic forms of the new wing and its relation to the old were the result of much trial and error, but all the partis shared several themes. Among these were an interest in a courtyard typology common to Spanish-era California as well as to Stanford's Mission- and Romanesque-style campus and the conviction that the central axis of the original building be extended to a new centered element, solid or void, which would be the anchor of the expansion. Also important was the desire to reinterpret the forms of the old building in a way more open and accessible than the original. From this notion the system of planar walls was developed. Lastly a system of curtain-wall glazing and sunscreens issued from a desire to meld exterior and interior spaces, eminently possible in a climate like Stanford's. Further blurring the distinction between outside and in is the network of walls and terraces around the building, which facilitate the building's integration with the site. Both literally and conceptually these "ruins" wrap the building.

Courtyard, Cortile, and Garden

In conjunction with a series of gardens and courts these walls and terraces form a network of controlled spaces that wrap the built form of the museum and mediate between it and its surrounding edges. These outdoor "rooms" are part and parcel of the overall composition, woven together and alternating with the indoor spaces.

We consciously did not connect the three wings of the old building with the new in a symmetrical way, as this would not respond sufficiently to the asymmetrical footprint of the site and would result in an overly attenuated and inward-looking whole. Instead, the bulk of the new wing was shifted to the south, emphasizing its connection with the main campus and opening up the north side to the arboretum and town beyond. This asymmetry resulted in two open spaces with distinctly different shapes and qualities: south of the main axis is an enclosed hard-surfaced inner courtyard, a cortile, and to the north, a green, outward-looking court. To the south and north of the new wing are gardens with different scales and feelings. The south garden for late nineteenth- and early twentieth-century sculpture is small and intimate, bordered by low walls and plantings; overlooked by the cafe, it is intended to draw people in through this more permeable, informal entry. To the north a larger garden for late twentieth- and twenty-first-century work is more monumental in scale, as befits much work of our time. This space, overlooked by the new rotunda's sculpture terrace, is open to Campus Drive, and thus becomes one the museum's more visible edges.

The New Rotunda

The main interior entry hall of the old building is reinterpreted as a rotunda, the central element of the new scheme. Located at the center of a triangle formed by the three surviving rotundas of the original museum, the new rotunda sets up axial and spatial relationships, creating an ordering system for all portions of the new structure and anchoring the building to the old on the main axis. This circular form has been configured as the inverse of the existing lobby, an incomplete fragment in plan and section, its first floor containing the auditorium, an important new multiuse piece of the new museum, its second floor becoming an outdoor sculpture space, visually linking the galleries to the gardens around them. The "ruin" has been recast as a contemporary form, open to the campus, the landscape, and the future.

Circulation and the Promenade Architecturale

Perhaps the most delicate part of the balance struck between new and old is the zone where the transition actually takes place. We have pulled the solid volumes of the new wing slightly away from the old and in this zone introduced a circulation gallery. Glazed along its eastern courtyard side and also at its ends, this "spine" is a circulation armature connecting all the pieces and making the relationship of old to new perceptible. It completes the *promenade architecturale*, which begins in the old, passes through the new, and ends in the old again. Standing in it, one will be able to read the two buildings almost in their entirety and visually relate the two gardens at the north and south as well. In this space the contrast between old and new is most legible.

Unlike the *enfilade* sequence of the original building, the new circulation gallery allows one to bypass galleries in the new wing, an essential element of a flexible institution with constantly changing exhibitions.

Structure and Enclosure

In contrast to the hermetic, foursquare, enclosed volumes of the old museum, the new wing is conceived as a series of planar walls, floors, and ceilings, which simultaneously enclose space and are "parted" to allow the admission of light. Overlapping fields of space are thus created, which allows a free flow between volumes and merges inside and outside space. The same system continues outside the enclosure, the "ruins" extending and connecting with the landscape. Originally conceived in concrete, the same structural system as the historic building, the final solution is, in fact, a more economical, braced-steel frame. As many of its parts are deployed to reinforce the old building, the steel frame can be seen as having thoroughly invaded the old structure and in many places is on display, interacting with the architecture and structure of the old.

Glass Infill and Brise-soleil

A glass-and-metal membrane, which is woven between the new and old solid volumes, both links and separates the elements. Related in material and color to the old, the new skin provides transparency where needed to create as much openness as possible and a shading device (brise-soleil) to modulate and protect inside from outside. All connections to the exterior are made through this wall system. It is the openness of this system more than any other that distinguishes the new structure from the old with its rhythm of small, "punched" windows.

Materials and Details

The major materials of the new design were selected for their compatibility and resonance with those of the historic structure. Clad in stucco, the new wing's walls are similar in texture and color to the stucco coating of the old but are slightly lighter, smoother, and tauter as befits the nature of the vocabulary. They are edged in Roman travertine, which enriches them and accentuates their crisp, planar quality. Many of the floor surfaces, particularly in circulation areas, are scored concrete, again the same as the original. Although different in configuration, window wall systems are painted metal, like the old. Interior walls in both new and old wings are treated as floating planes, furthering the vocabulary of the main walls of the new building and allowing it to invade the old. Within the original building this has the added benefit of permitting one to distinguish the different periods of construction and read one overlapped on the other. The same strategy is also applied at smaller and smaller levels, down to the details of cabinetry, providing a logic for the building as a whole.

Stanford and its "Histories"

This last idea is perhaps emblematic of the scheme as a whole and our intentions while designing it: that the true richness of one's experience here will derive from the perception of the palimpsest of histories at Stanford and this museum. The legibility of these inherently complex, overlapping histories is ultimately important to the understanding of the place.

ACKNOWLEDGMENTS

Architecture is above all a collaborative art, one that involves numerous individuals from various disciplines, bringing different points of view and areas of expertise to a project, but all working in concert toward a unified whole. No one person is capable of creating it on his own, and our office, in particular, tries very hard to utilize the talents of everyone involved, no matter how inexperienced, which we believe will result in the best possible solution. In that spirit the following people must be identified for their invaluable contributions to the design and construction of this building.

Three people from our San Francisco office were instrumental in the making of this building: David Robinson, whose lifelong enthusiasm for art in general and knowledge of museum design in particular were guiding forces; Stefan Hastrup, whose unfailing discerning eye and skillful hand is evident everywhere in this design; and Richard Kosheluk, whose determination, "team player" attitude, expertise in construction, and general good humor actually got this building built.

Design Team

James Stewart Polshek
Richard M. Olcott
C. David Robinson
Richard Kosheluk
Stefan Hastrup
Joanne Hermance
Kenneth Ong
Roberto Sheinberg
Thomas Silva
Andrew Tyley
Thomas Wong
Amanda Martocchio
Minsuk Cho
John Fernandez
Amy Eliot

...the museum

serves both

as burial chamber of the past

—with all that entails

in terms of decay, erosion, forgetting—

and as a site

of possible resurrections,

however mediated

and contaminated,

in the eyes

of the beholder.

— Andreas Huyssen
Twilight Memories

The Iris & B. Gerald Cantor Center for the Arts at Stanford is a unique institution, especially in light of the intention behind its foundation: to serve as a memorial to the only child of Jane and Leland Stanford. Bright and precocious, Leland Jr. was an avid collector of antiquities. It was, in fact, while on a family trip to Europe to visit various archaeological sites that young Leland contracted typhoid fever and died at the age of 15.

His grief stricken parents vowed to build a monument to the memory of their son. Thus the Leland Stanford Junior University and Museum were born out of a profound sense of loss. For the rest of her life, Jane Stanford made it her mission to augment Leland's fledgling collection of artifacts and curios. In its early days, the museum served as something of a shrine to her son, largely reflective of his interests and aspirations. But over time, and with much diligence, Jane Stanford was able to assemble a collection that rivaled other museums in size, if not quality.

On Loss and Resurrection

By the time of her death in 1905, the Leland Stanford Junior Museum was the largest private museum in America. A year later the collection was largely reduced to ruin as a result of the great 1906 earthquake.

My introduction to the now renamed Stanford University Museum of Art came in the late fall of 1995 after the museum had been closed for 6 years following the Loma Prieta earthquake. My work centers around the ways in which we collect and preserve our cultural heritage, and I have recently photographed a number of museum collections as well as archaeological sites. Viewed in a certain light, museums serve as cultural reliquaries, places where one can encounter a deeper sensibility concerning history and memory. However, the museum can also be seen as a mausoleum of sorts, preserving a dead past. At any given time, most of a museum's collection remains in storage, never to be viewed. At Stanford, I discovered a museum engaged in the process of transformation.

I recall wandering through the moribund Stanford Museum galleries observing large cracks in the plaster walls and paint peeling from the ceiling. With the exception of the marble statue of Athena in the grand entry lobby, most of the museum's collection was in boxes. One gallery, however, remained intact: the Stanford room, with its larger-than-life-sized portraits of Stanford family members. These portraits seemed to peer out from beneath layers of protective plastic covering. Nearby was a vitrine with a full figure mannequin modeling Mrs. Stanford's elegant evening gown. This display was positioned across from a portrait of her wearing the same dress. Most curious in this room was a painting of the Stanford family jewels, which I later learned was commissioned by Jane Stanford to commemorate her once extensive jewelry collection. She sold the jewels to support the library collections at the university and this painting offered her a way to let them go and keep them at the same time.

The room, despite its heavy air of pathos and sentimentality, struck me. It was as if Jane Stanford had somehow willed her family to remain long after the rest of the collection had been removed to storage. Had Mrs. Stanford anticipated the changes which lay ahead of the museum so devotedly wrought in the name of her son, she might well have resisted the diminishing presence of her family. Standing as mute witnesses to the transformation now underway, these portraits are vestiges of a time in the museum's history that will never be repeated. Twice damaged by earthquakes, the Museum has been resurrected for a second time and promises to be a much different place.

Indeed the Cantor Arts Center at Stanford is a very different place. The following photographs offer a glimpse of the museum in transition. While the refounded, renamed and renovated museum addresses the concerns of a different era, one hopes it will also preserve its own poignant history.

Richard Barnes

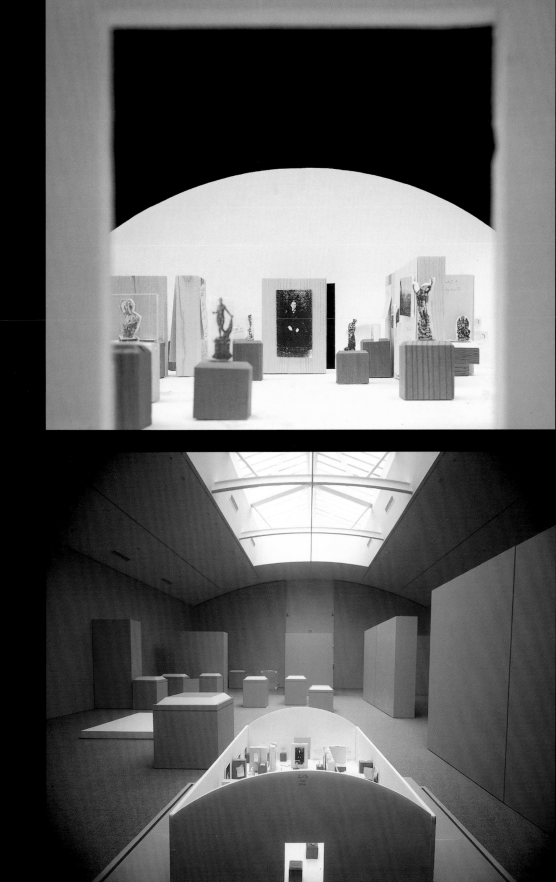

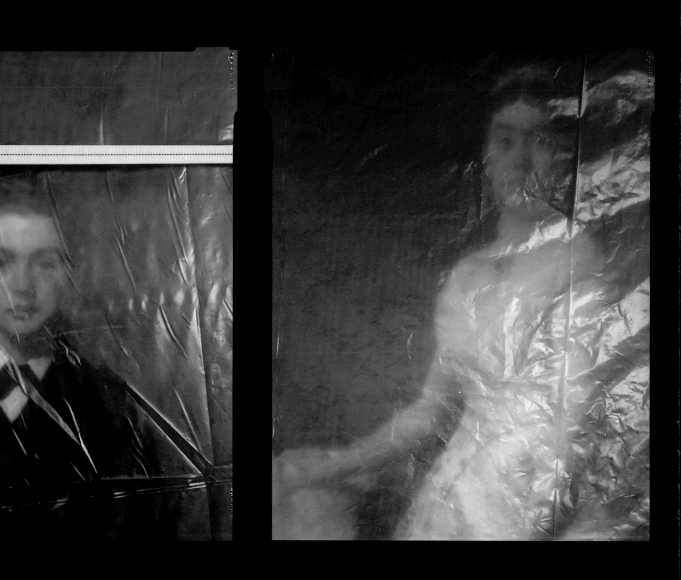

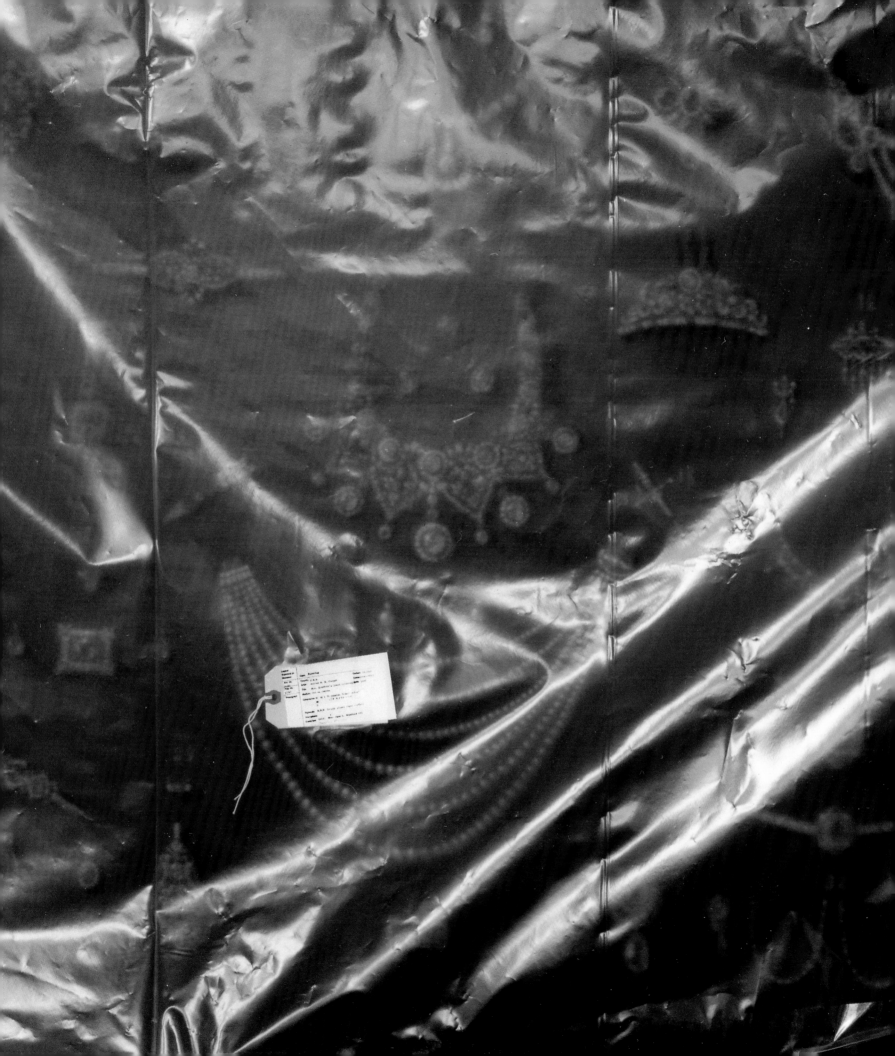

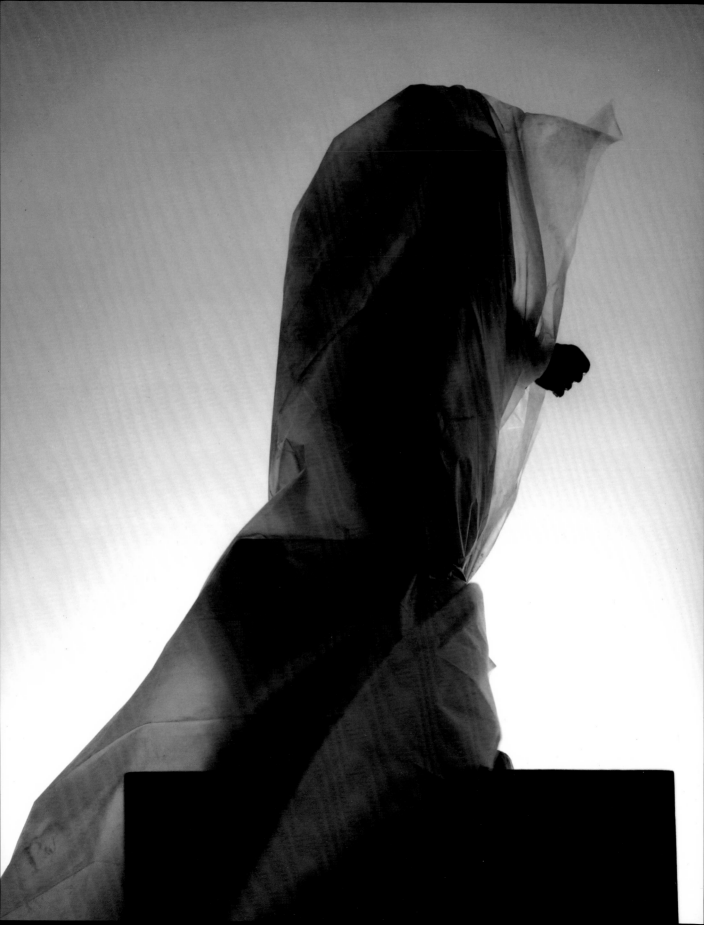

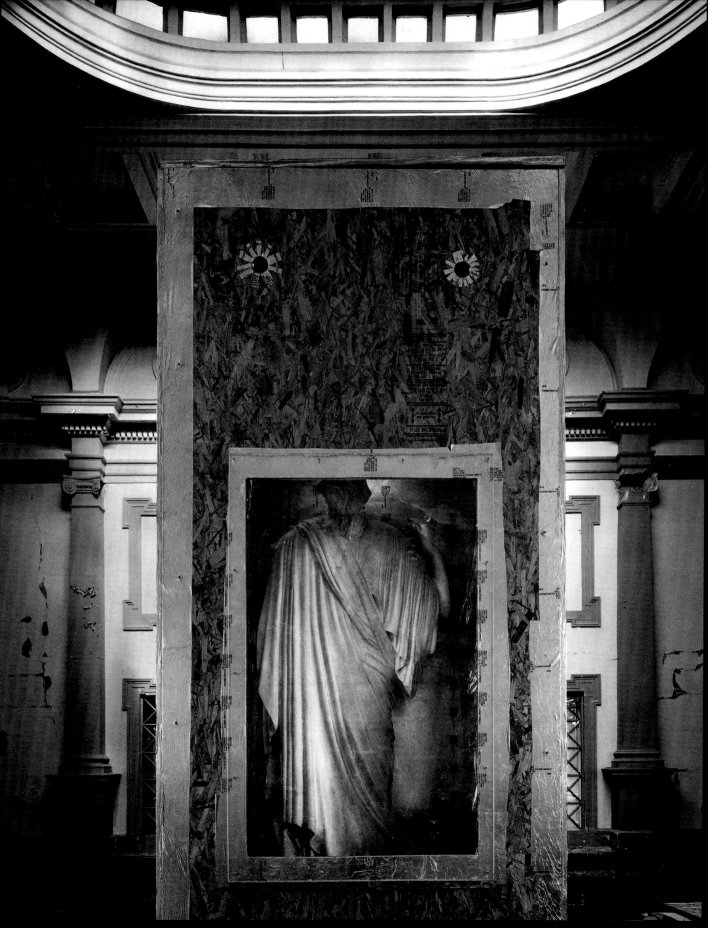

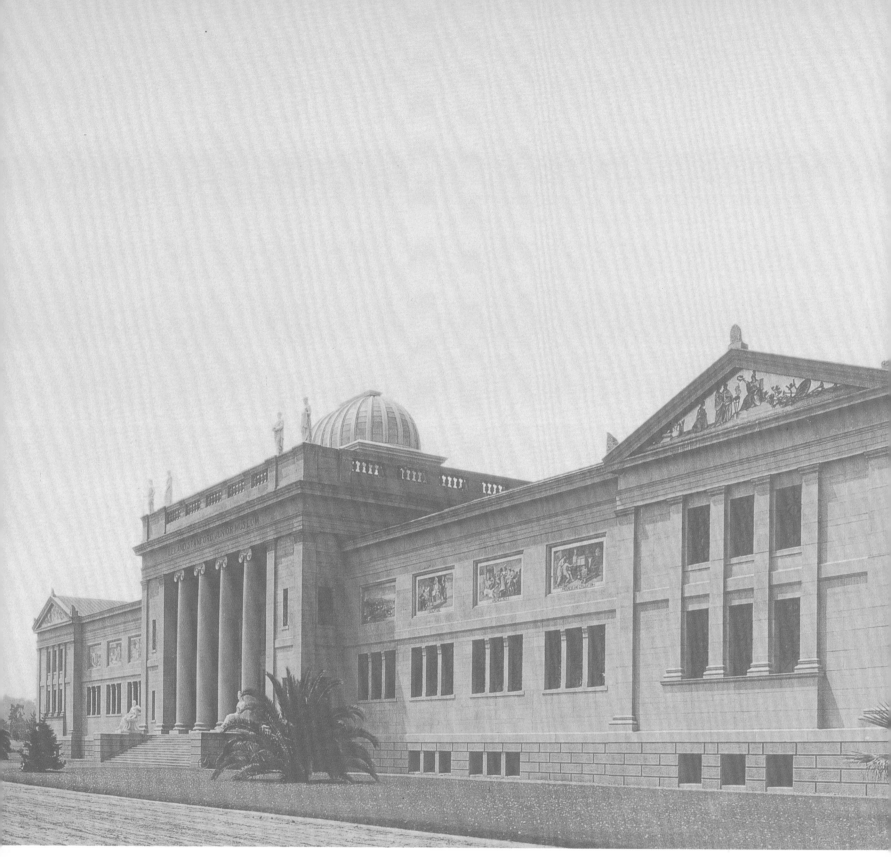

fig. 1
George Washington Percy and F. F. Hamilton.
Leland Stanford Junior Museum, east elevation, c. 1891.
Photograph: University Archives.

Building on the Past

Leland Stanford, Jane Lathrop Stanford
and Leland Stanford Jr., Paris, 1880.

It should be the aim of the institution to entertain and inculcate
broad and general ideas of progress and of the capacity of mankind
for advancement in civilization.[1]

Leland Stanford

PART I

THE LELAND STANFORD JUNIOR MUSEUM

The beginnings of the Leland Stanford Junior Museum were auspicious. Founded in 1891
by Leland and Jane Stanford as a memorial to their only child (fig. 1), it boasted seemingly
inexhaustible funds and patrons dedicated to amassing collections rivaling those of the
great museums of the day. At its heart lay a miscellany not unlike an eighteenth-century
European *Kunstkammer*, a cabinet of curiosities consisting of natural-history objects, curios,
and personal mementos assembled by Leland Jr. Surrounding it was a vast array of art
from Asia, the Americas, and Europe. By 1905, the year of Jane Stanford's death, the Stanford
Museum (fig. 2) had grown both in scale and collections to be the largest private museum
in America and seemed destined to emerge as one of the country's great institutions.[2]

However, the museum exuded the ineffable air of a private shrine. Although
extensive permanent collections filled the galleries for public consumption, they were largely
overshadowed by the almost mythic personae of the museum's founders. Until the 1960s the
museum was perceived by the public as a private memorial with a reputation for curios and
Stanford family memorabilia rather than important art collections. This is one of the more
surprising and disappointing aspects of the early history of the museum, since Leland
Stanford had initially planned a significant educational role for his son's collections. When
the Stanfords located the museum on the grounds of the university they were also building
as a memorial, they stamped it with the school's pedagogic mission: to advance progress
and civilization. Indeed, Leland Stanford's accomplishments were perceived nationally as
embodying the pioneering spirit of progress (fig. 3).

Yet the foundations of the museum were built on sand. The museum became
Jane Stanford's personal passion from an early date, and she rushed to complete the memorial
project. Her acquisitive energy and determination were largely responsible for securing the
museum's innumerable collections—between 1884 and 1894 alone, some fifteen thousand
objects were added to those her son had collected—guided, it seems, by Leland Jr.'s ambitions
for an "International Museum."[3] After her husband's death in 1893, the museum increasingly
became a family reliquary, not only commemorating her son but also the Stanfords themselves.
(The museum might be compared with the only other classical building on campus at the time,
the mausoleum [1889]. This granite and marble temple is reminiscent of the marble-lined
lobby of the museum, which one newspaper criticized as cold and gloomy.[4] This relationship
was perhaps not so unusual; for example, the Trumbull Art Gallery at Yale, the first university
art museum, built in 1832, held a crypt in its basement for the body of the artist-benefactor
and his wife.[5])

Note to Notes: Unless otherwise indicated,
all materials are located in the University
Archives, Green Library, Stanford University,
Stanford, California.

1 Leland Stanford to the university's first board
of trustees, in *The Leland Stanford Junior
University* (San Francisco: Bancroft, 1888), 41.

2 At the height of its construction shortly
before the 1906 earthquake, it measured some
200,000 square feet with an additional 90,000
square feet of storage. See Carol M. Osborne et
al., *Museum Builders in the West: The Stanfords
as Collectors and Patrons of Art* (Stanford:
Stanford University Museum of Art,
Department of Art, 1986), 15. Its size
challenged the Metropolitan Museum in
New York and the Boston Museum of Fine
Arts, both of which were opened to the public
in the 1870s, and those great repositories in
Europe, the British Museum in London and
the Altes Museum in Berlin, founded in
the 1820s.

3 Osborne et al., *Museum Builders*, 17.

4 "University Notes," *Redwood Gazette*, 21
November 1891, University Clippings,
vol. 1, p. 180.

5 Jay Cantor, "Temple of the Arts: Museum
Architecture in Nineteenth-Century America,"
Metropolitan Museum of Art Bulletin 28
(April 1970): 334.

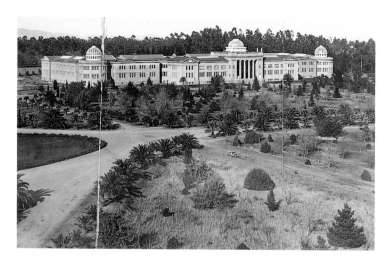

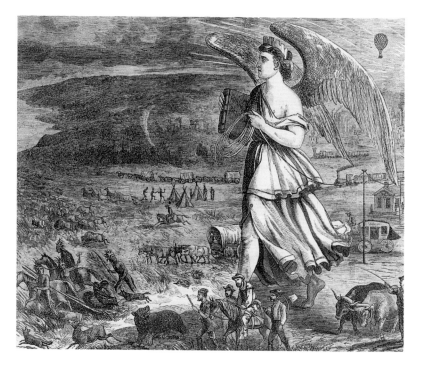

fig. 2 above
Stanford Museum, aerial view, c. 1905.
Photograph: University Archives.

fig. 3 above right
Progress, *Crofutt's Western World*, 1, no.1 (November 1871).
Lithograph: University Archives.

Jane Stanford was more interested in the scale and scope of the institution that she was building and for which she was collecting than she was in its educational program; the necessity of a specific endowment for the museum or a structure of management and operation ensuring its future after her death were largely irrelevant to her memorializing purposes. And since the museum was not tied to any academic department, it was subject to the changing needs and interests—or lack thereof—of university administrations. Although Jane Stanford expanded the museum threefold between 1898 and 1905 (with construction continuing after her death), the additions were of unreinforced brick and collapsed in the 1906 quake; only the long west wing, known as the "west annex," and two of the rotundas survived relatively unscathed.

The museum was also unsound in constitution, affecting its history. During the following decades it struggled to survive. Its curators, none of whom was professionally trained, were ineffectual in carving out a niche for it and its collections within the university or providing some active purpose for its existence. The museum, as Jane Stanford might have wished, remained fixed in time, and the Thomas Welton Stanford Art Gallery, built in 1917, became the focus of exhibitions. Quietly and with little interest from the university a great many of the museum's objects were dispersed, and various parts of the building were taken over by other academic departments. By 1930 the museum shared its facility with the Museum of Natural History. By 1945, when its director retired, the building had fallen into such ruinous condition that the university closed the museum "for inventory." Not until 1954 did the university reopen the museum, after a controversial sale of objects from its collections led to renewed interest in Stanford's heritage from a public clamoring for access. Although the museum seemed to have garnered new respect for its collections, the specter of its reputation for curios remained; one newspaper reported that the museum had reopened without its display of ham and eggs— Leland Stanford Jr.'s purported last breakfast.[6]

6 "Stanford Museum Reopens without Its Ham and Eggs," *San Francisco Chronicle*, 23 May 1954, Stanford Museum, file #3602. The culinary display was proved to be a forgery perpetrated by an art student.

Few museums could have endured the curious twists and turns of the Stanford Museum. Yet almost miraculously the museum experienced a surprising resurrection beginning in 1963, when Professor Lorenz Eitner became chair of the art department and director of both the Stanford University Museum of Art and the Thomas Welton Stanford Art Gallery. Through a steady program of building the museum as an adjunct to the art department and as a faculty resource, Eitner developed the Stanford Museum into a vital and prominent institution, erasing the perception of it as a repository for curios and creating an institution recognized for its research, teaching, and exhibition programs.[7]

Today, almost ten years after the Loma Prieta earthquake forced the museum to close its doors, a more inviting and pubic-oriented facility has reopened, boasting a new wing by the internationally renowned firm of Polshek and Partners, the first addition since those by Jane Stanford. Polshek's design not only embodies the historical memory and traditions of the museum but also reflects the new realities of late twentieth-century museum building and the museum's broader artistic and pedagogic role within both the university and the surrounding community. The Leland Stanford Junior Museum has been reborn as the Iris & B. Gerald Cantor Center for Visual Arts at Stanford University. As such, it has come full circle, and the history affecting its design is the subject of this essay.

THE EARLY HISTORY OF THE LELAND STANFORD JUNIOR MUSEUM

In late 1884, shortly after his return to California with the body of his son, who had succumbed to typhoid in Florence, Leland Stanford revealed plans to complete his child's dream of building an international museum.[8] Its cornerstone laid in 1891, the museum was opened to the public in 1894. Its conception was extraordinary: at a time when only a handful of such institutions of any significance existed in America, it would rival in size and collections those of the "metropolitan cities of the world."[9] The Stanfords would amass from relatively humble beginnings a "great repository of curious and instructive objects" for the "gratification and education" of the people of San Francisco (which was originally conceived as the site of the museum) as their son had wished.[10]

The Stanfords set out to fulfill Leland Jr.'s wish to collect "antiquities and curious things from all parts of the world," beginning only a couple of months after their son's death with the purchase of five thousand pieces from the Luigi Cesnola collection of Cypriot pottery in the Metropolitan Museum of Art.[11] Jane Stanford assembled collections "from the mounds and dwellings of the pre-historic races of our own continent, and both ancient relics and modern curios from the islands of the Pacific and oriental countries."[12] The McAdam collection (American mound objects), the DeLong collection (Japanese materials), and the Rhousopoulos collection (Greek antiquities) were among the more significant purchases made in the 1880s. The Stanfords also acquired collections of Korean and Northwest Coast Indian artifacts, so that by 1893 it was reported that the collections represented "all ages and all peoples."[13] The Stanford Museum was truly a "universal survey museum" on a vast scale.[14]

7 In 1986 Carol Osborne and Paul V. Turner dispelled many of the myths surrounding the Stanford collections and revealed the architectural significance of the museum building itself. Turner, "The Architectural Significance of the Stanford Museum," in Osborne et al., *Museum Builders*, 92-105.

8 Osborne et al., *Museum Builders*, 52. "The Story of Stanford University, Part III, Chap. LIV," Harry C. Peterson Collection, box 3 . Articles by Peterson published in the *San Francisco Call* between 13 January and 11 April 1919. The Stanfords may have been spurred to build the museum even before their son's death, when Leland Stanford was asked publicly to build a "picture gallery" in San Francisco. Unidentified and undated newspaper editorial (though it is included among articles dating from 1882), Stanford Family Scrapbooks, vol. B, p. 78.

9 "At Grace Church, San Francisco," *Sacramento Record-Union*, 1 December 1884, Stanford Family Scrapbooks, vol. 8, p. 3.

10 Herbert Nash, *The Leland Stanford Junior Museum: Origin and Description* (n.p., 1886), 1. Nash stated that it was Leland Jr.'s desire to build a museum for the benefit of the people of San Francisco before his death, and his parents intended to carry out this request. Leland Stanford had previously made a gift of collections to the city. In 1882 he purchased a natural history collection with Charles Crocker and donated it to the California Academy of Sciences. The collection consisted of casts of fossils made from originals in "great museums in every country and constitute a complete exhibit of all that is yet known of the wonders of the fossil world." It was to form the kernel of a "British Museum" for the city of San Francisco. Unidentified newspaper article dated 1882, Stanford Family Scrapbooks, vol. B, p. 57. Osborne et al., *Museum Builders* (17) notes that Stanford, again with Crocker, helped found still earlier the Agassiz Institute, a museum dedicated to the arts and sciences, although no date is given.

11 "Leland Stanford, Jr., Museum," *The Argonaut*, 9 April 1887.

12 Ibid.

13 "Destined for the People," unidentified and undated newspaper article, Stanford Family Scrapbooks, vol. D, p. 43. The history of the Stanfords as collectors is told in Osborne et al., *Museum Builders*.

14 Carol Duncan and Alan Wallach, "The Universal Survey Museum, " *Art History 3*, no. 4 (December 1980): 448-69.

Unlike the typical Gilded Age museum, the Stanfords built their museum around the nucleus of their son's earliest objects.[15] Herbert Nash, Leland Jr.'s tutor, provided a detailed inventory of the collections in his *Leland Stanford Junior Museum: Origin and Description.*[16] These included natural-history specimens and a potpourri of objects significant of the "social, political, and religious life of Jerusalem, of Continental Europe, and our own national history," a variety of arms from different historical epochs in Europe, including suits of armor and modern French weapons; an "immense cannonball" shot at Fort Sumter; a cane presented to Jane Stanford's grandfather by Lafayette and made from a timber of the *U.S.S. Kearsarge*; ammunition and bread from the siege of Paris in 1870-71; a spur worn by the Emperor Napoleon III and coins showing the "bitterness of popular feeling against the fallen sovereign"; and a "gigantic pair of horns of Roman cattle, of unusual size and beauty."[17] In almost every case Nash highlights each object's historical associations and personal meaning for Leland Jr., not its aesthetic merits.

Nash regarded these early collections as immature, the evidence of a youthful curiosity. Clearly biased, Nash felt that only those objects obtained during Leland Jr.'s last trip to Europe in 1883-84, when the youth resolved to "make [only] a collection of Egyptian, Greek, and Roman" antiquities (although he also purchased artifacts from Babylon and Assyria), would inaugurate his international museum. The new direction in collecting reflected a significant change in Leland Jr.'s interests, doubtless guided by Nash, toward an archaeologically oriented museum. This shift was also significant of a rising scientific spirit, which began to dominate collecting in the museological world toward the end of the nineteenth century.[18] Philosophers, such as Hippolyte Taine in the 1860s, posited a close relationship between science and empiricism affecting research in anthropology and archaeology, areas in which Leland Jr. had acquired much "practical knowledge," according to his father. (Leland Jr. had even wished to conduct an archaeological dig on Rhodes.) Nash contended that the true "landmarks of history and civilization" consisted of Leland Jr.'s collection of Greek glass vases, bronze work, and terra-cotta statues, marbles from Greece and Rome, sarcophagi from Egypt, and cuneiform tablets and human-headed lions from Babylon and Nineveh.[19] The Stanfords and Nash shifted the focus of the collections away from its private appeal to one more public and universal, realizing that a great public institution could not be built on the miscellany of Leland Jr.'s historical curiosities.

PROGRESS AND CIVILIZATION

The Stanfords' collecting habits were not unusual for the Gilded Age. They shared the nineteenth century's belief that the whole of the natural world (as it had come to be defined by Pliny's *Natural History*, which encompassed all natural and artificial objects) fell within the range of human knowledge, an Enlightenment tradition. Museums founded after 1870, such as the Brooklyn Museum, the Cincinnati Art Museum, and the Metropolitan Museum of Art, all of which were inspired by the South Kensington Museum (now known as the Victoria and Albert Museum), institutionalized universal knowledge by representing world cultures in their collections.[20] When Stanford told reporters that his museum would include the "antiquities of God and man," he affirmed this encyclopedic concept of learning.[21]

15 Before the Stanford Museum was built, these objects were housed in the family's Nob Hill mansion, which also contained a picture gallery. The house was destroyed in the 1906 earthquake.

16 Nash, *Stanford Museum*. Nash noted the precise location of the objects in the rooms, moving through them in a clockwise manner. His meticulous record suggests that the Stanfords had already decided to replicate the rooms with their objects in their proposed San Francisco museum.

17 "At Grace Church." This information is taken almost verbatim from the memorial-service booklet and represents the earliest public listing of Leland Jr.'s collections. Doubtless it was compiled by Nash.

18 Richard Guy Wilson et al., *The American Renaissance 1876-1917*, exhibition catalogue (New York: Brooklyn Museum, 1979), 57-61. Wilson notes its influence in other areas of Gilded Age society as well.

19 Leland Jr. to Aunt Kate, 25 December 1883, Leland Stanford Junior Collection, Box 1, folder 1. Leland Jr.'s taste for such antiquities was influenced by his mother and Nash.

20 Leland Jr. visited the Metropolitan Museum of Art in New York prior to his last trip to Europe, where he also visited the South Kensington Museum. These museums may have inspired his decision to collect on a comprehensive scale.

21 "At Grace Church."

The Stanfords' comprehensive collections served their university's educational program, which claimed to encompass the "epitome of the universe."[22] Leland Stanford declared that knowledge was limitless when he averred, "We may always advance toward the infinite," and literally embodied this pedagogic principle in the design of the plan of the university with its potentially unending string of quads, its arboretum, and vast extent of lands.[23] Universal knowledge, moreover, exemplified Leland Jr.'s "latest thoughts and intellectual tendencies" toward producing something "good for humanity [through] the civilizing force of education."[24]

The Gilded Age tended to interpret universal collections generally as indexes of civilization, and the history of art as the history of a nation's "faith," "loftiness of spirit," and the "embodiment of its ideals."[25] Andrew White, president of Cornell University and one of America's most eminent educators consulted by the Stanfords about the planning of their university, further elaborated on the incentives behind universal collections, which show the "progress of...science or art thus far, prepatory to...developing it further." The "great doctrine of evolution," continued White, had demonstrated that "great improvements in civilization are rarely...sudden and complete creations; they are generally developed out of the past by a constant process of improvement [built upon] the accumulated thought and work of those who have gone before."[26] But Leland Stanford drew different conclusions from and proposed different purposes for the cultural panorama represented by his collections.

White doubtless inspired and encouraged the Stanfords, who declared that their museum would "illustrate the progress of mankind."[27] Progress, as White had indicated, alluded to the advancement of civilization abetted by its technological prowess, according to Leland Stanford. Through "labor-aiding" machines, such as the McCormick reaper, or the development of electricity and steam (both of which would power the university as well as the museum), America, especially in the late nineteenth century, had risen to a level of technological superiority.[28] For Stanford, machines demonstrated "man's power to perfect his control of the forces that surround him," giving concrete form to ideas in the quest for "life, liberty, and the pursuit of happiness."[29] Technology elevated the general citizenry to new standards of comfort and freedom.

> It seems to me that what particularly marks our civilization as superior to that of the ancients is the mechanical arts and the sciences which may be applied to practical uses. The Greeks and Romans had orators, statesmen, poets, philosophers and generals, and perhaps in each one of these respects they showed ability equal to that of any moderns, but the comfort of the people–of the great masses–was very far from that to which our people have attained.[30]

Leland Stanford frequently declared that his university would produce practical "missionaries...of civilization."[31] His educational program was embodied in the course he set for the university, first outlined in his address to the newly created board of trustees in late 1885, titled the "Broad and General Ideas of Progress," and later grandly amplified in the sculptural frieze representing *Progress of Civilization in America*, which, as it wound its way round the top

22 "Stanford's Aims Some Idea of What the Great University Will Be When Complete," *Post*, n.d., Stanford Family Scrapbooks, vol. 9, p. 22.

23 "Leland Stanford Jr. University," unidentified and undated newspaper article, University Clippings, vol. 1, n.p.

24 Untitled newspaper clipping, *New York Semi-Weekly Tribune*, 27 May 1884, Leland Stanford Collection, box 7, folder 9. (There are two Leland Stanford collections, SC 33a and SC 512, in the University Archives. Unless otherwise noted I am referring to the main collection, SC 33a.)

25 These associations were made by Charles Eliot Norton, a professor of art history at Harvard. Quoted in Wilson et al., *American Renaissance*, 29, 58. See also Alan Trachtenberg, *The Incorporation of America: Culture and Society in the Gilded Age* (New York: Hill and Wang, 1982), 140-61.

26 White to Jane and Leland Stanford, 26 May 1892, Leland Stanford Collection, box 7, folder 1.

27 The Korean collection, for example, was held to "illustrate the progress of arts, science or manufacturers in the Kingdom of Corea." "In Palo Alto's Farm," *San Francisco Examiner*, 28 March 1893, University Clippings, vol. 3, p. 64. While the museum's development is rightly credited to Jane Stanford, both her husband and White apparently played previously unacknowledged roles in its early formation.

28 "Leland Stanford Junior University," *Omaha World*, May 1893, Stanford Family Scrapbooks, vol. 3, p. 87.

29 Ibid.

30 Unidentified and undated newspaper article, Leland Stanford Collection (SC 512), box 2, folder 7.

31 Stanford to David Starr Jordan, 24 August 1892, Leland Stanford Collection, box 6, folder 1.

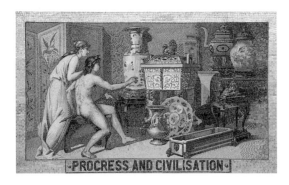

fig. 4
Antonio Paoletti. Progress and Civilization, mosaic panel, east elevation of the Stanford University Museum of Art, c. 1904. Photography by Thomas K. Seligman.

32 "The Memorial Arch of Stanford University," *San Jose Daily Mercury*, 27 October 1901, Memorial Arch, file # 0290.

33 The panel shows two figures gazing on a distinctly Eastern cultural legacy, perhaps an allusion to the large collection of oriental objects housed within the museum and not indicated in any of the other panels.

34 Unidentified and undated newspaper article, Leland Stanford Collection (SC 512), box 2, folder 7.

35 "Jane Lathrop Stanford upon Her Inauguration as President of the Board of Trustees of Leland Stanford Junior University," 6 July 1903, Ray Lyman Wilbur Personal Papers, box 75. "Historical (early through 1915)" folder. The letter was written to Jane Stanford by White from Berlin on 10 May 1901.

36 "Leland Stanford Jr. University," unidentified and undated newspaper article (but probably 1885), University Clippings, vol. 1, n.p.

37 "A New Memorial College," *New York Semi-Weekly Tribune*, 27 May 1884, Leland Stanford Collection, box 7, folder 9.

38 To this extent the Stanfords stood apart from conventional Gilded Age aspirations of philanthropy and public munificence, since ultimately they were concerned with the spiritual basis of life and the power of art to reveal that presence within any culture.

39 Turner, "Architectural Significance," *Museum Builders*, 132 n. 12. The fact that the architects did prepare drawings for the museum suggests that Leland Stanford was involved in its development, since the firm was then engaged as well on the design of the university under Stanford's direction.

40 Nathaniel Burt, *Palaces for the People* (Boston: Little, Brown, 1977), 163; Germain Bazin, *The Museum Age*, trans. Jane van Nuis Cahill (New York: Universe Books, 1967), 245.

41 Burt, *Palaces for the People*, 163.

of Memorial Arch, the gateway to the university, revealed a technological evolution of civilizations culminating in the great achievements of Victorian America.[32] Jane Stanford shared her husband's beliefs and demonstrated her support by including a representation of *Progress and Civilization* among the mosaic panels adorning the front of the museum[33] (fig. 4).

In the Stanfords' minds, however, a purely technocratic society was ill equipped to advance civilization. "The imagination needs to be cultivated and developed to assure success in life," Stanford affirmed. "A man will never construct anything he cannot conceive. I think the tendency of purely scientific and mathematical education is to curb imagination, and make one feel that that is impossible which he cannot see and feel, or measure or put in the scales and weigh."[34] Jane Stanford agreed that the arts improved life and were a necessary complement to the sciences. In her address to the board of trustees of the university in 1903 she quoted a letter from White, "whose opinion and advice I value highly," to voice her sentiments about the role of the arts within education:

> I believe devoutly in the mission of the Arts, Architecture, Sculpture, Painting,
> and Music in uplifting human life. Vastly important as science is, I should dislike
> institutions which are restricted to the cultivation of science alone.[35]

While science tended to society's limited physical needs, "a man's mind…or his appetite for beauty and art" can never be satisfied, Leland Stanford maintained.[36] Art was symptomatic of a society's intellectual, moral, and religious development. Leland Jr.'s museum was born with the thought that art revealed the "practical bearing of enfranchised thought upon the advance of civilization…[making apparent] the vital importance of education."[37] The museum not only could bolster technical progress but also could elevate civilization morally and spiritually.[38]

A UNIVERSITY ART MUSEUM

The Stanfords had initially planned to build their museum in Golden Gate Park and asked the architectural firm of Shepley, Rutan, and Coolidge, who were then designing the new university, to prepare drawings for it in 1887.[39] However, by late 1888 the Stanfords had decided to locate it on the campus of the university in Palo Alto and in 1890 hired the San Francisco firm of George Percy & Frederick Hamilton. Unlike other university art museums, Stanford's would surpass all others in scale and coverage. Although university art museums existed in England, notably the Ashmolean at Oxford (1683) and the Fitzwilliam at Cambridge (1848), the scholastic art museum has been recognized as a distinctive American type.[40] In general they were small, even rural institutions serving as "teaching museums."[41] Their educational goals were met primarily with representative examples, such as casts or copies of paintings, rather than exclusively with masterpieces. Reflecting their environment, such museums tended to acquire broadly, creating a universal survey of the history of art and design. Collections were usually integrated within their respective departments, with only a handful of exceptional university art collections housed in their own buildings, such as those at Yale (1832) and Princeton (1887).

fig. 5
**Ludwig Lange, Panages Kalkos, and Ernst Ziller.
National Archaeological Museum, Athens, main elevation,
c. 1880s. Photograph: Museum Archives.**

The Stanfords' decision to locate the museum on the grounds of the university was a logical choice for several reasons, not least among which was the university's grant of endowment of 1885, which provided for such "seminaries of learning [as] museums, [and] galleries of art."[42] Francis Walker, president of the Massachusetts Institute of Technology and one of the preeminent educators consulted by the Stanfords in late 1886 about plans for their university, noted the need to include separate museums of fine arts and natural history among the campus's first buildings as adjuncts to the various departments.[43] Yet Jane Stanford never envisioned building a conventional university art museum; she turned to the largest museums in the world as her paradigms. To then marry that aspiration with the university created an unprecedented institution: an urban-scaled museum in the middle of a wilderness. Nevertheless, the Stanfords recognized that the "collections were the connecting link between Leland Junior and the cornerstone of the University."[44]

During the planning of the university, the Stanfords at first tried to situate the museum among the buildings of the outer quad, dividing the collections into separate buildings for natural history and the fine arts. A contemporary description of the proposed university in 1888 described a two-story art museum to the right of Memorial Arch, containing a large reading room on the lower floor and a skylit picture gallery entered through a long corridor lined with statuary on the upper floor.[45] The gallery was to be filled with the collections of ancient and modern art from the Stanfords' home in San Francisco, including "cases of priceless treasures, purchased lately in Europe, also plaster casts of Greek sculpture." Balancing the art museum on the other side of Memorial Arch was the "natural history museum" intended to exhibit Leland Jr.'s collections of curiosities, including "rare objects" and other groups of materials added by his parents since 1884.

Jane Stanford, however, decided to model the museum after the National Archaeological Museum in Athens (fig. 5), which Leland Jr. had visited shortly before his death.[46] The neoclassical style of the Athens Museum was incompatible with the Romanesque-Mission flavor of the quads (curiously, Jane Stanford later remarked that she felt she had created a building very much in harmony with the style of the quads), and a new site was chosen on Lomita Mall. Another probable cause for the museum's removal from the quad was doubtless Jane Stanford's unwillingness to divide her son's collections. She planned to replicate the rooms in their Nob Hill house holding her son's collections in specially designed galleries in the new museum. Dispersing the collections would have undermined the integrity of the museum as a memorial, and building on a relatively isolated site would have strengthened that purpose. Unwittingly, though, the Stanfords undermined the importance of the museum to university teaching by locating it away from the core of campus life. This detachment would plague the museum as a relevant pedagogic tool throughout its history.

42 The Grant of Endowment. "Stanford Dead," *San Francisco Examiner*, 21 June 1893, Stanford Family Scrapbooks, vol. D, p. 2. Several incentives may have encouraged the Stanfords to build a museum at the university rather than in San Francisco. Doubtless two museums would have stretched the Stanfords's resources beyond what they could have afforded. See also Turner, "Architectural Significance," 96.

43 For a history of Walker's role in shaping the building program for the university, see Paul V. Turner et al., *The Founders and the Architects: The Design of Stanford University* (Stanford: Stanford University, Department of Art, 1976), 21-22. Separate buildings may also indicate the growing proclivity for a greater scientific classification of materials as had taken place at Oxford's Ashmolean and the Altes Museum in Berlin during the latter half of the nineteenth century (Bazin, *Museum Age*, 195).

44 Osborne et al., *Museum Builders*, 129 n. 11. The quote is from Harry Peterson.

45 Revenues from the estate would furnish the trustees with funds to purchase artworks for the gallery, which, it was prophesied, would become the richest west of New York. "At Palo Alto," *San Francisco Morning Call*, 3 December 1888.

46 Turner, "Architectural Significance," 96. Henry Codman, the on-site architect for Shepley, Rutan & Coolidge, noted that "Mrs. Stanford has certain ideas about it which might not be possible to get properly in harmony with the other buildings" (Codman to Frederick Law Olmsted, 21 April 1890, Shepley, Rutan & Coolidge Miscellaneous Correspondence, box 2). Codman believed a block in the outer quad would not be large enough to house the museum. He suggested that if the museum grew, it could also occupy another block on the other side of Memorial Arch. He proposed reserving all four blocks of the north flank of the outer quad for Mrs. Stanford's purposes (Codman to John Olmsted, 10 October 1889, Shepley, Rutan & Coolidge Miscellaneous Correspondence, box 2).

fig. 6 above
Stanford Museum lobby, c. 1890s.
Photograph: University Archives.

fig. 7 right
Stanford Museum, transverse section, c. 1891.
Blueprint. Facilities Project Office, Maps and Records.

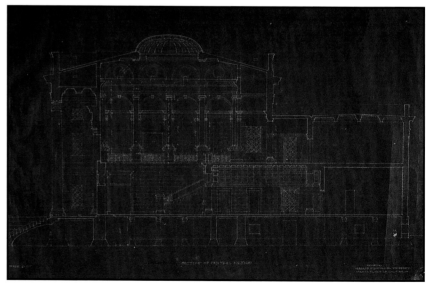

Ground was broken for the Leland Stanford Junior Museum on 23 November 1890. As a university art museum it had few equals.[47] Andrew White commented that the museum was the "most sumptuous and complete art gallery connected with any university or college in the United States, indeed, one of the most perfect in the world."[48] The classical splendor of the interior contrasted sharply with the austere exterior. The lobby was an elegant two-story chamber lined with a cool, grayish marble and detailed with white pilaster strips (fig. 6). A grand double staircase dominated the lobby and led to a encircling, colonnaded gallery lined with sculpture. Overhead, a coved ceiling with oculi ringed both the lobby and gallery, evoking the grandeur of a Renaissance palazzo. A large, reinforced-concrete dome some sixty feet above the floor lit the room (fig. 7). Directly opposite the entry was a coffered, barrel-vaulted passageway that cut through the base of the staircase and led to the Leland Stanford Junior Memorial Room, which replicated the family's galleries in their Nob Hill house.[49] At the top of the staircase, immediately above Leland Jr.'s gallery, was the Stanford Family Memorial Room. This was, in fact, a family vault; it was locked behind a great metal door, its walls were wired to an electric alarm system, and it had a burglar-proof, reinforced-concrete, ceiling with over two thousand pieces of "telescope glass" embedded in it to permit light to filter through.[50]

White recommended that the museum's "main purpose should be to contain a gallery of casts representing the whole development and progress of sculpture from its Egyptian and Assyrian beginnings through to modern times…as an immense value to historical studies." This suggestion indicates that White viewed the museum as a university art museum, where representative examples of objects were more important than masterpieces.[51] The extent to which the Stanfords accomplished this is unclear, however. In 1891 Leland Stanford ordered changes to three of the upper-floor galleries to accommodate copies of "all the best examples of the old masters…to present to students the past and present ages of art," suggesting that he too conceived of the museum at this time as a complement to the university's educational program.[52] Stanford also had "modern paintings" copied and wanted to represent the "triumph of Medieval Art." Although he died before he could complete the task, Jane Stanford fulfilled his wishes.[53]

THE MUSEUM AS AN EMBODIMENT OF PROGRESS

It is hard not to see the design and construction of the Leland Stanford Junior Museum as a demonstration of Leland Stanford's passion for technology.[54] The museum was hailed as the "first of its kind in any country," a pioneering work of reinforced concrete.[55] Touted as the largest building in the world made of concrete, it was widely regarded as evidence of America's technological prowess and progress in architecture, engineering, and culture.[56] Stanford himself was convinced that its unorthodox construction represented a remarkable new technology that could be utilized to harness the forces of nature. Indeed, fearing that the great sixty-foot columns on the front of the building would collapse during an earthquake, he ordered that the concrete be poured day and night without interruption, creating seamless, monolithic shafts.[57]

47 For a history of the university art museum, see Burt, *Palaces for the People*, 163-69. Burt notes the eccentric nature of Stanford's collections, including its purported representation of Leland Jr.'s last breakfast.

48 White to Leland and Jane Stanford, 26 May 1892, Leland Stanford Collection, box 7, folder 1. Trachtenberg notes that such sumptuous classical temples were common during the Gilded Age, though he is wrong in claiming that they existed before the Leland Stanford Junior Museum or the 1890s (*Incorporation of America*, 144).

49 Jane Stanford had the museum's architect, George Washington Percy, visit the galleries in her Nob Hill house to assure accuracy in replicating the rooms in the museum (Mrs. Emma C. Percy to Donald Tresidder, 2 December 1943, Ray Lyman Wilbur Presidential Papers, box 129, "Museum" folder).

50 "The Stanford Museum," *Palo Alto Mayfield*, 5 November 1891; "University Notes," *Redwood Gazette*, University Clippings, vol. 1, p. 180.

51 Andrew White to Leland Stanford, 26 May 1892, Leland Stanford Collection, box 7, folder 1.

52 Untitled newspaper article, *Santa Maria Times*, 27 June 1891; "Art in Copy," *Philadelphia Times*, 28 June 1891, University Clippings, vol. 1, p. 29.

53 Jane Stanford told David Starr Jordan that "I have added a large number of copies of the famous paintings in the different galleries of Europe in order to fill up the gallery which Mr. Stanford commenced, and intended to devote solely to copies of the old masters" (Stanford to Jordan, 19 May 1901, Jane Lathrop Stanford Collection, box out 2, folder 1).

54 See Turner, "Architectural Significance," 92-105. The building was originally meant to be constructed in brick with a veneer of sandstone, but the costs were apparently prohibitive.

55 "A University Museum," *New York Tribune*, 24 April 1892, University Clippings, vol. 2, p. 52.

56 "Stanford University," *New York Tribune*, 22 September 1891, University Clippings, vol. 1, p. 67.

57 Richard Keatinge, "Stanford Built for Earthquakes," *Stanford Alumnus* 7, no. 8 (May 1906): 45-46. Although Jane Stanford is generally given credit for supervising the design and construction of the museum, Leland Stanford played a behind-the-scenes role, which is still unclear. Ernest Ransome himself credited Leland Stanford with the "confidence and foresight to realize the technical and commercial importance of the novel construction, often in the face of severe criticism and bitter attacks" (Ernest L. Ransome and Alexis Saurbrey, *Reinforced Concrete Buildings* [New York: McGraw-Hill, 1912]: 6-7). Stanford also ordered the same method of pouring concrete for Roble Hall (1891), the hastily erected women's dorm.

58 "Stanford University," *Los Gatos News*, 26
June 1891; "At Palo Alto," San Jose Record,
23 September 1891; "Stanford University,"
New York Tribune, 22 September 1891,
University Clippings, vol. 1, p. 26.

59 "At Palo Alto."

60 "Stanford University," *Los Gatos News*.

61 "The Stanford Museum," *Palo Alto Mayfield*.
This last feature further aligns the museum
with the first mausoleum, which was also
wired against burglary ("An Art Museum,"
San Francisco Chronicle, 14 January 1891,
Museum, file #3602).

62 "Architects Inspect the New Concrete
Buildings at Palo Alto," *Oakland Enquirer*,
28 September 1891, University Clippings,
vol. 1, p. 75.

63 Turner notes that the plans for the Athens
Museum were drawn up in 1860 by Ludwig
Lange, but the building was still under
construction when the Stanfords visited in
1884. In 1888 Jane Stanford wrote to the
architect Ernst Ziller, who revised the
origninal plans, asking for copies, but
apparently never received them
("Architectural Significance," 94).

64 "An Art Museum," *San Francisco Chronicle*.
The later additions to the Leland Stanford
Junior Museum were designed by Charles
Hodges, the unofficial university architect;
Jane Stanford revised them. Stanford to
Hodges, 6 January 1902, Jane Lathrop
Stanford Collection, box out 2, folder 1.

65 It is unlikely that the Leland Stanford Junior
Museum was the catalyst for change, since
the Chicago World's Columbian Exposition
of 1893, for which planning had begun
several years earlier, stole the spotlight
nationally and made prevalent the American
classical style of architecture from the 1890s
forward. The great bronze doors of the
museum, embossed with scenes illustrating
the history of architecture, suggested the
prestigious heritage of the museum.

66 An iconographic program has yet to be
explained, though fragments or isolated
elements are indicative of the Stanfords'
personal ideals and philosophy surrounding
art and its production. Charles Hodges
acknowledged Jane Stanford's large role in
creating the mosaic program (Hodges to
Jane Stanford, 12 March 1904, Architecture
of Stanford University, box 1, folder 5). The
Stanfords' San Francisco house also had an
extensive iconographic program, apparently
worked out by Jane Stanford with a "Miss
[Harriet] Hosmer," a renowned American
sculptor, and designed in 1876 in the
"Pompeiian style" by G. G. Gariboldi ("An
Art Treasure," *San Francisco Chronicle*, 1876,
Stanford Family Scrapbooks, vol. B, p. 53).
Also on the same page of the scrapbook is an
unidentified and undated newspaper article
describing this work. See also Osborne et al.,
Museum Builders, 27-28, although she does
not note Jane Stanford's contribution. Such
grand decorative programs were a Victorian
convention and usually the prerogative of
wealthy women (Trachtenberg, *Incorporation
of America*, 140-81).

The museum's making fascinated both the popular and professional press. They frequently reported such technological features as its fireproof and earthquakeproof construction; its monolithic mass reinforced with twisted metal bars, creating the largest concrete beam spans yet attempted; and its rapid construction time, two-thirds less than that of a conventional masonry building, and costing half as much.[58] Percy was often quoted boasting that there would not be enough wood in the building to make a tooth-pick.[59] Its processes were equally scrutinized, especially the relatively small work force of one hundred men and the "complicated steam machinery" used to make concrete.[60] In addition to these features, it was also noted that the building was electrified for lighting, maintained a constant temperature, and in at least one room had an alarm system of wires embedded in the walls every three inches.[61] Percy attempted to identify the building's modernity with the greatest of all classical buildings, the Parthenon in Athens. He observed that portions of the temple that had "material well preserved for two thousand years, were of concrete."[62] He was anxious perhaps to establish a prestigious ancestry for his modern classical temple conceived in an unorthodox and still largely unknown material.

The Leland Stanford Junior Museum descended not from the ancient Parthenon, however, but from the more recent National Archaeological Museum in Athens, a stark building coincidentally suggestive of concrete construction.[63] The Athens museum was organized around an inner quadrangle, which Jane Stanford loosely copied with the later addition of wings.[64] Nevertheless, the Stanford Museum's borrowed classical garb introduced the type to America.[65] Before 1890 in America no established type had prevailed. Rather, the public was treated to an array of styles, such as the flashy, polychromatic Ruskin Gothic of the National Academy of Design (1865) in New York by Peter B. Wight or the more restrained Metropolitan Museum of Art (1880) in New York by Calvert Vaux, both perhaps inspired by Oxford's Ashmolean Museum (1860) by Benjamin Woodward. Victorian America may also have liked the moral tone of Ruskin's Gothic or the more intimate, almost domestic feeling of the buildings effected in this style rather than a hard, cold classicism, which had been reserved in America almost exclusively for political and commercial aggrandizement, as in Thomas Jefferson's State Capitol building (1785) in Richmond, Virginia, or William Strickland's Second National Bank of the United States (1824) in Philadelphia, Pennsylvania. The Stanford Museum's classical vocabulary, like that of its European counterparts, referred to the archaeological nature of the collections housed behind the classical portico.

THE MUSEUM'S ICONOGRAPHY

The museum was richly adorned in a variety of media whose references encompassed, among other things, the foundations of the Western museological universe. It is unclear if a coherent iconographic program was intended or if the subjects depicted were chosen at random to reflect the traditional sources of Western learning and art. Before the 1906 quake, freestanding sculpture of both historical and mythological classical figures lined the roof balustrade and ringed the second-story balcony of the interior lobby. A series of mosaic panels still decorate the outside walls of the building, identifying the origins of the collections within and the museum as a temple glorifying learning and the arts.[66]

Among these panels are the mechanical arts Painting, Architecture, and Sculpture representing the sphere of the craftsman or manual laborer as well as History and Literature, representing the realm of the intellect.[67] Along the roof balustrade were concrete sentinels Aristotle, Plato, Herodotus, and Plutarch standing for the ancient foundations of Western philosophy, art, history, and literature. On one side of the museum's portico, on a lower rung, is the seated figure of Menander, the great Athenian dramatist, whose work is identified with the trials and tribulations of the common person, perhaps a reference to the university's cause to offer education to all. In addition to these paragons are depictions of cultural pinnacles in Western civilization—Rome, Egypt, and Cyprus—whose artifacts laid the foundations for the collections of both the Stanford Museum as well as those elsewhere. Archaeology, represented on a mosaic panel, is the modern instrument that brings to light those collections for the benefit of contemporary civilizations. The museum's spoils, gained not by war but by wealth, therefore, may have suggested a coming of age for home-grown American progress and civilization.

Allegorical representations also fill the pediments over the flanking end pavilions. These classically inspired scenes of mythological figures depict the triumph of arts and learning. In the pediment over the north block, Athena, the goddess of wisdom and the patroness of the arts and institutions of learning, welcomes the arts—Painting, Sculpture, and Architecture—and holds out a laurel wreath to crown their achievements. In the south pediment the seated figure of Truth holds her mirror and beckons to the arts, while a wreathed figure armed with a shield and a sword, perhaps Apollo, the God of Truth, vanquishes Disorder, symbolized by a giant python, which coils itself around Deceit, whose emblem is the mask. These scenes ascribe a moral dimension to art inspired by both ancient and baroque imagery.

The figure of Faith is seated by the entrance to the museum. The Stanfords believed that Faith was the ultimate source of Truth and Wisdom and the inspiration behind all human endeavors. The nonsectarian nature of Faith coincided with the university's pedagogic mission and linked the museum with another statue of Faith once sited in the Oval, a large lawn at the head of the university's earliest buildings, the inner and outer quads. Faith, along with Hope and Charity, is one of the three Christian virtues that appears on the facade of Memorial Church and is further represented by the heart and tongue decoration of the arcade capitals. Faith offered the necessary spiritual complement to education and human action, alluding to the Stanfords' belief in the immortality of the soul and in a Divine Creator. Jane Stanford affirmed this intention in a letter to Andrew White:

> I am very anxious indeed to have Stanford University send out to the world the best
> and noblest men and women that ever went forth from any University on earth and to
> permeate the whole Institution…[with] the teachings of the greatest of all Teachers, our
> precious Savior. No theological doctrines, no creedisms, of any kind, only the simple,
> beautiful truths taught us by our Master Teacher, Jesus Christ.[68]

Both the university's Memorial Church and the museum were to nourish the spirit as the intellectual basis of action and human conduct. From the beginning the museum was a repository of personal, spiritual values.

67 Other mosaic panels represent: Egypt, Rome, Cyprus, Painting, Sculpture, Architecture, Archaeology, and Progress and Civilization along the walls of the main elevation, and History, Literature, and Ancient Art over the doorway. The bronze doors represent the History of Architecture. Many of these subjects were portrayed in the Stanfords' San Francisco house ("An Art Treasure.")

68 Stanford to White, 19 May 1901, Jane Lathrop Stanford Collection, box out 2, folder 1.

Holding court in the main lobby at the head of the double staircase (fig. 6) were freestanding sculptures of Athena and Apollo (the latter destroyed in the 1906 quake). They reinforce their reference to the civilizing influence of truth and learning inherent in the *raison d'être* of the museum as well as the university. The allusions supplied by such ancillary arts as mosaics and sculptures enrich the meaning and significance of the collections within the museum. But the Stanfords also believed that art had the power to elevate taste and to effect social and intellectual change. Leland Stanford once told a reporter:

> I believe in painting. I believe in having it possible for the masses to have their tastes
> cultured so that they can enjoy the finest art, and I think they should have public
> halls where the best works of the masters might be found—painting, sculpture, and
> the fine art generally—where the public could go and enjoy them, as persons with
> cultured tastes always will.[69]

The arts at Stanford University were initially important to the founders' purposes. One newspaper reported that the art department held a "unique position with the university [having been placed] on a par with other departments [where] work leads to a degree [while] elsewhere, art schools are nominally connected to the university."[70] For whatever reasons, however, the museum and the art department never attained the working relationship the Stanfords originally envisioned.[71] And this disconnection affected the future viability of the museum as a useful educational institution.

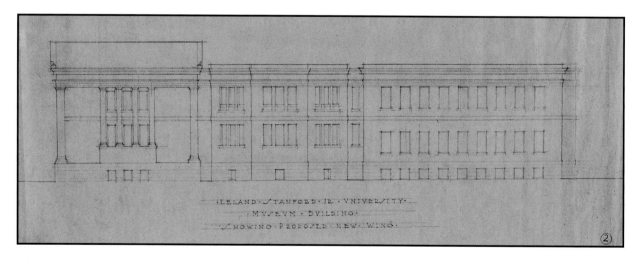

fig. 8
Charles Hodges ?
Stanford Museum, north elevation additions., c. 1902.
Graphite on tracing paper.
Facilities Project Office, Maps and Records.

69 Unidentified and undated newspaper article, Leland Stanford Collection (SC 512), box 2, folder 7.

70 "Art Models in Palo Alto," unidentified and undated newspaper article, Stanford Family Scrapbooks, vol. D, p. 74. The clipping probably dates from November or December 1893.

71 Originally there was only a freehand drawing department, which offered a few basic art courses.

Following her husband's death in 1893 Jane Stanford continued to direct the museum, overseeing its period of greatest expansion. In 1898 she began to build the wings that would nearly triple the size of the existing building, eventually enclosing a quadrangle behind the original museum (fig. 8) and gradually added its mosaics and sculpture. She furiously acquired collection after collection to fill its vast gallery spaces, with, it seems, only one clear objective. She told Harry Peterson that she was unperturbed that visitors to the museum failed to recognize the value of the collections. She was chiefly concerned that they recognize the humanity of her son. They must "come away with one thought," she said, "he was but a boy, and my son." She wanted "people to judge my son by what he has left behind."[72] This may explain why she never implemented an educational program served by the museum's collections. The museum seemed to follow an increasingly personal course during these years, partly accounting for her conscious avoidance of hiring professionals or consulting faculty to advise her or to run the museum during her frequent absences.

University president David Starr Jordan noted that visitors were critical of Jane Stanford's inclusion and organization of materials, and they often ridiculed the "extremely personal nature" of the family's memorabilia and the heterogeneous character of her son's collections. In his autobiography Jordan somewhat critically noted:

> Mrs. Stanford's multitude of intimate and interesting things of all sorts—family photos, heirlooms, gifts from relatives and friends (some of no intrinsic value, perhaps, but dear to her as expressions of affection) as well as a number of her own elegant dresses representing earlier modes of fashion, besides a superb collection of lace and one of splendid shawls, historical relics, and I know not what else.[73]

Jane Stanford's staffing of the museum was even more puzzling, particularly in light of her demonstrated competence in running the university after her husband's death.[74] If she needed an immediate model for developing a first-class institution whose collections had been gathered and whose policy had been determined by professionals in their fields, she only had to look across the bay to her neighbor, Phoebe Hearst, and her burgeoning, rival university museum of anthropology and ethnology. Jane Stanford apparently recognized her oversight too late to prepare a foundation for the museum's administration.[75] In all likelihood she avoided the chores of management because she regarded the museum first and foremost as a memorial and only secondarily as an art gallery.

In 1900, after several curators had come and gone, Jane Stanford again hired an inexperienced if eager assistant, Harry Peterson, an engineering student who assumed the position until 1917. Like all the curators before him, Peterson was powerless to influence acquisitions, museum organization, or management. When he took the job in 1900, he expected to advise, direct, and purchase but quickly resigned himself to the realization that he was little more than a caretaker. He was helpless to correct the museum's passive role and seeming aimlessness, which fostered the public's perception of it as a "repository of curios."[76] Peterson wanted to build an institution for "study and for instruction, to learn from the vast amount of exhibits something of value, something that will set them thinking, something that will stir them to better efforts."[77] Instead he superintended a museum increasingly growing in collections but moribund in purpose or direction.

72 Peterson, "The Story of Stanford University, Part III, Chapter LIX," Harry C. Peterson Collection, box 3.

73 David Starr Jordan, *The Days of a Man*, 2 vols. (New York: World Book, 1922), 386.

74 Most museums built during the Gilded Age were staffed by "professionally trained personnel" (Trachtenberg, *Incorporation of America*, 144). Osborne et al. notes that Jane Stanford hired a series of Stanford graduates to assist her before Harry Peterson arrived in 1900 (*Museum Builders*, 66).

75 Stanford wrote Luigi Cesnola of the Metropolitan Museum asking him to recommend a director, but he was unable to think of anyone (Osborne et al., *Museum Builders*, 79).

76 Harry Peterson to Jane Stanford, 6 February 1902, Harry Peterson Collection, box 1, folder 2. Peterson must have surprised Jane Stanford with this comment.

77 Ibid.

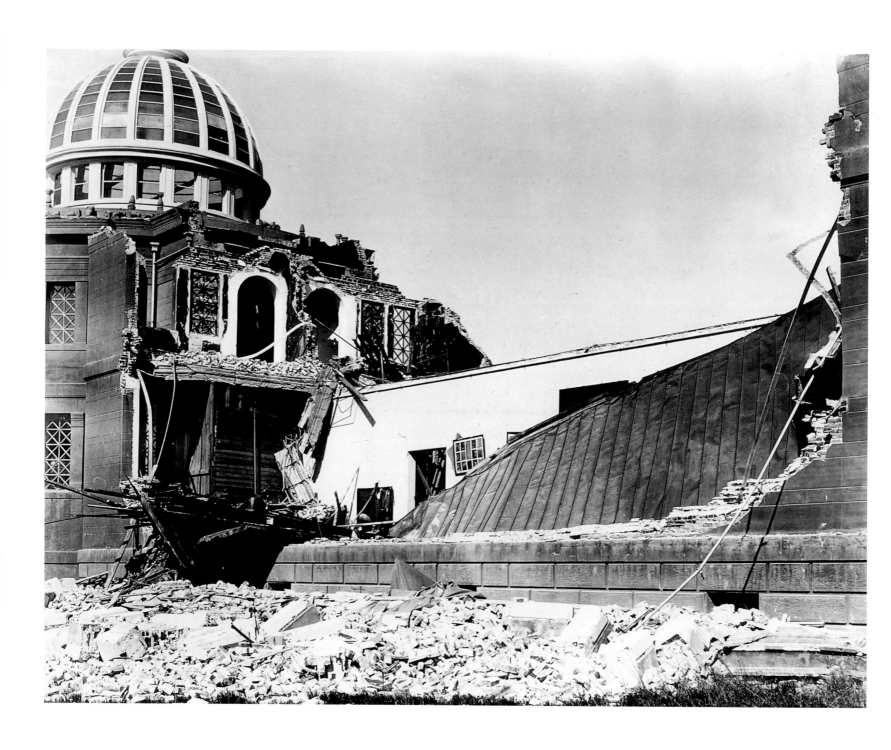

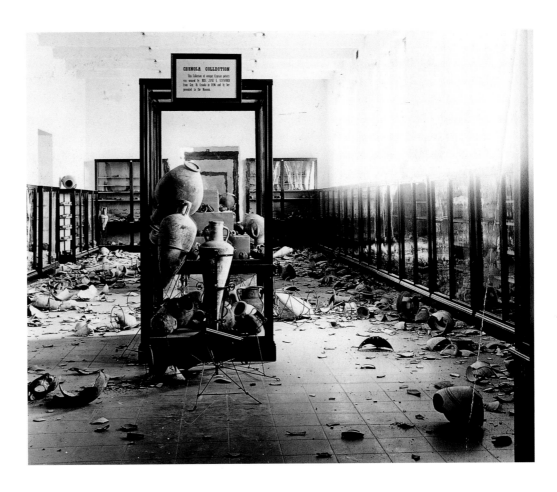

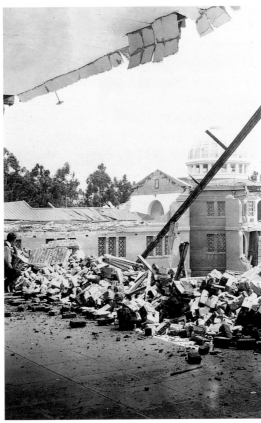

fig. 9 previous page
Stanford Museum, view of the north annex following the earthquake, 1906. Photograph: University Archives.

fig. 10 left
Stanford Museum, view of the south and west wings following the earthquake, 1906. Photograph: University Archives.

fig. 11 above
Stanford Museum, damage to the Luigi Cesnola collection, 1906. Photograph: University Archives.

78 Dorsey to Peterson, 20 June 1902, Harry Peterson Collection, box 1, folder 2.

79 Peterson to Dorsay, 27 June 1900, Harry Peterson Collection, box 1, folder 2; Peterson to Dorsay, 9 July 1902; Peterson to Dorsay, 6 December 1902, Harry Peterson Collection, box 1, folder 9.

80 Peterson to David Hewes, 30 April 1904, Harry Peterson Collection, box 1, folder 2.

81 Peterson, "My Personal Connection with the Museum," March 1917, Ray Lyman Wilbur Presidential Papers, box 14, folder 10.

82 Peterson to Hewes, 10 September 1908, Harry Peterson Collection, box 1, folder 4.

83 Peterson to Hewes, 23 June 1909, Harry Peterson Collection, box 1, folder 4.

84 Ibid. Peterson notes that the university had decided to appropriate the west wing for the medical school several months before the school was established. A. J. Bain, superintendent of university buildings, prepared drawings for this conversion at the time (Maps and Records, 07-100). A new medical school was constructed in 1909 on the site now occupied by the Hoover Pavilion ("Important Day in Stanford History," 3 September 1909, Ray Lyman Wilbur Personal Papers, box 75, "Stanford University-Historical-Early-1915" folder).

85 Peterson to Hewes, 19 May 1909, Harry Peterson Collection, box 1, folder 4. Peterson says that he opened the museum on May 8, 1909, six weeks before it was ready for visitors. However, according to the *Stanford Alumnus* 11, no. 1 (September 1909): 16, the museum had only recently reopened after the 1906 quake, with the exception of a "few days in May."

86 Vanderlynn Stow to Wilbur, 11 November and 14 November 1914; Wilbur to J.C. Branner, 16 November and 19 November 1914; Wilbur to Professor Manwaring, 8 December 1914, Ray Lyman Wilbur Presidential Papers, box 14, folder 11. The surviving Bakewell and Brown drawing is dated 27 January 1915 (Maps and Records, 07-100).

It must have been frustrating when, in 1902, Peterson's colleague, George Dorsay of the Field Museum in Chicago, observed in a letter that Stanford once had a "glorious opportunity for building a fine West Coast museum" but would soon be overtaken by its rival at Berkeley under Phoebe Hearst's direction.[78] Although Peterson complained to Jane Stanford and claimed that he was given a year to prove himself, he lamented that she showed no interest in any of the collections he brought to her attention and that things at the museum were "going from bad to worse…I expect more trouble."[79] Two years later Peterson, clearly a changed curator, could only affirm that he "liked Mrs. S. here…She knows what she wants done and does it."[80] Peterson's failure to influence Jane Stanford was indicative of her perception of and purpose for the museum as a memorial, leaving the future almost to chance and virtually assuring a troubled era after her death in 1905.

The museum faded from university notice following the 1906 earthquake. Jane Stanford's additions were largely wrecked, leaving useful only the west wing (now known as the annex) and two of the rotundas still standing along with the original 1891 reinforced-concrete building (figs. 9-10). The exhibits were in ruins and innumerable objects destroyed (fig. 11). Peterson described the scene as a "morgue of relics."[81] Many of the collections were left exposed to the elements and infestations of beetles and moths, which the university remedied by filling the galleries with "dead air napthalin gas" without the benefit of ventilation, leaving Peterson to complain of its ill effects on his "liver and kidneys."[82] In 1909 he lamented the university's inactivity, noting that "everything is dead at the university. There is little building now."[83]

During the next thirty years the museum's future seemed doubtful as various proposals were put forward for its use. In 1909 academic priorities led to the appropriation of the west annex for the departments of anatomy, physiology, and bacteriology of the new medical school.[84] The museum's galleries were reopened only gradually beginning in 1909.[85] However, in 1911, renewed interest in the museum was sparked by a gift of money from Thomas Welton Stanford, Leland Stanford's brother, for the construction of a new picture gallery to house paintings he had donated in 1905. With Stanford's consent the board of trustees amended the gift to include the possibility of restoring the museum and rebuilding one of its damaged wings to house the new picture gallery, but in 1914 they decided to make the gallery the cornerstone of a new library quad. In that year Ray Lyman Wilbur, dean of the medical school, was asked to explore the viability of converting at least half of the museum for use by the departments of anatomy, physiology, and bacteriology, which had been housed in the west annex. In November Bakewell and Brown, the university's unofficial architects, presented blueprints for the museum's conversion, including additions to the rear of the building for a lecture room and library (fig. 12). For unknown reasons the plans to "advantageously use the museum building" were never carried out.[86]

The Stanford paintings were transferred from the museum's south wing to the gallery in late 1917, and Bakewell and Brown's Thomas Welton Stanford Gallery of Art was opened to the public in December of that year (fig. 13). The gallery became a more vital center for art on the campus than the museum. It served not only to house the Stanford paintings but also became a space for changing exhibitions. The art gallery at last brought some fraction of the museum's collections within the fold of the university as part of the academic experience, but by doing so it further marginalized the museum's presence on the campus.

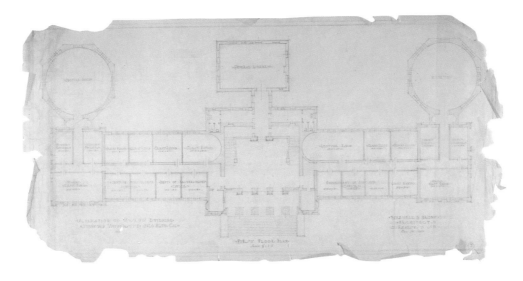

fig. 12
John Bakewell, Jr. and Arthur Brown, Jr.
Plan to convert the Stanford Museum into the medical school, 1915.
Graphite on tracing paper. Facilities Project Office, Maps and Records.

At the same time efforts were made to assess the significance of the museum's collections and to make them useful to the university's academic programs. In 1916 Wilbur, now president of the university, ordered that, after the removal of the Stanford paintings to the new "art museum," "a new classification of the material in the original building…be arranged, and the exhibits confined to objects of historic, artistic, scientific, sociological and general educational value" so as to establish a closer working relationship with the various university departments.[87] Control of the museum was transferred to the president's office in 1917 and an inventory of the collections was begun for the first time. Peterson worked on this project until his resignation in July of that year.[88]

In his last "Annual Report of the Leland Stanford Junior Museum," submitted in June 1917, Peterson summarized the progress of the inventory and his attempts to reassemble objects broken in the earthquake. With only a third of the original museum left to him, Peterson struggled to provide a suitable "rearrangement, segregation, and classification of all exhibition materials, [and] the retirement of such articles as are not essential at this time to the work in hand."[89] At the same time, however, the board of trustees took advantage of the reorganization of the collections to do a general housecleaning by removing embarrassing items, "bibs, books, and boots."[90] Purging the collections of their three Bs reflected a significant transformation in the way collections were perceived. Shortly before he quit the museum, Peterson outlined the shift in methods and ideals in the museological world over the previous fifteen years:

> [T]he museum was a collection of curios to be gazed at. You "absorbed" culture intuitively because you were among things that had rubbed shoulders with "culture" some time in the past. The predominant thought was—it belonged to Queen Anne or King Philip. The article, intrinsically, had no meaning. It was only a question of its association. That is all changed. The up to date museum teaches why the article was made, the influences behind its creation, how it was made and the use made of it and of what benefit it will be to mankind. If Queen Anne had once been the proud possessor, so much the better, that means added interest.[91]

87 *President's Report*, no. 31 (July 1916): 36.

88 Peterson had asked for a salary comparable to that of other museum directors but was rebuffed. A search for a new curator was conducted even before Peterson's request was officially denied.

89 "General Museum History, cont'd," Museum Archives. Peterson was assisted by Archibald Sayce and Carl Whiting Bishop in evaluating the quality of the various collections, which they enthusiastically lauded. Peterson to Wilbur, 7 March 1917, Ray Lyman Wilbur Presidential Papers, box 14, folder 10. Wilbur to board of trustees, 14 March 1917, Board of Trustees, box 12, folder 17.

90 Stow to Wilbur, 9 August 1917, Ray Lyman Wilbur Presidential Papers, box 23, folder 3. Items from Leland Jr.'s collections were felt to be too personal for general interest. Wilbur was annoyed that Peterson had reopened the Leland Jr. gallery without first being notified so he could "eliminate certain exhibits." Wilbur to Stow, 15 August 1917, Ray Lyman Wilbur Presidential Papers, box 23, folder 3.

91 Peterson to Wilbur, "My Personal Connection with the Museum," March 1917, Ray Lyman Wilbur Presidential Papers, box 14, folder 10.

fig. 13
John Bakewell, Jr. and Arthur Brown, Jr. Thomas Welton Stanford
Art Gallery interior, c. 1917. Photograph: University Archives.

Although Peterson's summary is problematic—surely the Stanfords viewed their collections as more than curios—it, nevertheless, encapsulates a pedagogic role for the collections left unfulfilled since Jane Stanford's death. As well, the university recognized the necessity of a memorial to its founders, and in July 1917 a less personal Leland Stanford Junior Memorial Room was reopened in the museum. Nevertheless, a new museum age had dawned.

THE DARK YEARS

From 1917 to 1945 Pedro deLemos (fig. 14), Peterson's successor, presided over the bleakest period of the museum's history.[92] During his directorship half of the museum's spaces were taken over by other academic departments, and on his retirement in 1945 the museum was closed and innumerable art objects unaccounted for. DeLemos was an unusual choice for director of the museum. The university was eager to replace Peterson, who threatened to quit after a pay dispute. DeLemos, who was then director of the California School of Fine Arts, had no museum experience.[93] Rather he was a versatile arts and crafts designer and occasional architect (although he never received a degree). He had a keen, lifelong interest in the methods of teaching art and in 1919 became editor of *School Arts* magazine. Nevertheless, he was seen as an educator who might usefully establish a relationship between the museum and the university's academic departments.[94]

92 Pedro Lemos changed his name to deLemos early in the 1930s. The spelling of his name sometimes appears as de Lemos, though the spelling I have adopted was the one he used on his university resumé.

93 In February 1945 deLemos completed a Stanford University Faculty Record form in which he claimed that he was director of the San Francisco Art Institute. However, other evidence seems to contradict this. In a letter to President Wilbur from J. Nilsen Laurvik, director of the San Francisco Art Association and the California School of Fine Arts, responding to an inquiry about the position of director of the Leland Stanford Junior Museum, deLemos is listed on the letterhead as director of the school (Laurvik to Wilbur, 9 December 1916, Ray Lyman Wilbur Presidential Papers, box 14, folder 10).

94 *President's Report*, no. 32 (July 1917): 25. The report notes that the inventory was completed at this time and that it could now serve as a basis for "establishing that correlation between the Museum and the various related departments of the University which is so desirable."

In his March 1917 letter of application to Wilbur he proposed to direct and correlate the museum's activities and collections with the university's courses, suggesting that the museum would be closely affiliated not only with the art department but also with those scientific departments whose collections the museum then housed. He further recommended adding to the existing collections of natural history, supplementing the ornithological, zoological, and mineral exhibits, a gesture that would have appealed to the administration's preference for a natural history museum.[95] DeLemos also spoke of collecting materials from periods not yet represented in the museum's collections, doubtless referring to his own broad interests in the history of the production of arts and crafts objects. In 1922 he proposed assuming the position of head of the graphic art department, overseeing it as well as the museum and art gallery, in an effort to implement his ideas, a proposition President Wilbur regarded with some contempt, suggesting that already there had been a cooling of relations between the university administration and the museum's director.[96]

fig. 14
Pedro deLemos, c. 1920s. Photograph: University Archives.

In a 1928 article deLemos elaborated on the role of the museum. He noted that the museum's benefit of "visual education" was increasingly perceived as both a pedagogic and social asset within academic institutions. He recommended that the "museum today should be a place of recreation and delight where the achievements of past ages are exhibited in a natural and satisfying way [that arouses] general enthusiasm, elevate[s] public taste, and create[s] a demand for art of all kinds." The museum, deLemos continued, should exhibit the "outstanding achievements of all ages in all media" to broaden the interests of students and to encourage them to "acquire new and inspiring ideas." DeLemos noted that the museum collections had been reorganized to satisfy these ideals. However, he gave pride of place to those arts and crafts collections from the colonial and mission eras that appealed to his own tastes. The California Room, started under Peterson, contained objects from California missions, though deLemos was intent on building up the collection to record not only the history of the area around Stanford but also that of California generally. He remarked on the American Room, also started under Peterson, with its objects recording the "life of the early settlers in America." And he cited his own efforts to collect artifacts from the Southwest and Northwest Indian cultures, which were to be housed "in a special location in the Museum." DeLemos concluded by observing that:

> The Museum, with this program of exhibits…has had no small part in creating
> a definite art interest in the community. It is a project of great value, not only
> to the University, but to secondary schools of the entire region who share in these
> benefits. Stanford has not funds to make additional acquisitions for the Museum,
> and insufficient funds to bring in all the collections which would be desirable…
> This Museum is not merely a place to house relics of the past, but it is a public service
> institution which can play an increasingly important part in western education."[97]

95 DeLemos to Wilbur, 19 March 1917, Ray Lyman Wilbur Presidential Papers, box 14, folder 10.

96 Note by Wilbur dated 13 March 1947 appended to letter, de Lemos to Wilbur, 5 June 1922, Ray Lyman Wilbur Presidential Papers, box 77a, "Museum" folder.

97 DeLemos, "The Stanford Museum and Its Work," *Stanford Illustrated Review* 26, no. 5 (February 1925): 261-62, 290; idem, "The Museum and Art Gallery," *Concerning Stanford* 5, no. 2 (November 1928).

fig. 15
Stanford Museum, Dudley herbarium, c. 1924.
Photograph: University Archives.

98 "Peterson Resigns as Museum Curator–
Lemos Is Successor," *Palo Alto Times*,
10 July 1917, "General Museum History,
cont'd," Museum Archives. The newspaper
noted that the position had been offered to
deLemos some months previously and that
Peterson delayed his departure to the end
of the academic year to finish the inventory.

99 "DeLemos Quits as Stanford Art Gallery
Head to Devote His Entire Time to Creative
Work," *Daily Palo Alto*, 13 September 1945,
Museum Archives.

100 John Dodds to Tresidder, 11 February 1944,
Ray Lyman Wilbur Presidential Papers,
box 129, "1943–" folder. "The Stanford
Museum: Proposed Plan," n.d. (probably
1952), Wallace Sterling Collection, box 24,
folder 14.

101 The museum had been in poor repair since
the 1906 earthquake. Electrical conduits
severed in the quake were never repaired.
John LaPlante, former associate director
of the museum, recalls that in the 1950s
a wire was strung from a nearby pole and
fed through a window to provide electricity.
He also remembers a cobweb stretching
from the lobby ceiling to the floor and
was astonished to discover that the lobby
actually had a patterned mosaic and
terrazzo tile floor, concealed under years
of dirt. LaPlante, interview with the author,
7 November 1997. Ray Faulkner to Alvin
Eurich, 28 August 1947, Wallace Sterling
Collection, box 24, folder 12.

102 David S. Jacobson to Tresidder, 5 November
1943, Ray Lyman Wilbur Presidential
Papers, box 129, "1943–" folder.

103 L. E. Anderson to J. E. W. Stirling, 30 August
1951, Wallace Stirling Collection, box 24,
folder 12.

104 A collection of American Indian artifacts,
donated in 1941, was unaccounted for in the
subsequent inventory made by a museum
committee set up shortly after deLemos
retired. Neither deLemos nor his brother
Frank was able to account for the missing
collection, as well as other objects,
other than to note the poor security
and condition of the museum.

DeLemos endeavored to make Stanford the focus of an important art center in Palo Alto.[98] His frequent exhibitions, however, gave prominence to the art gallery with its changing shows rather than the museum with its static displays. Assisted by his brothers, deLemos mounted exhibitions, he said, of "the sort of material which would contribute to the lives of both students and visitors at the university, giving them beauty and enriching their every-day existence."[99] And he attempted to disseminate the influence of Stanford's collections by illustrating his numerous articles in *School Arts* magazine with objects from the museum.

For reasons that remain unclear, he realized few of his stated goals. Increasingly after 1920 his frequent absences from the university while traveling in the Southwest and Europe led to a gradual deterioration of the collections and the buildings and a growing criticism by both faculty and administration of his abilities as director. One dean complained after being rebuffed by deLemos, who refused to help arrange a special exhibition, that "there is no adequate provision for exhibits" on campus, and deLemos's own exhibitions were generally regarded as inconsequential.[100] The museum fell into ruinous condition, becoming an "embarrassing liability" and a "serious hindrance to public relations…and gifts."[101] University administrators agonized over its operation and what it should exhibit. They were aware of losing collections to other museums because donors were "wary of how Stanford handles and displays the collection."[102] Alumni visitors to the museum before it was closed noted that recently donated collections had been poorly maintained.[103] The museum itself was in chaos; its basement was still cluttered with the debris of objects damaged or destroyed in the 1906 quake, and the building still showed evidence of that cataclysmic event. Most seriously, a large number of objects, and even an entire collection of American Indian artifacts, were "missing."[104]

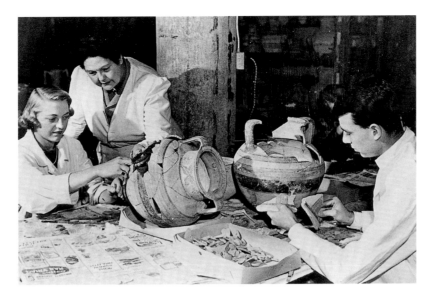

fig. 16
Professor Hazel Hansen and students repairing objects from the Cesnola collection, c. 1950s. Photograph: University Archives.

The university, however, was not entirely blameless. DeLemos tried to explain dwindling attendance figures and, more importantly to the administration, income, as early as 1926 by commenting that there existed a widespread impression that the museum was only half its original size since other academic departments had occupied much of the building's gallery space.[105] The administration had appropriated museum space for the zoology department and the Dudley herbarium in the south wing (fig. 15) during the 1924 academic year, so that by 1934 the Stanford Museum was also officially listed as the Natural History Museum, which occupied the southern half of the building.[106] DeLemos abetted encroachments on the museum's space, approving still yet another request from the administration in 1929 for an area for "fisheries investigation." DeLemos remarked that the museum should "not only be a place for exhibits, but for work."[107] Probably the most remarkable instance of this was the archaeology classes conducted by Professor Hazel Hansen beginning in the 1930s. With her students she painstakingly reassembled the pot shards from the Cesnola Cypriot ware damaged in the 1906 quake (fig. 16).

Such loss of gallery space, of course, removed exhibits and forced collections to remain in storage, further sapping the museum's vitality and reducing its presence, though deLemos believed that it promoted more frequent circulation of the collections. When in 1944 Laurence Vail Coleman, author of the comprehensive survey *The Museum in America*, urged the Stanford Museum to join his American Association of Museums, a routing slip attached to Coleman's request advised the president that it was "not worth doing until we have a museum."[108]

REASSESSMENT

Both during deLemos's tenure and after the university repeatedly tried to find more useful purposes for the museum. In 1944 it was considered one of the possible sites for a new law school, clearly indicating that the university no longer regarded the museum as a credible or viable institution.[109] Certainly there was an economic interest on the part of the university. When the museum's admission fee came under discussion in 1943, one administrator complained to President Donald Tresidder that it seemed that the "amount [of money] received isn't worth the effort we put into it [the museum]."[110] And in December 1944, as the university was reorganizing

105 DeLemos to Wilbur, 3 May 1926, Ray Lyman Wilbur Presidential Papers, box 63, "Museum" folder. DeLemos was referring to the occupation of the museum's south wing by the department of biological sciences.

106 *President's Report*, no. 3 (January 1926): 160, 242, 333. DeLemos's own report for this year noted that the most prominent development was the housing of the botany and zoological collections in the south wing of the museum, condensing the exhibition space for the museum's collections.

107 R. Swain to Wilbur, 10 January 1929, Ray Lyman Wilbur Presidential Papers, box 77a, "DeLemos" folder.

108 Coleman to Wilbur, 22 September 1944, Donald Tresidder Papers, box 12, folder 5. Laurence Vail Coleman, *The Museum in America*, 3 vols. (Washington, D.C.: American Association of Museums, 1939).

109 Eldridge Spencer, "Conversation with Alvin Eurich on Projects That Need Immediate Attention," 20 December 1944, J.E. Wallace Sterling Collection, box 57, folder 1. In 1948 the university briefly considered converting the art gallery into the new administrative building, but decided against it because of the cost and its location outside the quad. The museum and art gallery were retained only because of the unsuitability of the buildings for other purposes and the prohibitive cost of a new art building.

110 David S. Jacobson to Tresidder, 5 November 1943, Ray Lyman Wilbur Presidential Papers, box 129, "1943–" folder.

a number of departments into a school of humanities, administrators observed that "there seems to be a question as to what these units [the art gallery and museum] should consist of why and where. If these are included in a School of Humanities, they should be organized to function with the School of Humanities."[111] John Dodds, dean of the new school, which he established in 1942, brought the museum and art gallery under his purview. For the first time since their founding the museum and art gallery were included within the university's pedagogic mission as part of a renewed graphic art department.

Dodds, moreover, envisioned the museum more broadly as a vital part of the humanities interdisciplinary educational program. He recruited Lewis Mumford, who became a professor of humanities at Stanford in 1942, and invited him to write a program titled "Teaching of the Arts." Mumford proposed not only revamping the graphic art department but also building a small museum "conceived more as a library and a workshop than as a means of display" with teaching as its primary objective. Mumford suggested that it might form the "central nucleus building of a new group of humanities buildings."[112]

Mumford's report identified the museum's distant location from the core of campus activities as a fundamental problem. His recommendations were apparently adopted later by Ray Faulkner, who in 1947 suggested abandoning the museum altogether in favor of a new art building that would house the museum's permanent collections and have gallery space for temporary exhibitions in an area accessible to the community.[113] Like Mumford, Faulkner lamented the museum's isolation from the heart of the campus in the midst of the proposed Science-Medical Center sector but nevertheless admitted "a real need" for such an institution.[114] In April 1944 an anonymous "Proposal for a University Art Museum" gave further evidence of a shifting perception of the museum, its purpose, and the relevance of the existing building.[115] The museum would consist of a number of intimate "rooms" organized around sculpture courts or opening onto natural surroundings with displays of objects arranged in a homelike environment. With the exception of its research and study facilities, which were to tie it into the educational program of the university, the proposal is not too distant from what Jane Stanford had envisioned when she founded her museum in 1891.

With deLemos's departure in September 1945 the museum's doors were closed indefinitely, or "unless substantial funds become available from outside sources for improving the quality of custodianship which may be provided in it."[116] The museum seemed to have come to the end of its usefulness. Shortly after deLemos retired, the president's office convened a museum committee, led by Faulkner and Helen Cross, assistant director of the museum, to inventory the collections (completed in 1947), assess their value, and propose a course of action. The committee ascertained the educational, scientific, cultural, and monetary values of some forty thousand items for the university. It compiled a list of artworks considered to be of negligible value and to be disposed either by transfer to other academic departments or at auction.[117] Between 1945 and 1950 Faulkner and Cross as well as other members of the graphic art department culled such works from the collections, a process that invited subjectivity, and, of course, differences of opinion.

111 Spencer, "Conversations with Eurich."

112 This is probably the new "Cultural Quad" proposed in the exhibition *Stanford Builds*, organized by Ray Faulkner and held in the art gallery in 1948. Lewis Mumford, "Memorandum on the Teaching of the Arts," 10 April 1944, John Dodds Collection, box 1, folder 7. Moreover, Dodds felt that he would not be able to implement his plans for the museum and art gallery as long as deLemos remained director.

113 Faulkner to Eurich, 28 August 1947, J.E. Wallace Sterling Collection, box 24, folder 12.

114 Ibid. Until his plan was implemented, Faulkner recommended that the museum continue its on-going process of "cataloging, documenting, and organizing materials of Classical Anthropology and Far East" while remaining open for research.

115 The author may have been either John Dodds or Ray Faulkner. The proposal gave emphasis to "conditioning the undergraduate to beauty" and to "provide for the local community, as well as the university student, special, temporary exhibits." "Proposal for a University Art Museum," 14 April 1944, Ray Lyman Wilbur Presidential Papers, box 129, "Museum" folder.

116 Unidentified notes, 18 March 1948, J.E. Wallace Sterling Collection, box 57, folder 6.

117 Helen Cross to Eurich, 21 May 1946, J.E. Wallace Sterling Collection, box 24, folder 12. The museum committee had first to determine the proprietary rights of the objects in the collections. Surprisingly no records of whether artworks had been lent or donated were kept before this time, and gifts were rarely acknowledged.

John LaPlante, then the curator of Asian art, was concerned over the sale of certain oriental artworks, and Faulkner believed the Stanfordiana Collection had "great public interest and value as a chapter in American taste."[118] A number of nineteenth-century academic paintings, then largely out of favor, were slated for sale as were poor copies of old masters from the Thomas Welton Stanford and David Hewes Collections, furniture (probably the most famous example of which was the imperial Chinese bedstead purchased by the Stanfords), Japanese bronzes, and Swiss wood carvings among other items (fig. 17). These objects were sold at auction between 1951 and 1952.[119]

The sales had a curious effect. Cheerless public rebuke stunned the university, which was accused of selling a unique inheritance. Letters repeated a ringing refrain: the Stanford Museum had never been an art museum at all but a museum personal to Stanford University–and the community. Oddly, the museum's earlier, minor reputation as a repository of curios had now become its most endearing aspect, indeed, its raison d'être; it alone preserved in its memorabilia the special interests of the founders. And ironically deLemos's neglect of the museum, which saved the Stanford Family Memorial Room and Leland Jr.'s collections more or less as he had inherited them, had fostered this nostalgic sentiment for the founders.

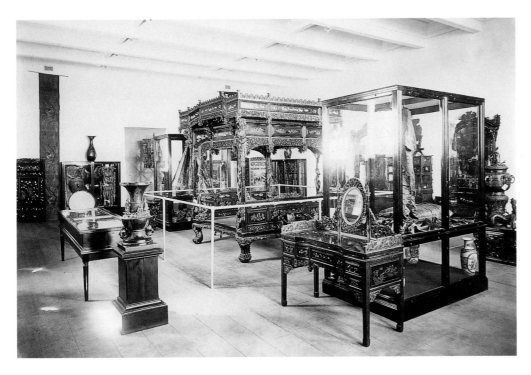

fig. 17
Stanford Museum, the Asian collection, showing the auctioned Chinese bedstead , c. 1890s. Photograph: University Archives.

118 Faulkner to T. A. Spragens, n.d., Wallace Sterling Collection, box 24, folder 12.

119 The auctions were apparently limited to antique dealers and conducted by Frank James, a renowned New York auctioneer. The proceeds amounted to some $25,000 and were deposited into the university's general funds. They were meant to defray the $28,000 needed to refurbish the galleries, which was undertaken by Victor Thompson of the art and architecture department, formerly the graphic art department.

Museum patrons who happened to visit the cocktail lounge at Rickey's Hyatt, a local hotel, were dumbfounded to find their favorite watering hole now fitted with the great imperial Chinese bedstead, Japanese bronzes, and paintings that not only had once belonged to the Stanford Museum but also had been in certain cases the centerpiece of a collection. The profane spectacle prompted one writer to remind President Wallace Sterling that the memorabilia may have had no "sentiment today, but it is a quality that should be nurtured and inculcated in our growing generations."[120] Another held that the material was a "visible and enduring record of the Founders of the University and its own special history as well as much that pertains to the early history of California and the West." The value of the collections, the writer continued, was for all "Stanford people, present and future…every article has sentimental and historical value independent of artistic merit for a Museum which should be—and was formerly—outstandingly individual to Stanford."[121] The writer dismissed Sterling's pragmatic explanations by declaring that "Stanford is confused about the purpose of the Art gallery and that of a Museum."[122]

A beleaguered president, who had quietly belittled the collections, now came to regard the museum as a "headache" and urged Faulkner to bring the matter to "some finality."[123] Sterling attempted to appease his critics by outlining the museum's "reorganization program" and noting that its staff and that of the art department had "endeavored to retain an adequate number of examples of everything which was considered of possible historical, sentimental, or cultural value." He further observed that "neglect of the museum was regrettable, but I am sure that it was compelled by the judgment that available funds had to be used for faculty salaries and for the maintenance and improvement of the academic plant." Stirling left no doubt as to the museum's marginal use to the university. Current interest in the museum, he declared, "has been guided by the idea of using it as a teaching tool."[124] Undoubtedly to his relief Sterling later transferred control of the museum to the art department.

In 1951 the president's office urged Faulkner to reopen the museum, and in May of that year some two thousand visitors were admitted during a two-day trial, prompting the Associated Stanford Students Union to call for the museum's permanent reopening. Faulkner cautiously speculated that the museum "if reopened would be neither a source of great pride nor cause for embarrassment."[125] He believed that its "greatest value is a study group for students in Anthropology, Archaeology, History, and Art," though he also recognized a wider public interest. In 1952 the museum committee presented a proposed plan for the management of the museum. The committee emphasized the growing interest in building museums within university settings to enhance the recent pedagogical phenomenon of visual education, and they assured numerous academic departments that the museum was indeed a compelling educational tool:

> It illustrates pre-history and enlarges and vivifies written history. It increases the visitor's concept of the capabilities of man, thus playing an important part in broadening his horizons, in multiplying his interests and developing and enriching his personality. It provides a means of intellectual and aesthetic enjoyment for both layman and specialized student.[126]

120 Anderson to Sterling, 14 July 1951, J.E. Wallace Sterling Collection, box 24, folder 12.

121 Eleanor Severance to Sterling, 9 October 1952, J.E. Wallace Sterling Collection, box 24, folder 12.

122 Severance to Sterling, 16 January 1953, J.E. Wallace Sterling Collection, box 24, folder 12.

123 Sterling to Faulkner, 16 January 1953, J.E. Wallace Sterling Collection, box 24, folder 12.

124 Sterling to Mrs. Harold L. [Eleanor] Severance, 17 October 1952, J.E. Wallace Sterling Collection, box 24, folder 14.

125 Faulkner to T.A. Spragens, n.d., J.E. Wallace Sterling Collection, box 24, folder 12.

126 "The Stanford Museum: Proposed Plan."

The committee further stated that such a museum enhanced public relations by advancing the "aims and desires of the university." The committee had brought the museum securely within the orbit of academic interests, whether educational or financial. The museum's survival, however, rested largely on the generosity of volunteers, including the staff and the Committee for Art at Stanford, which was created in 1953 to help raise funds for the museum.

FROM CURIOS TO ART

Beginning in the early 1960s the museum experienced renewed life and growth. In 1963 Professor Lorenz Eitner became chair of the department of art and architecture at Stanford as part of the university's program to revitalize the humanities under Dean Robert R. Sears. Of little interest to the university was whether or not Eitner developed the department's two major resources, the museum and the art gallery. After the museum's reopening in May 1954, following nine years of stock taking, efforts by the art department, assisted by the Committee for Art at Stanford, to revive it had only marginal success. As an institution with seemingly slight relevance to the university's academic programs, the museum had been left to its own devices. Eitner recognized that it needed to be tied to a strong academic program forged by the art department.

Eitner's power to influence the university administration stemmed from a strengthened position within the art and architecture department. Before accepting the appointment at Stanford, Eitner stipulated that he wanted to recruit new faculty for the department, a request conceded by the university. With a fortified department and new curriculum and faculty he was able to persuade the university to consent to the construction of a new art building. At the same time, as director of the museum (a position he held on a volunteer basis for the duration of his tenure), Eitner began to utilize and expand its resources. Gradually the various departments occupying spaces within the museum were removed, and slowly the galleries were refurbished (completed in 1981) and sections of the building reinforced. Eitner decided to concentrate what slender resources were available for the museum (the university's contribution was minimal) on works of "artistic quality rather than didactic materials, artifacts, and specimens."[127] For the first time since its founding, the museum became a museum of art, which Eitner renamed the Stanford University Museum of Art, and a campaign (which continues today) of evaluating, cataloguing, and documenting works of art was started. Eitner estimates that some tens of thousands of objects were lost between 1906 and 1963. Indeed, Eitner recalled that by the time he arrived the museum had a reputation for selling artworks at bargain-basement prices.

From the wreckage of objects, many laying in ruins and abandoned since 1906, Eitner distilled the beginnings of a new museum collection. He retained a gallery devoted to the Stanfords as a memorial to the founders (later, under Eitner's directorship, the museum held two exhibitions detailing the history of the Stanfords as builders and collectors).[128] Remnants of many of the original collections purchased by Jane Stanford were reinstalled: Egyptian sculpture and ceramics; the Cesnola collection of Cypriot ware; Coptic textiles, which had been crammed with

127 Lorenz Eitner, "The Development of the Stanford Museum 1964-1984," n.p., 4.

128 The catalogues for these exhibitions were Turner et al., *The Founders and the Architects* (1976) and Osborne et al., *Museum Builders* (1986).

other artworks into a closet under the lobby staircase ("a Tutankhamen's tomb," in Eitner's words); and Chinese bronzes among others. In addition Eitner developed newer collections based on the strengths and recommendations of faculty of the art department: eighteenth- and nineteenth-century prints and drawings, Rodin casts, Muybridge photographs, and a substantial Asian collection. The rich mix of materials provided a solid foundation for the department's pedagogic mission. To this end the museum immediately began a series of publications, which in 1971 became the *Stanford Museum of Art Journal*. Its essays examined some of the more outstanding works in the collections and made use of the art department's intellectual resources as well as that of eminent scholars from around the world. The museum became a workshop for art history students, who engaged in seminars examining genuine works of art rather than relying solely on slides or other reproductions.

A regular series of exhibitions made the works of art accessible not only to Stanford but to the surrounding community as well. A development program was started. It was from the local area that the museum now relied heavily for its funding and volunteer support, without which few of its programs would have been realized. The Committee for Art was instrumental in establishing connections between the museum and the community through such activities as docent tours, fund raising, outreach educational programs, or study groups.

The museum had become a place of scholarship and study, the fruits of which were offered to the public. By forging this connection with academia, Eitner recognized that the university would have a stake in the vitality of the museum as a bridge to the community, as an adjunct to any number of departments, and as a recognized institution disseminating scholarship. By the late 1980s the museum's growing collections began to press for additional gallery and storage space. An art museum complex was explored initially with the idea that if an addition were made to the existing building, the most obvious location for it would be within the area between the museum and the anatomy building. Although the planning office considered building an additional museum building on the site of the old gymnasium destroyed in the 1906 earthquake, they decided to concentrate the museum's activities within a single area. Expansion on the present site was thought to be the most effective solution, and a conceptual quad plan extending the current museum was suggested. The new construction would echo the original 1906 museum footprint, replacing the existing anatomy building and enclosing a large internal courtyard. The proposal would have restored the museum's 1906 scale of 200,000 square feet of exhibition space and 90,000 square feet of storage. Other alternatives were more modest, one calling for a two-story addition with basement to the rear of the museum. The study, however, was given an unexpected urgency and relevance when, in October 1989, the Loma Prieta earthquake intervened, devastating the museum.

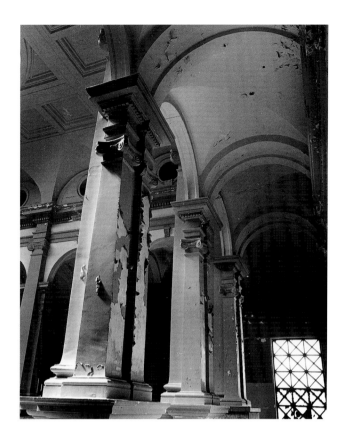

PART II

BUILDING FOR THE FUTURE: RESTORATION AND EXPANSION

Nature set into motion a new era of rebuilding and expansion. Shortly after Lorenz Eitner's retirement in 1989, a thriving museum closed indefinitely after suffering heavy damage in the earthquake (figs. 18-20). The lateral force of the quake caused severe diagonal cracking in the load-bearing walls, most spectacularly in the lobby's ceiling vaults, and rent open to the sky the unreinforced masonry octagons. Left relatively unscathed were the basement and portions of the administrative offices and print room (the old Leland Jr. Room) as well as the Meidel Room (the Stanford Family Memorial Room) on the second floor. Following a walk-through evaluation of damage to the building in November 1989, the structural engineering firm of Forell/Elsesser proposed the most economical minimum-fix scenarios, including rebuilding the octagons and adding reinforced-concrete buttress walls, which would shore up the existing museum along the west elevation using "shotcrete techniques" and structural steel.[129] Their proposals estimated repairs at between $11 million and $13 million.

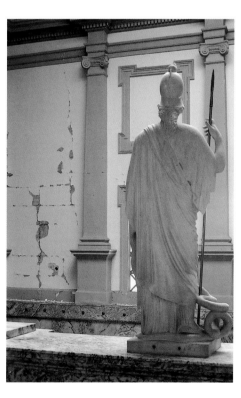

fig. 18 above
**Stanford Museum, upper gallery lobby,
damage suffered in the Loma Prieta earthquake, 1989.
Photograph by Leo Holub.**

fig. 19 far right
**Stanford Museum, east wall of lobby,
damage suffered in the Loma Prieta earthquake, 1989.
Photograph by Thomas K. Seligman.**

fig. 20 right
**Stanford Museum, south rotunda,
damage suffered in the Loma Prieta earthquake, 1989.
Photograph by Thomas K. Seligman.**

129 On 16 November 1989 Forell/Elsesser
Engineers submitted a report with their
recommendations for seismically
strengthening the museum.

Government funding through the Federal Emergency Management Agency (FEMA) required that the museum (the anatomy building was also considered initially) be reviewed for inclusion on the National Register of Historic Places. As a historic building the museum's restoration was subject to a stringent review by state and national historic preservationists to determine that such work would not cause any adverse effect to the fabric, which was to be returned to its 1989 state. Throughout the restoration process historic-preservation issues revolved around saving the rotundas, a benign structural reinforcement, patching and coloring of the cracked surfaces, repair and replication of damaged details, such as the lobby and roof balustrades, preservation of the lobby's marble panels, the scagliola columns in the rotundas, the mosaic panels in the north rotunda and on the front of the building, color of the galleries, and retention of the original concrete roof. Such issues were negotiated from the perspective of cost and feasibility, public safety, function, and timeliness. Sympathetic modifications to the interior of the building accommodating necessary functional changes also had to be approved by FEMA, such as enlarging the narrow, first-floor entryway into the west-end rooms. Separate issues revolved around the relationship of the new wing to the older structure, affecting the compatibility of materials, wall surface details, and scale.

EARLY SCHEMES TO REOPEN THE MUSEUM

Prior to the 1989 quake, plans to expand and update the museum had been initiated by Acting Director Wanda Corn. With a structurally unsound building requiring extensive repairs, Corn seized the opportunity to implement her proposal for an ambitious, long-range master plan aimed at modernizing the museum with the assistance of an architect. The building's major design flaws—inaccessibility, poor or nonexistent environmental systems and lighting, few teaching spaces, limited storage facilities, dead-end circulation routes, inflexible galleries subject to direct sunlight—were exacerbated by the reinforced-concrete interior walls, floors, and ceilings, which made changes to the fabric impractical or impossible.[130] In addition, the museum's isolation from the core of campus activities and its orientation away from the campus itself seemed to be an impediment to a more hospitable and welcoming museum. Corn recommended that new facilities be added during the course of reconstruction, including a director's office, an auditorium, seminar rooms, mechanical systems, and such public amenities as a museum bookshop and cafe. She also urged that a renowned architect be hired to oversee and design a "bold and exciting Modernization Plan."[131] Many of the program elements she suggested found their way into the design competition held for the restoration of and addition to the museum.

A program committee was formed and strategies developed for the reopening of the museum. The museum's severe structural damage, its functional limitations, and the unpredictability of funding immediately presented several options, including the possibility of partial or complete demolition of the museum (the north rotunda, for instance, was so severely weakened that it was felt for a long time that it would have to be demolished). A program and several design schemes were taken under consideration between 1989 and 1993. Corn's vision for a new museum led to the formation of three alternative proposals for its reopening: the least

130 Restoration of the original museum was hindered by the almost complete absence of working drawings or blueprints documenting Ransome's structural system. Although some drawings, most from later changes to the museum existed, an accurate understanding of the internal structural system was derived from taking core samples from walls and floors.

131 "Rebuilding and Modernizing the Stanford Museum," 20 November 1989, Stanford University Museum of Art Rebuilding Project, notes from 29 April 1988 to 7 May 1991, Museum Files. Corn cited the example of Charles W. Moore's Williams College Museum of Art, where the problem of a modern addition made to an existing neoclassical structure was masterfully solved by the architect. Shortly thereafter William Turnbull, Moore's associate for many years, was hired by Stanford to work out a new museum program.

costly, restoration of the existing building; the most costly, restoration and expansion; and the least feasible, demolition of the existing building and the construction of a new facility on the same site. Cost estimates and square-footage yield were calculated for each proposal, demonstrating that the most costly solution calling for the restoration and expansion of the museum offered the greatest program benefits and square footage.

Associate Director Carol Osborne articulated a partial program for the new museum. In addition to points made earlier by Corn, Osborne defined the role of the museum: "to collect, conserve, present, and interpret original works of art and make them available for teaching, scholarly research, and visual enjoyment in the university community." The museum was to "participate in the cultural enrichment of the broader Bay Area" with a phased expansion of the existing facility eliminating such outstanding problems as "the lack of adequate provision for loading and unloading works of art and for controlling temperature, humidity, and light intensity." She noted the museum's lack of large galleries for the exhibition of modern art, the lack of a director's office, the need for more substantial and effective teaching rooms, such as an auditorium, necessary administrative spaces for the projected growth of staff, and contemporary public amenities such as a cafe and bookstore.[132]

Damage to the building added stronger incentive to Corn's proposals to rebuild and modernize the museum. It was now necessary to hire an architect to help develop a master plan and strategies to realize it. In March 1990 several architects were interviewed by the project selection team, and William Turnbull Associates, Architects and Planners, in association with Charles W. Moore were selected to develop a feasibility study, which entailed commenting on and helping to complete the draft program drawn up by the project committee and assisting in evaluating the three concept designs: the restoration and seismic upgrade of the museum with and without an addition and the construction of a new building.[133] Turnbull was also contracted to assist in developing plans for the selected design program within a budget range of $8-13 million and a project completion date of July 1990. Almost immediately the third proposal— the demolition of the existing building and the construction of a new structure—was eliminated because of strong feelings for the existing building. Moreover, a new building would yield less space, and FEMA would provide no funds for its construction. Turnbull's efforts, therefore, concentrated on the first two proposals. of which the restoration of the existing museum and the addition of a wing quickly dominated discussions.

Turnbull explored the basic buttress scheme first recommended by Forell/Elsesser Engineers (fig. 21). The advantage of this scheme was that it mitigated site clearance issues, since the additions were largely contained within the overall area of the existing building and did not require the costly and lengthy removal of the primate facilities immediately behind the museum. Turnbull proposed a phased construction process beginning with the southern buttress, which included a courtyard and landscaping for the two-story block containing new gallery spaces, storage, workshop, and preparation areas, followed by an identical northern unit tucked in between the annex and octagon. However, the crowded area between the museum and the anatomy building interfered with loading access. The second scheme developed by Turnbull extended the footprint of the museum farther west into the area of the primate facilities, which the university eventually agreed to relocate in stages.[134] In this scheme Turnbull developed

132 Carole Osborne et al., "Museum Restoration," 22 March 1990, Museum Files.

133 The project selection team included Fouad Bendimerad, manager, Seismic Engineering; Corn; Lewis Darrow, project manager, Facilities Project Management; Jim Middleton, operations manager, Facilities Project Management (ex-officio); David Neuman, university architect; Carol Osborne; Jacqueline Wender, assistant dean, humanities and sciences; and Phil Williams, director of the Stanford University planning office.

134 Later, in 1993, Turnbull proposed an alternative plan sidestepping the primate facilities, but problems of circulation and access continued to plague the design.

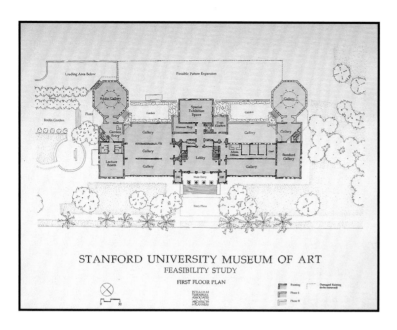

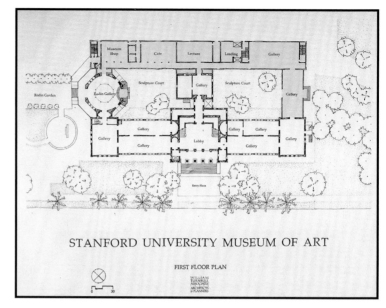

fig. 21 left
William Turnbull Associates.
Plan of the buttress scheme, 1990.
Storyboard: Museum Archives.

fig. 22 right
William Turnbull Associates.
Plan of the "bar" scheme. 1990.
Storyboard: Museum Archives.

135 Museum meeting minutes, 16 August 1993, Museum Files.

136 The gross square footage refers to the building's overall square footage before its division into gallery and ancillary spaces.

137 See, for instance, "Museum Reconstruction: Pre-Design Phase Status Report," 26 August 1993, Museum Files, wherein, under "Project Cost and Funding," the costs of retaining the rotundas was $24,600,000 and replacing them was $23,010,000.

alternative solutions that either preserved or replaced the rotundas. Both designs were based on a generic, two-story wing, known as the "bar scheme," appended to the rear of the museum (fig. 22). Mary Griffin, the principal designer for Turnbull on the project, linked the octagons with the bar to create an internal courtyard. The wing included new modern collection and temporary exhibition galleries, a coffee shop, bookstore, loading dock, and other facilities. Costs, problems of site clearance, accessibility, and loading plagued these proposals as well. Meanwhile costs for the various proposals had mounted from Forell/Elsesser's estimate of $12 million to $20 million.

A new level of program development and design marked the directorship of Thomas K. Seligman, who was appointed in May 1991, leaving a position at the Fine Arts Museums of San Francisco. Seligman refined the program further, emphasizing practicality as well as beauty. He scaled the maximum program size of the new building to the present collections and the university in general. He stressed an efficient loading dock, a fluid circulation system through the museum without dead ends, larger storage capacity, conservation facilities, greater accessibility to the campus, especially from the south, the inclusion of outdoor sculpture gardens and courts, and a modern, state-of-the-art building with separate galleries for temporary exhibitions and large-scale modern art, a cafe and bookstore with independent access, and a special-programs room available after hours. He also wanted to landscape the unsightly, cluttered site behind the museum, which appeared derelict. Seligman moved to establish closer ties between the museum and the university's academic departments as well as the surrounding community.[135]

Turnbull's buttress plan remained on the table until August 1993, when it was superseded by the bar scheme consisting of a two-story rectangular building of 36,000 gross-square-feet standing immediately behind and connecting the rotundas of the existing museum.[136] By mid-1993 the decision had been made to restore rather than replace the severely cracked exterior walls of the rotundas, since the cost differential was minimal and FEMA's support depended on retaining as much of the original fabric as possible.[137] Turnbull's alternative bar plans, which both maintained and replaced the existing rotundas, shifted the museum's space program farther west, allowing the possibility of opening an entry axis south toward the main campus as well as west toward the medical center with loading access off Campus Drive.

Seligman, however, felt that the various schemes were uninspired and became disenchanted with the proposed designs. He realized that fresh ideas and different perspectives were needed. The participants in the design process had become too close to the project to visualize more creative structural solutions.[138] Moreover, neither Seligman nor Turnbull believed that any of the current proposals could be brought to fruition within the extremely modest budget of $20 million, and new strategies were needed to raise additional funds. In late 1993, at the same time that Turnbull was revising the bar scheme, Seligman met with David Neuman, the university architect, and Gerhard Casper, the new university president, to propose an international competition of invited participants to design the new wing for the museum.[139] A month later a selection process was established.[140]

THE INTERNATIONAL COMPETITION

The design competition for the Stanford Museum was the second in a series of formal competitions initiated by David Neuman in 1992.[141] The first competition at Stanford, held in 1992 for the Allen Center for Integrated Systems, brought a stunning departure from the campus's conventional Romanesque-Mission-style pastiche. Antoine Predock's pink sandstone building with its distinctive copper-clad, barrel-vaulted portico (fig. 23) succeeded in revitalizing interest in high-quality design in campus architecture and planning. With the Stanford Museum competition, models and drawings were introduced to mitigate cost overruns incurred during the construction of Predock's building. This unusual procedure, occurring at the most preliminary stage of design, was expected to offer more accurate and predictable costs estimates. Nevertheless, the model provided a strong design focus at an early stage and gave nonarchitectural committee members a clearer sense of how a building would look and function in three dimensions.

The competitions were devised to raise both the quality and stature of Stanford's architecture and to restore the planning integrity of the original Olmsted master plan. They stressed a level of architectural design that was respectful of Stanford's heritage and at the same time promoted innovative reinterpretations of its vernacular traditions by renowned architects. For the museum competition Neuman compiled an initial list of twenty-five architects with significant experience in museum design, including many from other countries with international reputations. A committee consisting of Neuman, Casper, and Seligman winnowed the list to sixteen possibilities, and each was invited to submit a letter of interest with pertinent materials describing their experience in museum design. By mid-February 1994 four architects had been selected and invited by letter to submit a design concept and an outline of architectural services: Frank O. Gehry and Associates, Inc.; William Turnbull Associates with Hartman and Cox; Arata Isozaki & Associates; and James Stewart Polshek and Partners.[142]

The architects were asked to submit résumés of relevant work, fees for comprehensive architectural services, including engineering, landscaping, preservation, and lighting, a list of associates and local consultants, and a concept design model with cost estimates of its construction enabling the selection committee to assess the "approach to solving the general design issues involved."[143] The stipulation for a model and cost estimates had one drawback perhaps in that it excluded architects whose working methods were incompatible with a

138 Seligman, interview with the author, 9 January 1998.

139 Seligman to David Glen, Mona Duggan, Olivier Pieron, and Chris Ponce, 19 November 1993, Museum Files.

140 "Design Competition Consultant Selection Process," 16 December 1993, Museum Files.

141 Neuman had come from the University of California, Irvine, where he left an indelible mark on the campus, dramatically transforming its architectural landscape with designs authored by such internationally prominent architects as Frank Gehry and Robert Venturi. (He has tried to bring the work of both architects to Stanford). President Casper, who had come from the University of Chicago in 1992 with a well-known fondness for the work of Frank Lloyd Wright, has encouraged such new architectural developments.

142 Following the death of William Turnbull in 1997, his firm's name was changed to Turnbull, Griffin & Haesloop, Architects. James Stewart Polshek and Partners has since changed its name to Polshek and Partners.

143 David Neuman letter to the finalists, 15 February 1994. Museum Files.

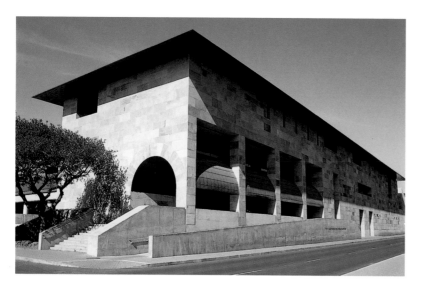

fig. 23
Antoine Predock. Addition to the Paul G. Allen Center for Integrated Systems, Stanford University, 1996. Photograph by the author.

144 The relative percentages of public spaces in large and small museums is presented in Stephen E. Weil, *Rethinking the Museum and Other Meditations* (Washington, D.C.: Smithsonian Institution Press, 1990): 33. The Stanford percentages fall within the normal range for smaller museums.

145 Neuman to Mary Griffin, Turnbull Associates, 15 February 1994. "Stanford Museum Restoration and Expansion (#6104): Request for Design Concept Study and Architectural Services Proposal," Museum Files.

146 In addition to Seligman, Neuman, and Casper, the members of the committee included Kemel Dawkin, Facilities Project Management; Irving Deal, member of the board of trustees; John Freidenrich, chair of the board of trustees; Ruth Halperin, member of the board of trustees; and John Shoven, dean of the school of humanities.

relatively fixed design at the outset of a project. Gehry withdrew early on in the process because his fluid, almost organic approach to design, using a series of styrofoam models, defied a singular cost model and raised the percentage of his fee far above that outlined in the program. (Of course, it could also be argued that this is a fundamental weakness in Gehry's working method.)

The winner of the competition would serve as executive architect in the restoration of the existing building, costing $13,000,000, and as designer for a new 37,000 gross-square-feet addition, estimated at $6,500,000. The spatial program was broken down into distinct functional areas and their dimensions in square feet. Gallery spaces accounted for 42,910 square feet, with an additional 9,470 square feet for other public areas, such as a cafe and bookstore, special-programs room, and the existing lobby; 14,400 square feet for art storage; 9,100 square feet for support spaces, such as a conservation lab, photography studio, loading dock, and a matting and framing room; and 5,470 square feet for administrative spaces—for a total net program area of 81,350 square feet. The total gross area for the existing building of 72,600 square feet and the addition of 37,000 square feet was 109,600 square feet. The ratio of public to private spaces was sixty-five percent to thirty-five percent, respectively.[144]

The architects were invited to visit the site in March 1994, a month before they presented their designs to the committee.[145] It consisted of distinct landscape elements: the museum is approached from the east on Museum Way, which traverses Olmsted's wilderness north of the main university buildings, and fronts Lomita Drive, its eastern edge. A second wilderness region lay to the north, intersected by Palm Drive, the campus's main ring road, and to the south is the Rodin Sculpture Garden and Roth Way. West of the museum is the condemned old anatomy building, enclosing a derelict site between it and the museum and partially screening a multistory parking structure immediately beyond.

The presentation models were cost estimated by Adamson Associates shortly before the campus interview.[146] Adamson's conclusions were revealing. Turnbull's design came closest to satisfying the program stipulations, costing about $7.25 million for 39,000 square feet; Isozaki's proposal was estimated at close to $11 million for 41,000 square feet; and Polshek's model came in double the program budget at $13 million for a substantially larger building of 64,000 square feet. The cost per square foot was equally revealing. The program had allowed for $176 per square foot, and again Turnbull's scheme came closest to meeting that estimate at $184. However, because Polshek estimated lower budgets per square foot for the building's various component parts, his overall cost per square foot was significantly less than Isozaki's, $208 and $265, respectively, emerging as an attractive middle ground. One result of the interviews was the realization that the new wing could not be realized for less than $200 per square foot, as Polshek had argued. Another result of the interviews was that Polshek and Partners was chosen to design the new wing but was asked to scale back its proposal.

THREE MODELS

The competition finalists highlight the array of solutions sought by Seligman in the design for the restoration and addition to the Stanford Museum. From Turnbull's contextual "sense of place" to Isozaki's layering and disjunction and Polshek's oppositional synthesis, each study represents a different current of architectural thought informing contemporary museum design. Certainly remarkable is the extensive variety of solutions appropriate to museum design today, where it is difficult to speak of a conventional approach. Of course, certain programmatic requirements are inherent in the museum type, but the way in which their design is effected has made the museum a vital and compelling area of architecture in the late twentieth century.

A Sense of Place

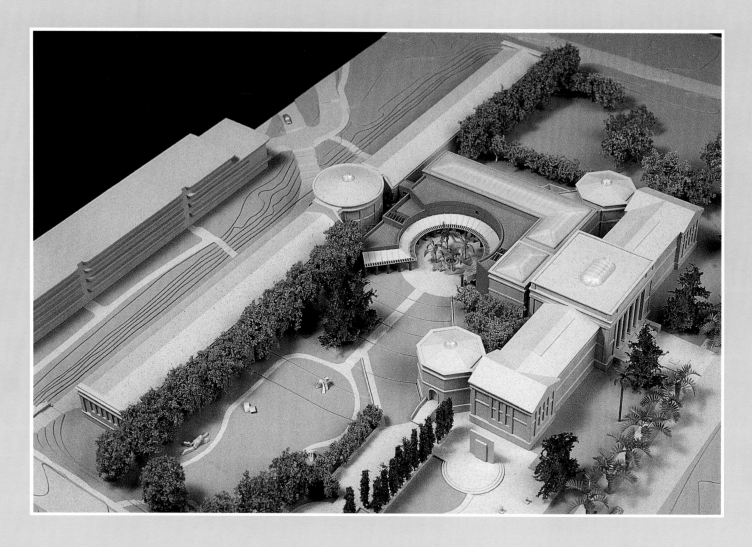

William Turnbull Associates
and Hartman–Cox Architects

Following his collaboration on Sea Ranch Condominium I (1965), that spectacularly sited collection of sheds that popularized California vernacular wood architecture traditions, William Turnbull became one of California's preeminent regionalist architects.[147] The ideals underlying Sea Ranch epitomize Turnbull's work: "The fundamental principle of architecture is territorial. The architect assembles physical materials from which the observer creates, not just an image of a building, but of 'place.'"[148] Unlike the work of Isozaki and Polshek, Turnbull's architecture eschews the language of the International Style with its emphasis on modern technology and materials. His domestic architecture in particular offers paradigms for building sensitively in California's Mediterranean-like climate: large, simple, and restrained forms, intimately connected with nature and redolent with contextual and public imagery. Turnbull's architecture is a narrative edging between building and landscape, each reinforcing the other's distinct values and qualities. Turnbull pursued the notion of making places rather than architecture; buildings were the means of creating memorable public landscapes that enhanced a feeling for community. His architectural touchstones—colonnades, porches, and plazas—were adopted, not as postmodern touches, but as practical symbols of public spirit that Turnbull had discovered regionally in California, in Italian hilltowns and cities while at the American Academy in Rome, and from his mentor at Princeton, the Beaux-Arts-trained architect Jean Labatut (Robert Venturi's mentor as well). Probably the most significant instance of Turnbull's sense of place was Kresge College (1973) for the University of California, Santa Cruz, where he created a "Village Street in the Forest."[149]

Turnbull's submission for the Stanford Museum competition, which featured Mary Griffin as the principal designer collaborating with Hartman and Cox, Architects, was the least monumental (fig. 24). Exemplifying the architects' sense of place, their proposal sought to transform a drab site (the rear of the existing museum closed along the west perimeter by the old anatomy building) into one of distinction and memory, an open public center framed by architecture and landscape. Of the three competition models Turnbull's most closely borrowed elements from Stanford's architectural vernacular, employing a covered colonnade and circular "oasis" reminiscent of the planted islands of the university's inner quad. A low-lying structure nestled between the existing buildings, the addition was a quiet presence opening onto the B. Gerald Cantor Rodin Sculpture Garden and the campus to the south (fig. 25). The wing's understated beauty and attention to utility and economy was a decidedly stronger variation of Turnbull's earlier feasibility study for the museum but still lacked Seligman's grander programmatic vision.[150]

147 *William Turnbull Jr.: A Regional Perspective*, exhibition catalogue (Cincinnati: Contemporary Arts Center, 1992). Turnbull collaborated on Sea Ranch with Charles Moore, Donlyn Lyndon, and Dick Whitaker.

148 Charles Moore, Gerald Allen, and Donlyn Lyndon, *The Place of Houses* (New York: Holt, Rinehart and Winston, 1974), 32.

149 *William Turnbull Jr.*, 33.

150 Partially this was due to the vagueness of the program, according to Mary Griffin and Eric Haesloop, both of whom worked on the Stanford competition entry for Turnbull. Mary Griffin and Eric Haesloop, interview with the author, 6 November 1997.

fig. 24 opposite page
William Turnbull Associates and Hartman-Cox.
Competition model, 1994. Museum Archives.

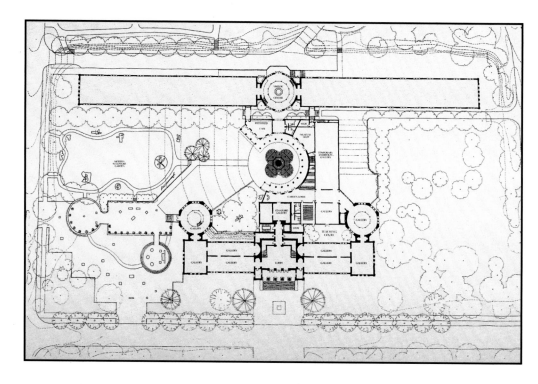

fig. 25 right
**William Turnbull Associates and Hartman-Cox.
Plan of Stanford Museum addition, 1994.
Storyboard: Museum Archives.**

The architects' goals were threefold: first, to create an "inspiring, yet efficient and accommodating" building within Stanford's budget; second, to "compliment and extend the precinct of the existing historic building"; and third, to "strengthen the overall site opportunities and connections back to the heart of the campus, and the west campus region."[151] Certainly the modesty of this plan stemmed from the firm's earlier experience with the museum staff to design a new program. Economy and a sense of place especially shaped the architects' design, which evolved from a fundamentally more formalistic and monumental parti (i.e. a basic design concept) based initially on the bar scheme. An early study showed a series of stepped bars receding from the rear of the museum and linked to it by a central corridor leading from the main lobby to the anatomy building's rotunda (fig. 26). A polygonal palm court punctuated the heart of the plan and became the fundamental ingredient of all the firm's subsequent design studies. This stoutly rectilinear composition was superseded by a much more dynamic and formative approach. Developed by George Hartman, a triangular composition (fig. 27) was evolved by snapping the bar into two wings that were extended inward on either side of the internal palm court from the rotundas at either end of the museum to the central rotunda of the anatomy building.

Hartman's scheme offers a potentially more alluring and distinct connection between the new wing and the existing museum through contrast rather than homogeneity. The arms of the new wing pick up the circulation routes from the proposed new entry through the rotunda of the anatomy building and out through those of the existing museum, establishing a dynamic diagonal opposition between the rectangular geometry of the old museum and the nonrectangular forms of the new. Although this proposal was extensively explored with minor variations—the palm court was alternatively hexagonal, octagonal, and circular—and major additions—oddly enough an incongruous dome with lantern was considered to cover the palm court (fig. 28)—the architects were unable to satisfactorily reconcile its closed and rigid geometry to the expansiveness of the site, a feature Turnbull felt had to be accommodated in the design of the new wing.

151 William Turnbull Associates and Hartman-Cox Architects, introduction, "Stanford Art Museum Restoration and Expansion: Statement of Qualifications" (1994).

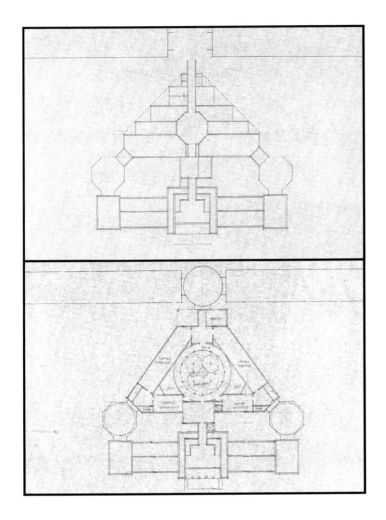

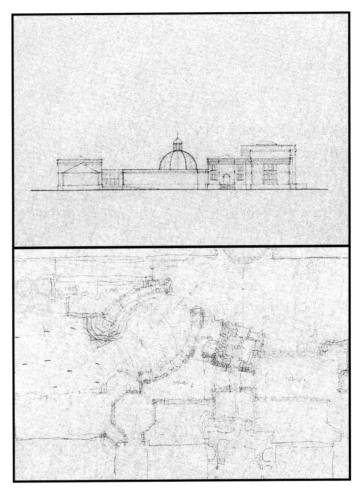

Nevertheless, Hartman's project offered a fresh approach, which the architects developed. They explored a more informal entry for the university community to the south, retaining the long horizontal flank of the anatomy building, which served both to screen the parking garage almost immediately behind it and to reinforce the site's southerly orientation. In one instance the architects explored a tortoise shell-like stepped approach from the south that divided the cafe and bookstore from the museum proper, perhaps its chief weakness (fig. 29). The new studies mitigated the tight geometry of Hartman's triangular plan by carving out a semicircular entry along the south arm facing the Rodin Sculpture Garden. The architects also located the twentieth-century sculpture garden on that side, just west of the Rodin Garden, although Seligman had stipulated that it should be sited north of the museum. The architects argued that the proposed budget did not permit a larger building that could more effectively utilize the vast site, and they felt obliged to prioritized their resources by developing the more important approach from the south. Seligman explained that the "specter of no money" haunted the Turnbull design from the beginning, but he believed that its most serious flaw was its closed northern edge, particularly since he had prescribed a new sculpture garden in that region.[152]

fig. 26 top left
William Turnbull Associates and Hartman-Cox.
Plan showing additions along west elevation, 1994.
Graphite on tracing paper.

fig. 27 bottom left
William Turnbull Associates and Hartman-Cox.
Triangular plan, 1994.
Graphite on tracing paper.

fig. 28 top right
William Turnbull Associates and Hartman-Cox.
Elevation with dome over the palm court. 1994.
Graphite on tracing paper.

fig. 29 bottom right
William Turnbull Associates and Hartman-Cox.
Tortoise-shell plan, 1994.
Graphite and ink on tracing paper.

152 Turnbull's decision to locate the loading dock on the north side posed another problem: it required curb cuts along Campus Drive, which the university was unlikely to permit. Seligman, interview with author, 9 January 1998.

Aspiring to a sense of place, the architects forged a singular design based on colonnades, pedestrian paths, courtyards, and terraces, organized around a central garden court. Adopting an "infill" scheme, the new wing covered the full extent of ground between the anatomy building and the museum, though it was distinguished from them by its red sandstone facing. The focal point of the architect's design was a new garden courtyard opening onto the Rodin Sculpture Garden and, more distantly, the university, framing views of the campus and Hoover Tower (fig. 30). Terminating the main pedestrian avenue of the burgeoning near west campus, the new wing snagged the faculty and student population to the south in a "catcher's mitt." The three-quarter-circular, screening colonnade, evocative of the arcades of Stanford's inner quad, supported a trellised corridor enclosing a central garden court. Distinctive of Turnbull's sensitivity to the edge between building and landscape was the sun-screen trellis bordering the low overhang, modulating light at a critical passage between indoors and outdoors.

At the heart of the garden court was a polygonal island of tall palms bisected by pathways leading to a fountain. Its geometry picked up that of the existing rotundas while also alluding to the planting circles of the inner quad, thereby making the design more community spirited. The garden court bisected the axis running through the existing museum's monumental east entrance and lobby fronting Palm Drive and offered an informal contrast to that ceremonial passage by creating a multidirectional, diaphanous building threshold. The court was an intimate enclosure, a relaxed setting distinct from that of the conventional, classical museum type of the nineteenth and twentieth centuries. The garden court's lobby offered views out onto the surrounding landscape and made an inviting contrast to the self-contained grand lobby of the older museum. Turnbull carved out and framed a stage set, reminiscent of a cyclorama, organized around a western garden of palms, giving the setting a regional flavor and exploiting, as he said, the benign climate. From within this ringing threshold, the garden court amplified the interior spaces while embracing the landscape both near and far.

Turnbull's scooped-out-block parti, however, contained a number of problematic features. Dead spaces resulted from the fixed geometry, as in the landscaped areas between the north and south rotundas; the teaching court to the north seemed especially gratuitous to Seligman. The parti was less novel than either of those presented by Polshek and Isozaki. Similar plans had been developed by Robert Venturi in his renovation project for North Canton, Ohio (1965), and Charles Moore, Turnbull's frequent collaborator, in his Piazza d'Italia (1978), New Orleans, both of which created memorable centralized spaces as the focal point of their composition. Turnbull himself employed a centralized social court as a formal contrast to the meandering plan of his Kresge College (1973) for the University of California at Santa Cruz (fig. 31). His addition to the Stanford Museum, however, was dogged by unfortunate comparisons to the design of a shopping center, a commercial reference Seligman found overwhelming and unappealing.

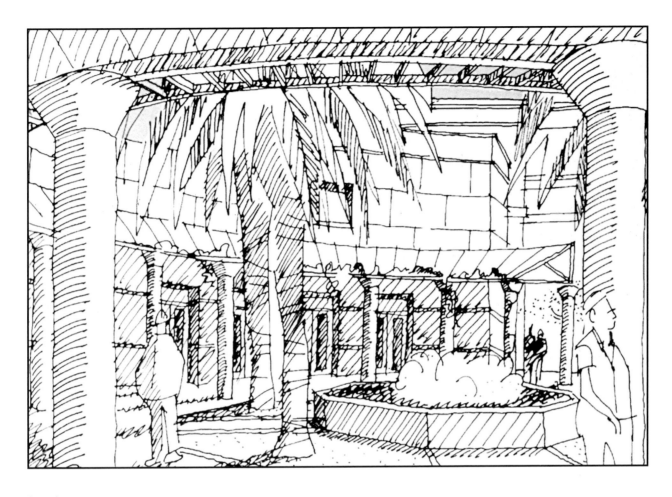

fig. 30 above
William Turnbull Associates and Hartman-Cox.
Garden court opening, 1994. CAD image.

fig. 31 right
Moore Lyndon Turnbull Whitaker.
Kresge College, University of California, Santa Cruz, 1973.
Photograph by the author.

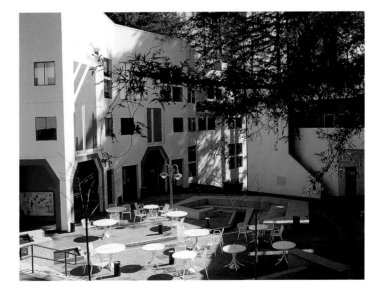

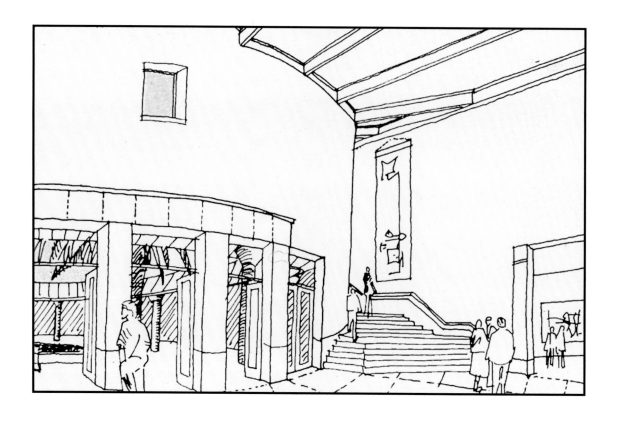

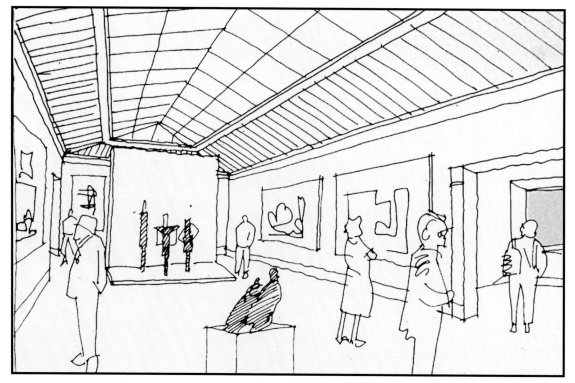

fig. 32 top
William Turnbull Associates and Hartman-Cox.
Garden lobby, 1994. CAD image.

fig. 33 bottom
William Turnbull Associates and Hartman-Cox.
Second-floor gallery, 1994. CAD image.

The steel-framed, red sandstone, and plaster building provided 37,000 square feet of enclosed space (not all of which, of course, was gallery space), with an additional 2,000 square feet created by the enclosed, curving interior corridor ringing the garden court. This latter area, however, was outside the secured zones of the museum, and it was unlikely that it could ever have any function other than a corridor linking the cafe and bookstore and the temporary exhibition gallery. The galleries were angled around the garden court forming a two-story L-block, entered from the garden lobby (fig. 32), which also opened onto the special-programs room with its teaching court and allowed entry into the older museum. From the new lobby a staircase led up to the modern galleries (fig. 33), which were "designed to be simple, elegant, skylit spaces that do not inhibit or compete with the art displayed."[153] The extensive skylights appeared embryonic and tentative in their detailing; it was not clear how they would have filtered light into the gallery spaces below. (In the designs by Polshek and Isozaki skylit galleries are more thoroughly developed, having light monitors, louvers, or diffusers to redirect the light entering the galleries and reduce its intensity.) How would the architects have handled the additional heat load or protected the artworks from the damaging effects of ultraviolet rays?

While Turnbull's design was responsive to the sense of place for the general public, its stewardship of the museum staff was perhaps less charitable; the architects relegated the director's office and other administrative spaces to the dreary confines of the older museum's low basement. Perhaps this was a pardonable gaffe given the budget-minded program, yet we cannot help feeling that Polshek's decision to let the museum staff out of the basement and into modern, airy office spaces, close to the public, the exhibitions, and the cafe, was only common sense. (Isozaki similarly overlooked this factor.) Turnbull did house the state-of-the-art support facilities, such as conservation and photography labs, in the basement of the new wing.

The Stanford Museum project was the firm's first comprehensive use of computer-aided design, or CAD. Almost all their competition materials consisted of slides presented at the time of the interview. Later, as committee members reflected further on the designs, only the model (fig. 24) and a single storyboard (fig. 25) were left to reinforce, clarify, and enhance Turnbull's presentation. The paucity of materials, especially next to the large number of presentation storyboards left by Isozaki and Polshek, seemed inadequate to fully recall more subtle inflections of planning or excite new discoveries, possibly hindering the potential allure of Turnbull's scheme by allowing its memorable features to fade from view.

153 Turnbull, "Stanford Art Museum: Restoration and Expansion," Museum Files.

THE LAYERED MUSEUM

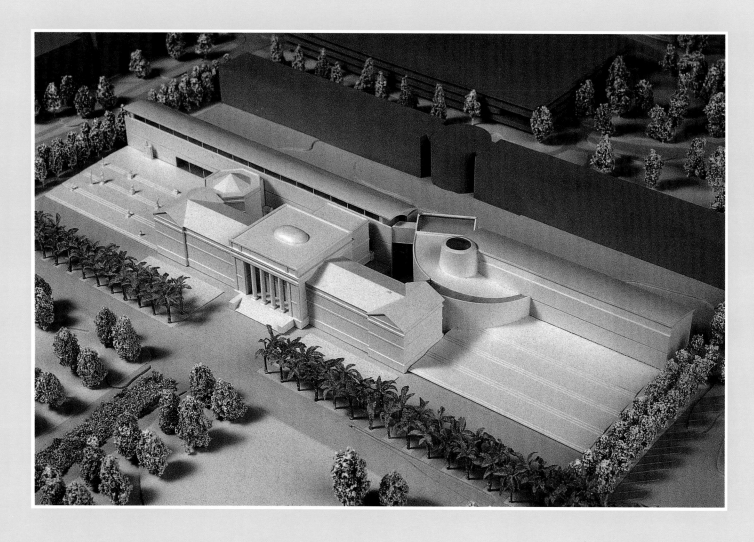

Arata Isozaki & Associates

The only architect from outside the United States to win a finalist's place in the competition was Arata Isozaki, whose main office is in Tokyo, Japan. At the time of the competition Isozaki had built less than a handful of buildings in the United States, making his participation in the Stanford Museum project something of a coup. Often described as a classicist-mannerist or late modernist, Isozaki's work is exceptionally diverse and idiosyncratic within the modernist tradition.[154] His early work was influenced by his mentor, Kenzo Tange and Japanese brutalism, massive concrete megastructures that seemed capable of remaking the world and often tried. Isozaki's commitment to Western rather than Eastern architectural history (possibly adopted from Japan's post-World War II circumstances and developments) is rooted in a belief in modern technology, materials, open spaces, and aberrant, if not outright arbitrary formal constructions derived from some aspect of a program or a building's context.

Isozaki's work is consciously inspired by the "heroic period" of modernism, but like many of his generation he often includes elements that mitigate its most rigid and purely formalist tendencies. His proposal for the Stanford Museum shows many such features (fig. 34). Although more expensive sandstone could be used, Isozaki proposed a reinforced-concrete building with cast-in-place concrete walls, beams, and slabs. Isozaki's basic organizational philosophy presented an evolutionary layering (figs. 35-36) of distinct museums, beginning with the original Stanford Museum. The classically articulated building of this first-generation museum symbolized the nineteenth century's institutionalization of private art collections. The second- and third-generation museums represented by Isozaki's additions were to be realized in stages beginning with the southern block and the emergence of the neutral modern-art gallery. The future northern wing would have presented site-specific installations, the most current direction in art according to Isozaki.

Isozaki's proposed minimalist buildings were both alluring and quirky. Consisting of two long, linear structures sharing a common axis, Isozaki's additions were unequal in length and were bridged by a curving hinge that replaced the north rotunda. His plan reinterpreted the long, linear axis organizing the original building's gallery spaces and composition, and he reinforced this connection by aligning the new wing with the existing roofline. He remarked in his project statement that his purpose was to restore the original frontage of the 1906 museum. Isozaki's buildings were singular volumes illuminated by a continuous light monitor that dramatized an otherwise inconspicuous and mundane feature of the existing museum's upper galleries. A curved metal roof, opened along the front by a continuous clerestory strip secured by vertical mullions, allowed natural illumination into the addition's upper galleries. It was a subtly dynamic touch to an otherwise closed, formal, and essentially rectilinear design.

154 Hajime Yatsuka, "Arata Isozaki after 1980: From Mannerism to the Picturesque," in David B. Stewart and Hajime Yatsuka, *Arata Isozaki: Architecture 1960-1990*, exhibition catalogue (Los Angeles: Museum of Contemporary Art; New York: Rizzoli, 1991), 18-23. Charles Jencks has classified Isozaki's work as "some of the most convincing Late-Modernism around" (Jencks, *The New Moderns: From Late to Neo-Modernism* [New York: Rizzoli, 1990]: 43). However, Jencks's few references to Isozaki suggest his difficulty in classifying the architect's work.

fig. 34 previous page
Arata Isozaki & Associates. Competition model, 1994.
Museum Archives.

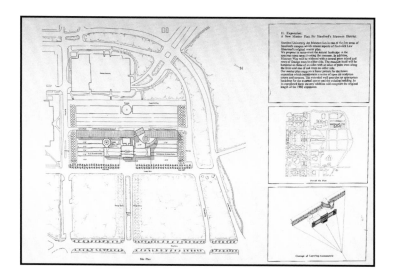

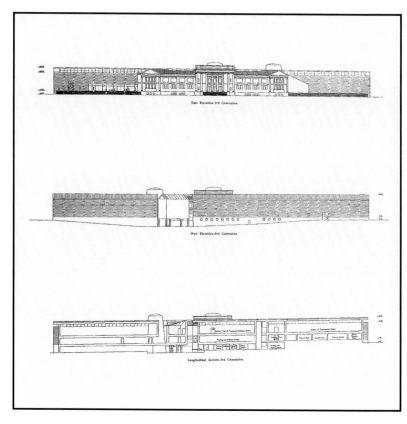

fig. 35 above
Arata Isozaki & Associates.
Axonometric drawing showing museum layering, 1994.
Storyboard. Museum Archives.

fig. 36 right
Arata Isozaki & Associates.
Elevations of new wing, 1994.
Storyboard. Museum Archives.

The predictable balance of the classical museum was broken in Isozaki's wings by their asymmetrical composition on either side of a curvilinear node. Unlike the proposals submitted by either Polshek or Turnbull, Isozaki's did not establish a new pivotal center immediately behind the existing museum's ceremonial lobby, reinforcing its minor cross axis. Isozaki's wing stood in serene isolation, serving as a distinct foil for the current museum and reinforcing its major linear axis and orientation on Museum Way. Oddly, Isozaki's plan retrenched the museum's focus away from the university when the program had called for an opening to the south.

The landscaping was perhaps the most controversial feature of Isozaki's plan, revealing an unexpected regimentation and a surprising gaffe. He applied the same rigorous organizing principle to the surrounding grounds as he did to his architecture. Isozaki reconfigured the Rodin Sculpture Garden, moving the *Gates of Hell* from a southern to a northern exposure, thereby depriving Rodin's light-mad figures, with their raisinlike surfaces, of their most fundamental ingredient, light (fig. 37a). The repositioning of the Rodin sculptures on an immaculate, stepped terrace headed by the *Gates of Hell* leading up to the new wing's main entry from the east in effect eliminated the only existing entry from the south. Isozaki compounded this error by establishing an identical contemporary sculpture garden immediately north fronting the future wing. The terraced gardens reinforced and extended the neoclassical museum's formality, continuing the lines of the linear gallery spaces out of doors and suggesting the classically inspired thinking behind the architect's plan. A third garden, based on an unbuilt and unsolicited "Hiroshima Memorial" project by the

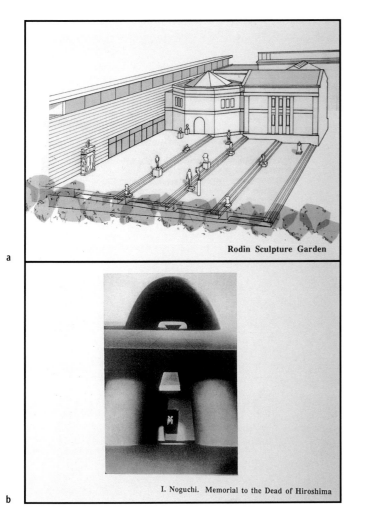

Rodin Sculpture Garden

I. Noguchi. Memorial to the Dead of Hiroshima

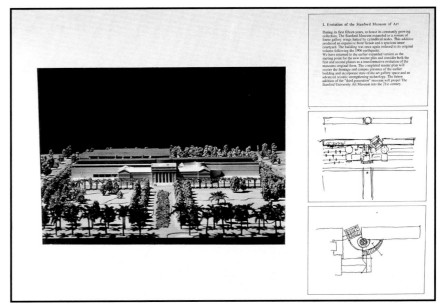

fig. 37 a&b left
Arata Isozaki & Associates.
Reconfigured Rodin Sculpture Garden (a)
and the Hiroshima Memorial (b), 1994.
Storyboard. Museum Archives.

fig. 38 above
Arata Isozaki & Associates.
Allees and ceremonial avenue (Museum Way), 1994.
Storyboard. Museum Archives.

Japanese-American sculptor Isamu Noguchi, was located in an inner courtyard between the older building's south rotunda and new wing (fig. 37b). To the west of Isozaki's wing, immediately beyond the access road along the building's rear elevation, lay an intermediate, unspecified realm of landscaped lawn separating the additions from the anatomy building; although Isozaki reserved part of this site for a future building, it is a purposeless and essentially dead spatial alley.

The peripheral landscape around the museum was equally disciplined. Isozaki created a new ceremonial avenue (fig. 38) with a turf median and edged the road with allées of orange trees lined up on the museum's central Ionic portico. The allées screened Olmsted's arboretum rather than exploited it and brought a contrasting rational, classical order to the wilderness of the surroundings. Across the front and sides of the museum were additional allées of palm trees and oaks, respectively. These formal, linear greenbelts reinforced the continuous axes of the original master plan, Palm Drive and its flanking minor avenues, Lasuen Way and Lomita Drive, and its major cross axis, Serra Street to the south. Isozaki's addition, therefore, was conceived and integrated within the larger historic context of the campus and strengthened the university's current restoration of Olmsted's plan, a project made known to the finalists. Nevertheless, Isozaki's landscaping underlined the severity of his rigorous, even uncompromising conception.

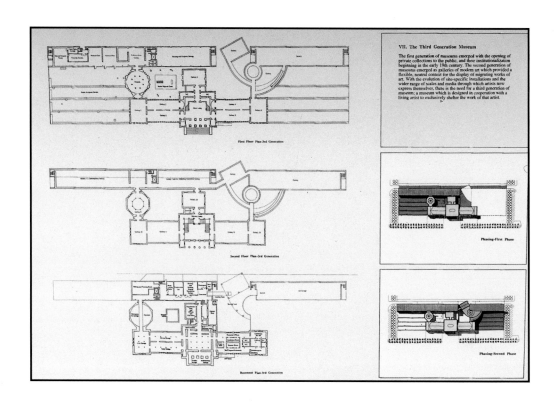

fig. 39
Arata Isozaki & Associates.
Plans indicating rooms, 1994.
Storyboard. Museum Archives.

The new wing embodied many of the ideals of his synthetic classical-modernist approach. In schematics it had a heightened, flat, linear quality, sustained in construction by a thin, planar veneer of concrete or, alternatively, sandstone wall surfaces, distinct from the robust multidimensional building blocks of the existing museum. Moreover, unlike the classical articulation of the museum's component parts, which add to its sense of weight, depth, and structure, Isosaki's unbroken wall surfaces concealed the building's underlying structural steel frame, a fact further emphasized by the continuous ribbon windows and unbroken roofline. As such his wing was fundamentally lightweight volumes contrasting with the heavy massing of the existing museum. Isozaki's modernism was entirely compatible with the museum's classical style, notably in the wing's abstract, formal purity, in his use of masonry sheathing, in the rigorous, linear, organizing axes, which sought to control even the surrounding landscape, and above all in the feeling of serene aloofness.

A Shinto sense of purification pervaded Isozaki's design. Although this was most apparent in the introduction of the Noguchi garden, which was added to the museum program, there were no overtly Shinto elements. Rather, a transcendent stillness, disciplined by a spareness, drove the overarching order. The sensuality of materials and meticulous craftsmanship distinctive of Isozaki's work heightened the wing's sense of immutability and timelessness. In his buildings this enduring quality was most profoundly realized in his use of light, the alluring forte of museum design. In his additions to the Stanford Museum Isozaki sacrificed the first floor (fig. 39) to the more prosaic functions, the special-program room, the cafe, bookstore, and storage facilities, and located the more important galleries on the second floor, where they could be manipulated with natural and artificial light. The only gallery space on the first floor was the print room, but because of the extreme sensitivity of paper to natural light, its situation away from a direct light source was entirely appropriate.

The new contemporary art and temporary exhibition galleries on the second floor were designed as tranquil, neutral environments that did not compete with the art, or so Isozaki said. The long, open spaces housing the contemporary and temporary exhibitions, according to Isozaki, were distinctive of the "second generation museum" where "galleries of modern art… provided a flexible, neutral context for the display of migrating works of art."[155] In his program statement Isozaki talked briefly about the "Idea of Light" within the galleries. These large spaces were envisioned as stunning, dynamic, light-filled rooms animated by their solar orientation, their vital raison d'être (fig. 40). The single curving slope of the roof consisted of two unequal and irregular arcs, which caught the light and bounced it off the ceiling, diffusing illumination evenly throughout the interior. The lower, shallower ceiling arc, which included supplemental artificial lighting, prevented any direct light from striking the back wall. The two arcs, which were cantilevered over glazed stairwells at the ends of the building like billowing sails, subtly divided the internal galleries into greater and lesser volumes. This division of internal space was reminiscent of the first-floor galleries of the original museum, with their long, narrow alley. A significant drawback of Isozaki's proposal, however, was its fixed orientation to the east, providing only a short duration of natural light during the morning.

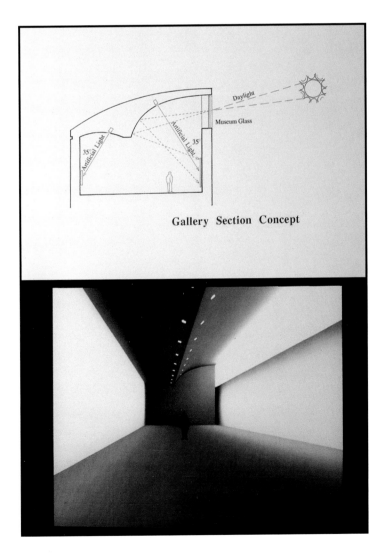

fig. 40
Arata Isozaki & Associates.
Solar orientation and upper gallery (CAD image). 1994.
Storyboard. Museum Archives.

155 Arata Isozaki & Associates, "Stanford Museum Renovation and Expansion," 27 April 1994, Museum Files.

79

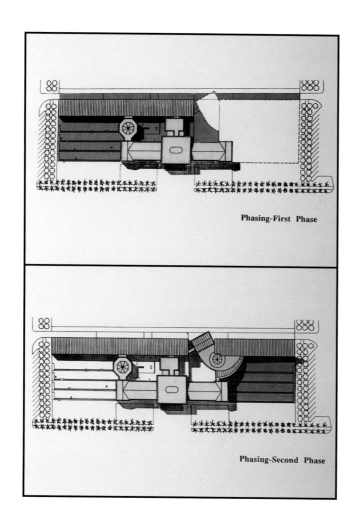

Phasing-First Phase

Phasing-Second Phase

fig. 41 left
Arata Isozaki & Associates.
Drawing of phasing, 1994.
Storyboard. Museum Archives.

fig. 42 above
Arata Isozaki & Associates.
Sketch of conical joint of third-generation museum, 1994.
Ink on tracing paper.

The third-generation museum, or future addition (fig. 41), abetted the site-specific nature of much of art today. The expansiveness of the galleries afforded a place for the wider range of scale and media distinctive of the modern museum, where galleries are commonly prepared with the cooperation of the artist. This museum wing provided an unusual juxtaposition of galleries of various shapes organized around a major axis. At the corner nearest the old classical museum was a skylit, conical rotunda (presumably a recasting of the north rotunda, which Isozaki expected would be demolished) rising to the roofline of the older building (fig. 42). Isozaki used a similar element as a light well and sundial in his Disney Team Building (1992) in Orlando, Florida. To one side of the rotunda he tucked in a curvilinear gallery rimmed by a curving, skylit staircase. A second gallery, serving as a bridge at its second-floor level between the two wings, was obliquely skewed and stood on concrete stilts, a disjunctive motif Isozaki has used elsewhere, as in the Gunma Prefecture Museum in Japan and the Museum of Contemporary Art in Los Angeles (fig. 43).

Disjunction, according to one critic, has been the hallmark of Isozaki's work since the 1980s.[156] He has used disjunction for both symbolic and formal reasons: on the one hand, it is a rejection of hierarchical organization, which Isozaki believes reflects the "loss of center" in current culture and is especially meaningful for capitalist society; and on the other, it denies a monumental presence where one might be expected. Often Isozaki incorporates a sunken court to further suggest the absence of a center or a monumental presence. Disjunction operated in the Stanford Museum project as a mode of connection to assemble a "loose collage" of geometric

156 Yatsuka, "Arata Isozaki," 19.

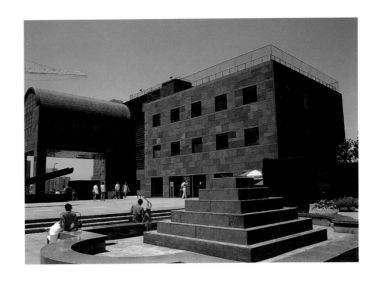

fig. 43
Arata Isozaki & Associates.
Museum of Contemporary Art, Los Angeles, 1986.
Photograph by the author.

forms of conflicting power and quality, rectangles and circles or arcs, which both complimented and contrasted with the existing museum. Disjunction also acquired a historical relevance, echoing the museum's original building components of wings connected by circular nodes. But rather than having the predictability of that earlier classical formation around an organizing quadrangle, Isozaki's composition was uncentered, and certain forms were skewed off axis while others were unpredictable. The quadrangular precinct in the fully extended building was generated, not by architectural elements per se, but surprisingly by the double allées of trees along three flanks (fig. 35). The third-generation museum made clear that the power of Isozaki's conception largely depended on this future addition being built, a risky proposition for a university art museum. The weakness with this process was that a large, indeterminate void existed to the north of the museum until that time.

The construction of the third-generation museum was equally important to the completion of the circulation system. At the heart of the juncture between the old and new museums was the serene calm of the Noguchi garden, around which Isozaki planned the circulation system (fig. 37b). The new wing was entered directly through the repositioned Rodin Sculpture Garden or from the Noguchi garden on the first floor, which opened onto the south rotunda leading to the print gallery, or from the second-floor gallery immediately behind the main lobby of the older museum, which led into the new temporary exhibition gallery (the storage facility below the gallery prohibited entry directly from the lobby of the first floor). However, the Noguchi garden remained a problematic inclusion, since Isozaki neither exploited its presence to enhance any interior space nor offered tantalizing glimpses of it from some gallery; indeed, even access to it was severely restricted. It was an isolated and contained, if unexpected, ordered oasis at the heart of the museum precinct. Without the second-phase addition, moreover, the north galleries of the older museum remained dead-end paths. In fact, it is unclear how Isozaki would have retained the north rotunda (FEMA required its preservation) within his overall scheme.

Doubtless Isozaki's phased-construction process undermined the credibility of his proposal. The uncertainty of funding and support both from the university and the community mandated the adoption of a self-contained building adhering to a master plan that could be realized in the immediate future. In addition, critical design issues remained unresolved following the interview, such as the orientation of the building, the reconfiguration of the Rodin Sculpture Garden, and the absence of a new entry from the south. Seligman believed that the design offered few compromises, and the project's success and integrity depended on an almost blind acceptance of its pristine formalism.

Building with the Past

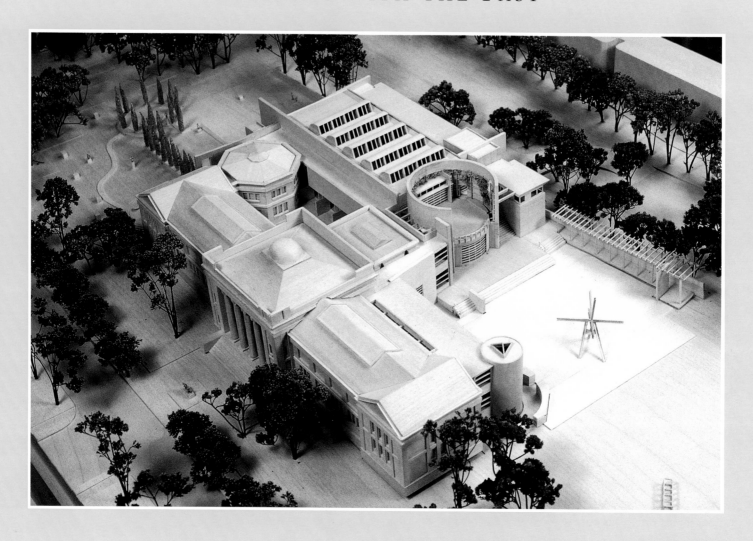

Polshek and Partners

The competition's winning entry by Polshek and Partners was perhaps the most startling of the three. Visually and intellectually the new wing is a complex addition (figs. 44-45). At first glance it seems to have little in common with the existing building. It appears to be the antithesis of the classical Stanford Museum, eschewing the older building's classical dress and formal composition, its hierarchic order and symmetry, its overt symbolic references, its aloof, ceremonial spaces, and its closed, rigid form. The design seems chaotically modern (more evident in the initial design and model), a radical interpretation of the museum program. Its most distinguishing feature is an open, circular drum at one end of the rectangular building block, standing at the nexus between the new and the old. Thin-skinned walls of glass screened by lightweight aluminum louvers contrast sharply with the deep window reveals and heavy masonry of the earlier building. The second-floor galleries were skylit by hood monitors (since eliminated), creating an irregular rather than uniform roof silhouette. Polshek's addition seems entirely independent, even arbitrary in almost every way, defying any stylistic logic or order.

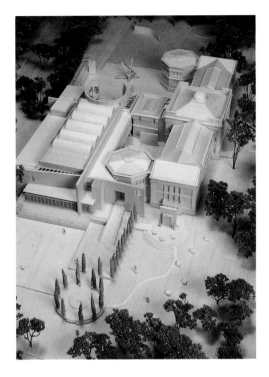

fig. 45
Polshek and Partners.
Competition model view from the south, 1994.
Museum Archives.

This daring interpretation of the program was mitigated by certain seductive features of the model. (The architects may not have been fully appreciative at the time of how singular their wing seemed on first inspection to a committee that had been examining minimal design scenarios for several years.) It was by far the largest of the three entries, and it had been deliberately overscaled both to elucidate aspects of the design and, equally important, to impress the jury. Unlike those of Turnbull and Isozaki, it was made of wood rather than synthetics, giving it an appealing warmth. The complex design proposed by Polshek and Partners engendered a finely detailed model, which was impressive and rewarded continued study. At the same time, however, their original submission was much larger in scale and in area than that stipulated in the program, providing almost 64,000 square feet rather that the requested 37,000, making it clear to everyone that the building was a far more expensive proposition. Indeed, their model was cost estimated at $13,000,000 for the new wing alone, double the projected budget. Nevertheless, following the interview with the architects, the jury was persuaded that its budget was too low. Polshek and Partners was awarded the commission both for the programmatic and aesthetic effectiveness of their design and their willingness to make necessary revisions.

THE ABSENCE OF STYLE

There is good reason for the seeming absence of style in the new wing by Polshek and Partners. The firm has a reputation for defying stylistic labels, and its fluid approach to architecture has recruited a sympathetic cadre of talented, but strongly independent architects. Richard Olcott, the principal designer on the museum project, remarks that within the firm he has his own "sandbox" but that his designs are always improved by Polshek's input, which tends to focus more on the details rather than on the composition. Olcott developed several working concepts

fig. 44 previous page
Polshek and Partners.
Competition model view from the north, 1994.
Museum Archives.

for the museum, which were discussed with Polshek, but Olcott was left to make the final decisions and to point the way. Throughout the design process for the Stanford Museum, Olcott refined its compositional, aesthetic, and intellectual direction (in addition, of course, to its functional requirements), favoring the use of few materials, originally simply concrete, wood, and glass. The individual skills and preferences of Polshek and Olcott, working in concert with the museum's director, have coalesced into a memorable building project for the Stanford campus.

Polshek and Olcott reject the idea of working within a prescribed convention universally applicable. Neither believes in a signature style that sweeps across every design as, for example, in the recent work of Frank Gehry (the formal differences between the Disney Concert Hall in Los Angeles, the University of Minnesota's Frederick R. Weisman Art Museum, and the Guggenheim Museum Bilbao in Spain are hardly discernible to the inexpert) or Richard Meier (whose new J. Paul Getty Center has been compared to a lofty corporate building rather than a cultural institution). Polshek and Olcott contend that such architecture and their architects are consumed fundamentally by questions of artistic identity and expression. Polshek has voiced his concerns about the "extraordinary pressures" put upon the architect to "invent, repeat, or copy new formal vocabularies."[157] However, after the widespread coverage of the opening of Gehry's Bilbao Museum and Meier's long-awaited Getty Center and their spectacular formal creations, it is difficult to accept completely Polshek's assertion (he is not alone in making this point, it should be noted) that the day of the signature building and the star architect will pass.

Polshek and Partners, however, shun stylistic predictability. An unpredictable diversity distinguishes the firm's work. Each building seems to have its own formal, material, and structural vocabulary. The architects assert that they have avoided the limitations of a single style and believe that they have enticed commissions that subsume such issues to symbolic and programmatic requirements. The firm is especially noted for its sensitive, yet challenging additions to older buildings. Their Seamen's Church Institute (1985) in New York (fig. 46), for instance, conforms to the street plane and neighboring masonry structures but rises above the skyline with an almost surreal roofscape, an enameled, streamline-moderne Noah's Ark, an *architecture parlante* reference to the building's function. Although consisting of sharp contrasts of materials and styles, and properties and qualities, the building manages to carry its parts as a unit, and its presence is somehow sensitively harmonized with its surroundings without surrendering its identity.

In their Brooklyn Museum project (1986) (fig. 47), done in collaboration with Arata Isozaki, Polshek and Partners designed a complex of modern additions that filled out the older, incomplete structure by McKim, Mead, and White. Polshek's contribution was to make "connections," as he said, between the old and the new, threading a circulation system both as "functional pathways and volumetric transitions" while establishing an overall neighborliness.[158] Moreover, Polshek extended bridges to the adjacent park, incorporating a reflecting pool and promenades along the west and a skewed open court stepping down into the Brooklyn Botanical Gardens to the south. Polshek said that the additions echoed the original master plan's unrealized internal courts and the park's original reservoir. A monumental obelisk at the center of the new plan symbolized the connection between the existing buildings and its additions. Many similar strategies reappeared in the Stanford Museum addition, albeit in fundamentally different form.

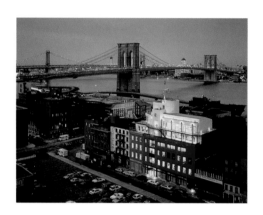

fig. 46
Polshek and Partners.
Seamen's Church Institute, New York, 1985.
Photograph by Jeff Goldberg/ESTO,
courtesy Polshek and Partners.

157 Helen Searing and Gwendolyn Wright, *James Stewart Polshek: Context and Responsibility: Buildings and Projects 1957-1987* (New York: Rizzoli, 1988), 73.

158 Ibid., 58. The concept of "connections" doubtless derives from Louis Kahn's idea of an "Architecture of Connection," or the experience of a building's spaces by movement through them (Kahn, "Form and Design, and Other Writings, 1957-62," in Leland Roth, ed., *America Builds: Source Documents in American Architecture and Planning* [New York: Harper & Row, 1983], 580).

Polshek was skeptical of a perceived architectural conformity at Stanford—its long tradition of red tile roofs and buff-colored walls—though the competition program did not mandate any vernacular. In fact Antoine Predock's addition to the Allen Center for Integrated Systems (1995), the first competition initiated by Casper and Neuman, adopted copper instead of the ubiquitous red tile, creating a dramatically dark tunnel-vaulted entry. Before the museum competition, therefore, there existed an environment that was not only sympathetic to iconoclastic architecture but also favored the complex marriage between the old and the new preferred by Polshek and Olcott. In Polshek's own words the design seeks to establish "two different time periods of style, audience, and sociological experience in architecture." [159]

Polshek's critique of hyperpersonalized style builds on a long-standing polemic within American architecture, exemplified earlier in the century by Frank Lloyd Wright. Distinguishing himself from the eclecticism of the nineteenth century, Wright held that the modern architect's clarion call and dilemma was not "what style?" but "what is style?"[160] Although Wright resorted to nineteenth-century romantic, organic analogies between architecture and the structure of trees and flowers, he nonetheless established that a building's design does not flow from a preconceived style but from the logical, even inevitable outgrowth in forms and materials of its distinct functional problems and requirements. From this theoretical standpoint Wright was able to achieve a staggering variety of formal and technological solutions within his domestic and public architecture. Similarly Polshek and Olcott question the concept of style in their work. They seem to revel in the uniqueness of each commission and client and the particular set of problems, conditions, and circumstances that entail specific design responses.

Architecture, according to Polshek, will always be an "ideal synthesis of tectonic and aesthetic principles."[161] The firm's formal and structural vocabulary is fundamentally modernist in its choice of materials, forms, spaces, and philosophy. Its architects prefer such materials as metal and glass, reinforced concrete, or fine masonry touches or veneers (in the case of the Seamen's Church Institute, white porcelain-enameled steel panels were used on the exterior in addition to masonry).[162] Equally important to them are advanced mechanical systems; bold colors and strong, sometimes powerful shapes are also frequent elements in design. Their addition to the Columbia University School of Law, New York, and the striking New York Times Printing Plant, New York, both completed in 1997 and both designed by Polshek and Olcott, employ these elements and have been highly lauded. They weave their materials in a skillful marriage of contrasts, each reinforcing the others. They believe that even in those situations, such as Stanford's, where an architect is commissioned to add on to an existing, historic structure, the appendage, while establishing links with the older building, should remain distinct and uniquely expressive.

The firm's architecture, moreover, is enriched by a palette of historical allusions and borrowings. This has proved to be a significant means of contextualizing a building, giving it both a regional as well as an international voice. Unlike the staunch modernist, Polshek readily admits a wide range of influences in his designs, which militate against strict classification. Yet both Polshek and Olcott have little patience for postmodernism's frequently insubstantial, decorative references to historical styles. They imaginatively reinterpret and incorporate their sources in a harmonious, idiosyncratic symphony of allusions. Preeminent among those sources

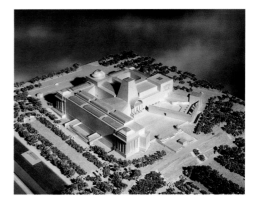

fig. 47
Arata Isozaki & Associates/Polshek and Partners. Model of the Brooklyn Museum master plan, 1985. Courtesy Polshek and Partners and Nathaniel Lieberman.

159 Polshek, interview with the author, 26 October 1995.

160 Frank Lloyd Wright, "In the Cause of Architecture," *Architectural Record* 23 (March 1908), reprinted in Frederick Gutheim, ed., *In the Cause of Architecture: Frank Lloyd Wright* (New York: Architectural Record, 1975), 56.

161 Searing, *Polshek*, 9.

162 Barry Bergdoll, "Sailor's Delight," *Architecture* 80 (November 1991): 66-73.

of inspiration are Louis Kahn, one of Polshek's mentors when he was studying architecture at Yale in the 1950s. Kahn, according to Polshek, recognized the impact of economy on architecture by giving value to mundane materials, as in the Yale University Art Gallery (1953) (fig. 48). Le Corbusier, James Stirling, and Carlo Scarpa (whose work consists exclusively of additions to existing buildings), and a variety of vernacular building traditions as diverse as Cistercian abbeys and Japanese tea houses have also influenced Polshek's architectural thinking.

Richard Olcott shares Polshek's admiration for such modernist architects as Kahn and Stirling but is especially fond of the minimalist aesthetic and elegant refinement of Mies van der Rohe's steel-and-glass buildings and Kahn's use of concrete. Olcott has also identified Fumiko Maki, the Japanese modernist, as a mentor, admiring the Shinto purity of his spartan, light-filled spaces, open plans, and hard-edged use of modern, industrial materials. In the work of both Polshek and Olcott we sense "God is in the details," as Mies claimed. Almost all of these influences are effectively blended in the new wing for the Stanford Museum yet are so subtly subsumed as to appear entirely personal. Indeed, perhaps because the firm's work so vigorously defies categorization and definition, they have been omitted from most contemporary accounts of modern architecture, including Charles Jencks's "comprehensive" listings.[163]

Polshek's exceptional humanistic perspective has earned him the sobriquet of "citizen architect."[164] He has said that:

> The work of the firm evolves not from a search for style but from a response to context.
> Our commitment to design each project appropriately to fulfill a spectrum of human
> needs remains fundamental. Stylistic labels such as Post-Modern or Neo-Modern do
> not apply to the work we do. Rather, the core of the practice continues to be the quest
> to create a morally and aesthetically responsible architecture.[165]

Polshek has brought an uncommon compassion to the modernists' social creed. His and his associates' architecture is a savory mix of influences and philosophical attitudes, many of which fall outside the conventions of modernism. Binding them is a humanist approach to architectural design. Although modernism advanced a social program, its realization was frequently inhuman, universal in its applications, and more likely than not, coldly objective and utopian. Vilified by postmodernists, who have obscured and stripped its complex history into a few cold, simpleminded myths, modernism continues to evolve myriad variations. Both Polshek and Olcott believe that architecture can both ameliorate social conditions and reinforce positive social values. They argue that style is subservient to perpetuating society's "civilizing ideals." The undeniable social impact of architecture is a fundamental tenet of modernist ideology and perhaps the thesis most central to its fall from grace. Polshek's pluralistic, historically responsive, restorative-minded approach has revitalized this polemic and reminds us that many of the most heroic tenets of modernism can still have beneficial value.

The social basis of Polshek's theories is perhaps best exemplified in his emphasis in architecture on a psychology of "interconnected relationships of anticipation, experience, and memory."[166] Polshek views architecture as a construction of opposites, not only of tectonic

fig. 48
Louis Kahn. Yale University Art Gallery, New Haven. Photograph by the author.

163 Jencks, *New Moderns*. The firm is also absent from the American Institute of Architects's own account of the most significant buildings of the 1980s, *American Architecture of the 1980s* (Washington, D.C.: American Institute of Architects, 1990). Polshek and Partners is also not included in Barbaralee Diamonstein's *Architecture Now II* (New York: Rizzoli, 1985) nor in Paul Heyer's *American Architecture: Ideas and Ideologies in the Late Twentieth Century* (New York: Van Nostrand Reinhold, 1993). These publications further suggest that the era of the star architect is hardly over.

164 Marisa Bartolucci, "Citizen Architect," *Metropolis* (June 1995): 63-79.

165 Searing, *Polshek*, 59.

166 "Precedents and Inspiration," n.p. Polshek makes the same assertion in Searing, *Polshek*, 9.

and aesthetic values, but also public versus private experiences. Indicative of the private or psychological dimension is the personal discovery of architecture. This is a cyclical process: it begins with the anticipation of the architectural experience, where imagination is required, and, after probing the building, resolves with our memory of that experience "reintegrating all that went before—the reinforcement and broadening of the anticipatory impulse."[167] As in the new wing to the Stanford Museum, the circulation routes, the quality of the spaces and their definition, their continuity and fluidity, context, and the integration of the surrounding landscape, among many other elements in the design, all forge a memorable psychological and aesthetic experience of architecture.

THE NEW WING

The firm has created a surprisingly diverse body of work from these guiding premises. In their addition to the Stanford Museum Polshek and Olcott exploit the conventions of museum design elaborated in the older, classical structure. Through various aspects of design and composition, materials, spaces, movement—in essence what the architects identified in their program submission, "Precedents and Inspiration," as the "museum experience from anticipation through memory"—they have established suggestive architectural references to the museum's classical type. Their design explores a complex dialogue of antithetical issues distilled from the older museum's classical symmetry, composition, and massing as well as accessibility, circulation, and integration with its site, among other considerations. The addition offers revelations about both buildings and architecture in general.

Polshek and Olcott conceived their design by attacking the cornerstone of the classical museum, its rigid formality and aloofness. The existing museum offered numerous compatibility challenges to the architects: it is grandly symmetrical, consisting of a projecting central block with wings and pedimented end pavilions; it stands on a high base several feet above grade with little communication with the surrounding landscape or community; it is a massive structure pierced by barred windows and great bronze doors; and at its center is a grand ceremonial entry marked by a colossal order of Ionic columns leading to an elegant, domed, two-story, marble-veneered lobby dominated by a double staircase. Today the typical museum is something more informal, a broadly defined social center, and the classical museum, with its ritual fanfare, is no longer deemed appropriate for a temple of the muses.[168]

Polshek has stated that "while the original building will provide cues for the design of the addition with respect to materials and proportions, compatibility will be a function of extrapolation, interpretation and invention rather than stylistic replication."[169] The architects drew on the historically significant features and limitations of the original museum in their design, creating a dialogue between the two buildings through a dialectic largely of materials and composition. For example, the Stanford Museum was a consciously modern construction

167 Searing, *Polshek*, 9.

168 The Stanford Museum has a distinguishing anomaly. The great museo-temples were built of finer, more costly, and precious materials, such as marble and granite, reflecting an archaeological and handicraft tradition of stereotomy that continued back to ancient times. The reinforced-concrete Stanford Museum, on the other hand, is perhaps more characteristic of Yankee tastes; Jane Stanford noted its fireproof qualities, and Leland Stanford embraced it as the enduring stuff of contemporary progress and civilization.

169 "Precedents and Inspiration," n.p.

in its pioneering use of reinforced concrete. In the firm's original model (since altered as the plan was refined) the architects proposed to use concrete wall segments that both underscored the existing building's material nature and its history as a ruined fragment. (fig. 49). The new wing itself was screened behind light, permeable skins in contrast to the essentially closed, thick concrete walls of the original museum. Interior spaces are memorable for their strong internal logic, continuity, and connection with the outdoors through wall apertures or extensive glazing that either frames vistas or segues into garden courts. A new southern entry provides greater accessibility to the campus without a self-conscious architectural gateway. There is no hierarchical ordering of parts—a central block with flanking wings and end pavilions distinctive of the older museum. Rather, the new wing presents a variety of facades and formal solutions, as in the curvilinear north elevation.

Olcott and Polshek chose materials both for their contrast and compatibility with the existing museum. Concrete, wood, masonry, metal, and glass created a play of distinct aesthetic properties and qualities—durable and fragile, hard and soft, warm and cold—amplifying the contrast between the classical building's austere reinforced-concrete construction (made to look like masonry) and the cool, gray marble-lined interior of the main lobby. Polshek maintains that in design such juxtapositions reinforce and enhance the character of each material. Mies's minimalist architecture was an aesthetic language of stunning material opposition, such as marble and chromium-plated steel. Polshek also cites the precedent of the Italian architect Carlo Scarpa, who combined both mundane and fine materials as a way of seamlessly weaving his buildings into the very fabric of the city itself; Japanese architecture also was influential (Polshek has spent years in Japan); and both Kahn and Le Corbusier practiced this method of enriching the ordinary in their architecture.

AN ARCHITECTURE OF FRAGMENTS

The new wing reverberates with allusions to the past, present, and future through architectural references to things lost, preserved, or uncovered. Richard Olcott tells a wonderful story of his first visit to the site on a typically brilliant, hot California day. Coming on the ruined building from its main approach along Museum Way, he noted the debris of the original roof balustrade heaped in piles in front of the museum. The scene might have been transported from the Mediterranean or Piranesi. Olcott was even prompted to compare it with the Acropolis. Unwittingly or not, his analogy underscores the deep archaeological tenor of the program and its associations with ancient Greece, stemming initially from Leland Stanford Jr.'s interest in antiquities and, therefore, closing a historical and evolutionary circle. Olcott's observation establishes a physical and intellectual bridge between the existing building and its addition. The new wing, according to Olcott, also resonates with the ruins of the 1906 museum: excavation of the site during the construction turned up the old foundations of its demolished wings, elevating the project, the site, and the act of rebuilding and restoration to an archaeological dimension.

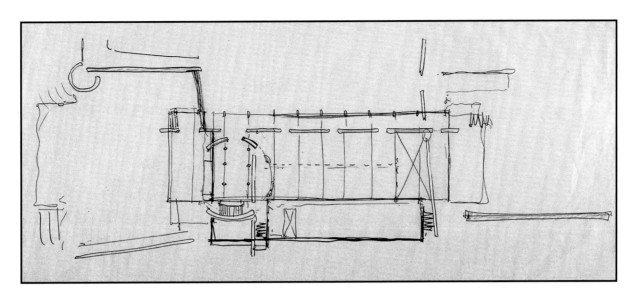

fig. 49
Polshek and Partners.
Wall segments, 1994.
Ink on tracing paper.

Moreover, Olcott's perception of the site was deeply affected by his appreciation for Kahn, who conceived of "wrapping ruins around buildings." The museum's wing is literally located within the ruined 1906 footprint and surrounded by the remnants of that extensive structure—the anatomy building to the west, the existing museum to the east, and the Rodin Sculpture Garden to the south, which occupies the foundations of one of the collapsed 1906 wings. The spatial and formal qualities of Kahn's architecture were universal rather than specific, like a ruin, he said, that "is again free of the bondage of use." His buildings are contemporary ruins refined into powerful spatial and geometric fragments. The Yale University Art Gallery, for example, has, in direct elevation, the appearance of a solid block of masonry, but from an oblique view reveals two parallel wall sections or fragments, their interstice filled by the glazed entry, an intimation of the glazed wall of the side elevation (Polshek notes that this wall of fixed glass played havoc with the building's climate control and was not practically successful). Kahn's architecture distilled from ruins the contrasts between mass and volume, the complete and the fragmentary, and prompted design choices in the Stanford museum's wing.

But whereas Kahn's statement about wrapping buildings in ruins was metaphorical, Polshek and Olcott were able to work with actual ruins. Olcott identified the firm's addition as a composition of fragments, and Seligman characterized the new wing as personal spaces (i.e., cafe, curators' rooms, seminar rooms, etc.) wrapped around neutral spaces (i.e., galleries). In the original model and drawings freestanding concrete wall panels not only partitioned distinct functional and spatial areas but consciously paid homage to Ransome's pioneering reinforced-concrete museum. The modern-day "ruin" consisted of segments of concrete slabs separated by glass walls offering views outdoors and open volumes, rather than closed boxes, pierced at their corners by entries or windows and illuminated from above by skylights (although this was not achieved to the extent originally envisioned). Walls pass by each other and define circulation, creating a flexibility lacking in the original structure.

Polshek and Olcott deliberately dismembered the conventional boxed room distinctive of the older building by eliminating corners and pulling the walls apart to create freestanding spatial planes rather than load-bearing supports. Such design strategies are reminiscent of Kahn as well as the open architectural plans of Frank Lloyd Wright and Mies. The permeability of the new wing is evident in the Kahn-like detailing of the modern garden court between the two buildings (fig. 50): like a palimpsest of emerging architectural ruins, marble strips are exposed in the concrete-paved courtyard passing under the window wall of the new wing, making the garden and the indoor gallery continuous.[170] This detail suggests the archaeological layering of the historical traditions embedded in the site and the building and admirably continued in the new wing. Initially a pool at the head of the court, channeled off to the sides, suggested both the meditative spirit of the Alhambra in Spain and Kahn's Salk Medical Research Center, La Jolla, where water serves a restorative, transcendent role under the brilliant sun. The architects, therefore, eradicate the idea of the museum as a closely guarded and hermetic storehouse or treasure trove. Such a reinterpretation of the older building, according to Polshek, was both an implicit and poetic response to the program.

THE DESIGN EVOLUTION

The preliminary designs for the new wing explored possible connections and associations between the two buildings through circulation routes, siting, and formal and spatial relationships. Olcott conceived several schemes before arriving at the competition design. In an early study the addition was organized around an open courtyard, or cortile, located behind the center of the existing building. A row of tall palms screening the existing museum along the west elevation lent the precinct a Mediterranean feel (fig. 51), one of the guiding principles from the outset. Olcott joined a series of buildings around the cortile by continuous circulation routes leading from the south rotunda and a new structure replacing that to the north (at this time it was thought that the north rotunda at least would be demolished). He studied ways of reestablishing the connection from this end. He adopted a sinuous curving wall and terrace leading from the older building to a new L-shaped block and the cortile. The curve was somewhat reminiscent of Isozaki's "Marilyn Monroe" silhouette at the Los Angeles Museum of Contemporary Art or possibly even that at the Neues Staattsgalerie in Stuttgart by James Stirling, In any event the plan fixed the area immediately behind the central portion of the old museum building as the pivotal node of the new design and underscored the difficult process of defining an elevation accessible from the north, where a new sculpture garden was to be sited.

Olcott continued to develop the courtyard scheme as the public hub of the new wing. In a number of drawings, cubes, rectangles, and an ellipse danced around the central courtyard as Olcott worked out access and circulation routes. The courtyard variously served as an outdoor sculpture garden (fig. 52), an open court with a perimeter staircase (fig. 53), and even a quadrangle (fig. 54). This last study developed an ambitiously large, skewed, elliptical drum set at one corner of a quadrangular composition. The blocky gallery outside the center of the quad opposite the museum offered a sharp, formal contrast and suggests Olcott's penchant for working with opposing elements. Other studies developed the north elevation and its relationship to the

170 Polshek told the author that he had in mind Kahn's National Assembly Building in Bangladesh, constructed between 1962 and 1983, where marble strips were embedded in the building's concrete walls (Interview with the author, 10 December 1997).

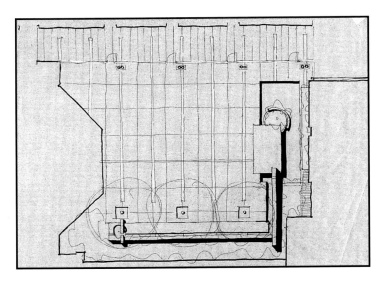

fig. 50
Polshek and Partners.
Marble strips between the inner garden court
and new wing, 1994.
Ink on tracing paper.

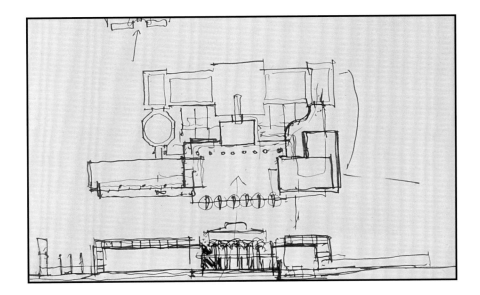

fig. 51
Polshek and Partners.
Preliminary study of the west elevation, 1994.
Ink on tracing paper.

fig. 52
Polshek and Partners.
Preliminary plan for new wing, 1994.
Ink on tracing paper.

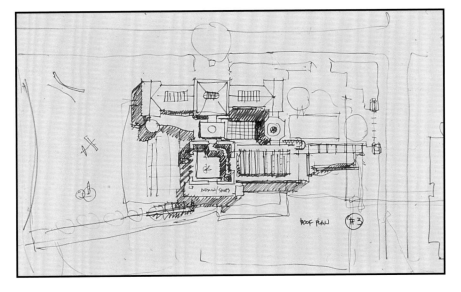

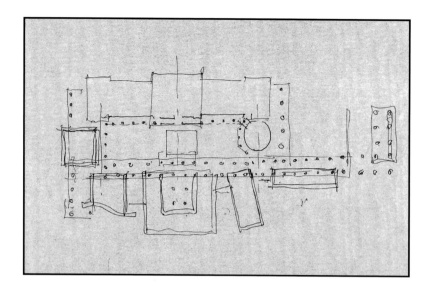

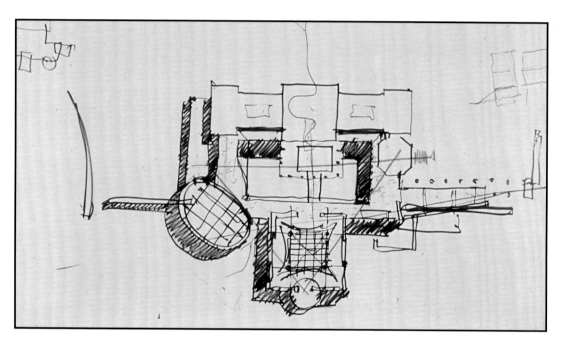

fig. 53 top
Polshek and Partners.
Open court, 1994.
Ink on tracing paper.

fig. 54 left
Polshek and Partners.
Proposed quadrangle, 1994.
Ink on tracing paper.

fig. 55 bottom
Polshek and Partners.
North elevation with tower replacing the octagon, 1994.
Ink on tracing paper.

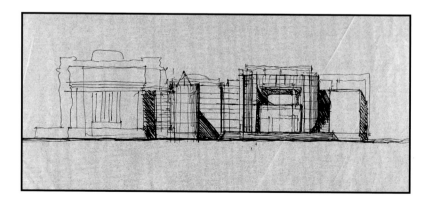

proposed outdoor sculpture garden. Several of the drawings (figs. 51-52, 55) presented a curving terrace with a circular tower standing at the end of it, balancing the remaining rotunda to the south. Circulation routes were extended from the rotundas to enclose the courtyard behind the existing museum. In the competition design the courtyard and gallery forms were merged and a less self-conscious entrance from the north was established by a broad expanse of stairs.

As the design evolved, the gallery and courtyard became a more tightly conceived unit (fig. 56). A circular, two-story drum replaced the open courtyard, becoming a defining ingredient in the present building and giving the north elevation a strongly sculptural quality. The drum lent a formal prominence and interest to that vital juncture between the main entry axis leading from the lobby of the older museum through to the rotunda of the anatomy building. The overall plan was also significant because the full extent of the original museum's 1906 foundations were represented, emerging ghostlike around the new wing and intimating at its historical underpinnings. Excavations for the new building as well as general site work, uncovered the foundations of the long-vanished museum, reinforcing a union of the past, present, and future through a layering of what once was and what will be.

The new rotunda is the predominant formal element of the wing. The large, two-story cylinder, containing the special-programs room on its lower floor with an outdoor sculpture terrace above (figs. 57-60) is cut open to offer views of an evolving sculpture garden to the north, and an area where further expansion might take place (figs. 61-62). (In preliminary drawings for the new wing the cylinder was larger and even more dominant.) It resonates with the rotundas of the older museum, which were regarded by the architects as symptomatic of the problems with the original building: their closed, pure form isolated them like freestanding pieces of abstract sculpture—precisely the characteristic they wished to avoid in the addition. The addition's fragmented cylinder, opening to the landscape, challenges the severe inward turning formality of the classical museum and ultimately reflects a different attitude toward the museological experience.

The rotundas are critical nodes in the design and serve as bridges between the old and the new; the south rotunda is the new lobby entered from the Rodin Sculpture Garden, while the drum of the wing represents a fresh social hub. The north rotunda, however, posed special problems for all the architects. It stands as an independent form on the edge of the future garden to the north and could only be marginally incorporated within the overall composition as an effective element. Polshek and Olcott planned to extend a terrace from the new wing to link the rotunda to the addition's north entry, though this was later eliminated (figs. 53, 56).[171]

The circular form has a life within museological history independent of the project. The rotunda can be found at the heart of one of the earliest of the great classical museum buildings, the Altes Museum in Berlin (fig. 63). Olcott and Polshek both affirm that the circular gallery in the Altes Museum was a source of inspiration. Friedrich Schinkel himself adopted the form from one of the most popular ancient monuments, the Pantheon in Rome, which enshrined statues of Roman deities. Schinkel seems to have appropriated that reference for his own building, referring to his rotunda as "the sanctuary."[172] In any event it served as both a gallery for painting

171 Early on in the competition there were discussions about preserving yet another rotunda, that of the old anatomy building (the westernmost wing of the original full-grown museum), which might serve as a visitor's center (as in Turnbull's design).

172 Nicholas Pevsner, *History of Building Types* (Princeton, N.J.: Princeton University Press, 1976), 127.

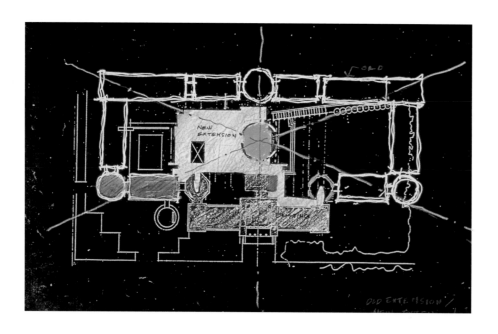

fig. 56 top
Polshek and Partners.
Preliminary plan, materials unknown, 1994.

fig. 57 right
Polshek and Partners.
Study for the drum, 1994. Ink on tracing paper.

fig. 58 bottom
Polshek and Partners.
Axonometric drawing of drum, 1994.
Ink on tracing paper.

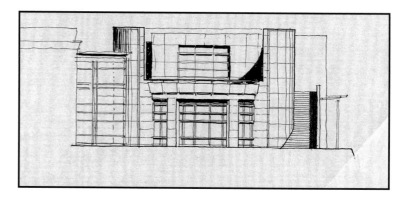

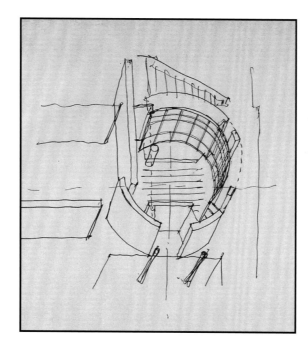

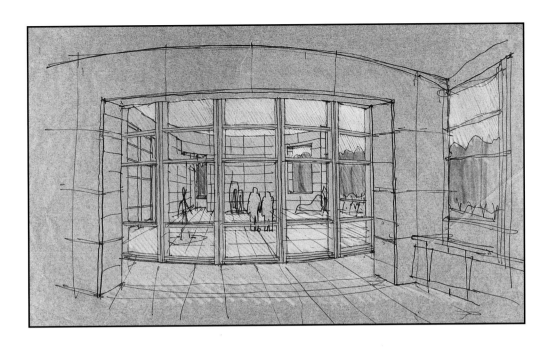

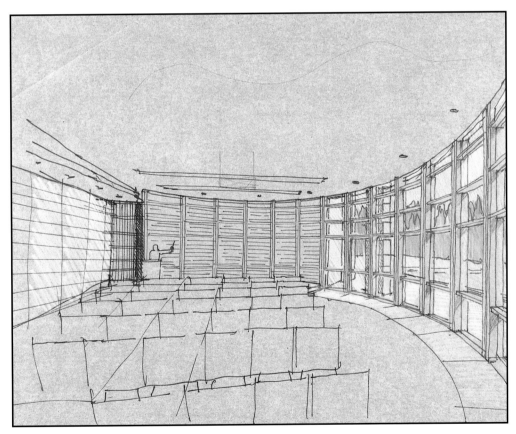

fig. 59 top
Polshek and Partners.
View through the outdoor sculpture terrace. 1994.
Ink on tracing paper.

fig. 60 bottom
Polshek and Partners.
View through the special-programs room, 1994.
Ink on tracing paper.

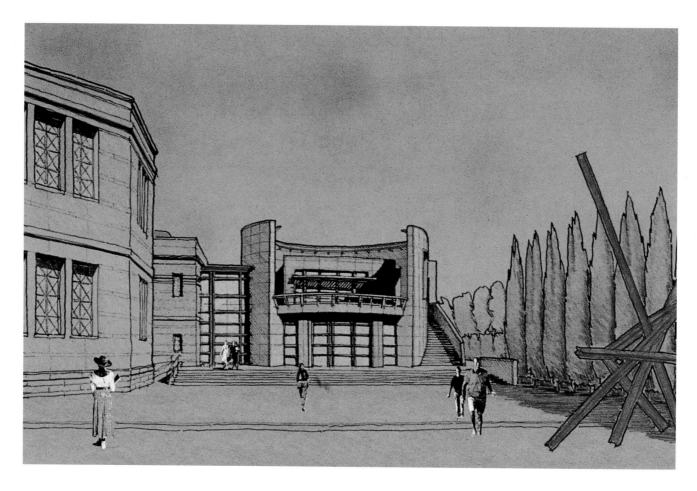

fig. 61 top
Polshek and Partners.
View of the drum along north elevation, 1994.
Storyboard.

fig. 62 bottom
Polshek and Partners.
Plan of the new wing showing extensive garden to north, 1994.
Storyboard.

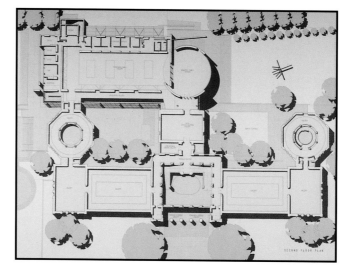

and sculpture, though at Stanford only the upper story is used as an outdoor sculpture terrace. The powerful centrality of Schinkel's design was a paradigm for many subsequent American museums, including the National Gallery of Art (1941) in Washington, D.C., by John Russell Pope, and possibly even Frank Lloyd Wright's Solomon R. Guggenheim Museum (1959) in New York.

The building that popularized the open rotunda and was cited by the Polshek and Olcott as an important influence was James Stirling's Neues Staatsgalerie (1985) in Stuttgart (fig. 64). Lined around its circumference with vegetation, evoking a Piranesian fantasy, the Staatsgalerie's rotunda is a ruined version of that of the Altes Museum, though Stirling, by adding a mock ruined classical temple within the precinct of the rotunda itself, seemed to comment further on the raison d'être of the museum as a collection of cultural and historical fragments, even endeavoring to suggest the progression of time through a spiral ramp that climbs along the perimeter of the rotunda. Olcott apparently borrowed this parti in one preliminary study (fig. 65).[173] The drum, as finally conceived in the wing of the Stanford museum, juxtaposes both an open and closed form. Above, on the second floor, it is an enveloping arc opening onto an outdoor sculpture terrace and the twenty-first-century sculpture garden beyond. Below, it is a lightly screened-in special-programs room, entered on axis, as is the sculpture terrace above, off the main entry of the existing museum.

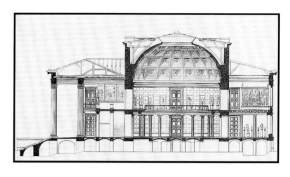

fig. 63
Karl Frederick Schinkel, Altes Museum, Berlin. 1823.
Cross section showing the central rotunda. From K.F. Schinkel.
Sammlung architectonisher Entrwürfe, 1819-1840,
reprinted in *K. F. Schinkel: Collected Architectural Drawings.*
New York: St. Martin's Press, 1982, plate 40.

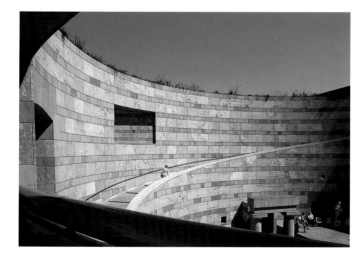

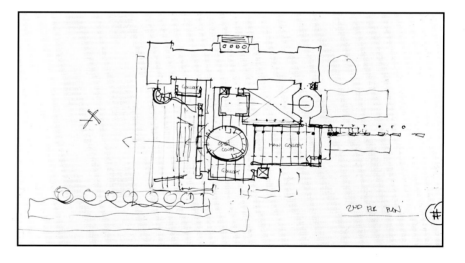

fig. 64 above left
James Stirling.
Neues Staatsgalerie, Stuttgart.
Photograph by Ezra Stoller/ESTO.

fig. 65 above right
Polshek and Partners.
Preliminary plan showing central drum with
perimeter staircase, 1994.
Ink on tracing paper.

173 Polshek cites Stirling's Staatsgalerie as an influence and was impressed by Stirling's contextual efforts, particularly the bridges he forged with the existing building, and the new building's integration with nature. Polshek admired the formal aspects of Stirling's addition as well as the architect's expression of technology and bold color. Stirling's addition plays on the Romantic aspects of architecture, according to Polshek (Interview with the author, 10 December 1997).

Challenging the plenary design of the older museum, the addition seems to segue into the wilderness prospect to the north and the Rodin Sculpture Garden to the south, effectively achieving the informal, inclusive plan Seligman outlined in the competition program. An early perspective drawing (fig. 66) of the south elevation, prepared for the competition committee presentation, reveals the interpenetrating spatial quality of the addition with its thin, planar walls seeming to slide through each, implying the building's edges and defying any sense of its finality. Where the walls intersect, glazed, louvered screen walls (originally intended to be of teak and glass) fill the void, making a strong contrast to the massive, almost blank forms of the old classical museum from this angle. At one point the architects planned a further contrasting element along this front, a two-story curvilinear, glazed tower (fig. 67). The most distinctive detail of these studies was the curving wall that sliced through the wing behind the cafe and glazed tower to emerge in front of the south rotunda, forming a new entry portal.

This freestanding curving wall, or symbolic portal, was perhaps a further homage to the architectural fragment. The concept of a welcoming gateway is similar to the entry portal of Richard Meier's High Museum of Art in Atlanta (1980), though the freestanding screen wall has become a postmodern cliché. This sweeping gesture represented a stronger architectural intervention toward the south than was required and was out of character with the practical elegance of the rest of the building. Polshek initially felt that such an identifying portal was needed along this front, one that contrasted with and concealed the existing older structure. At the same time the curving wall added a dynamic spatial element that reflected and enhanced the transition and movement of people from one area to another.

The curving portal was not well received by either Seligman or Caspar, however, and the superfluous wall was eliminated.[174] The south front as it now exists is more subdued as a permeable "portal" (fig. 68) and offers a more modest and accessible entry from the campus. The resulting facade is an imperceptible screen linking the old and the new. As a way of drawing visitors into the precinct of the museum without the onerous intent of "going to a museum," as Olcott put it, the architects blurred the boundaries between outdoor and indoor areas (unlike the hermetic environment of the older museum building).[175] They contended with the older museum's high elevation by screening a gently sloping ramp off to one side of the garden. (In addition to providing a required access ramp for the handicapped, it originally reinforced a diagonal line of trees bordering an access road along the back of the museum, but this has yet to be realized.)

Less perceptible correspondences between the buildings exist. Mathematical relationships subtly harmonize the museum and its addition. Olcott was surprised to discover that the museum and its rotundas, although constructed at different times by different architects, were proportionally alike. He employed a method of regulating lines (fig. 69) to scale the addition to the dimensions of the older building. A drawing of this study suggests that he adopted the

174 This motif, however, was not unique to the Stanford project. Polshek and Todd Schliemonn, the principal designer, used it previously as a dynamic compositional element in the suspended curving wall segment in their Yerba Buena Center for the Arts Theater (1992) in San Francisco and more substantially, with Susan Rodriguez, in the Banana Kelly Community Learning Center project (1994) for the Bronx as a large, curving yellow wall (the banana) bisecting the plan. The recurrence of such formal devices demonstrates that even Polshek occasionally adapts a favorite element for different functional reasons or dramatic effect when they offer a creative solution.

175 Olcott, interview with the author, 10 December 1997.

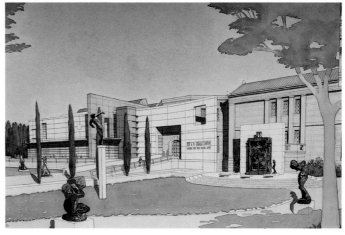

fig. 66 above
Polshek and Partners. Perspective drawing of the south elevation, 1994. Storyboard.

fig. 67 left
Polshek and Partners. South elevation with a glazed stair tower to one side, 1994. Ink on tracing paper.

fig. 68 below
Polshek and Partners. South elevation, 1995. Storyboard.

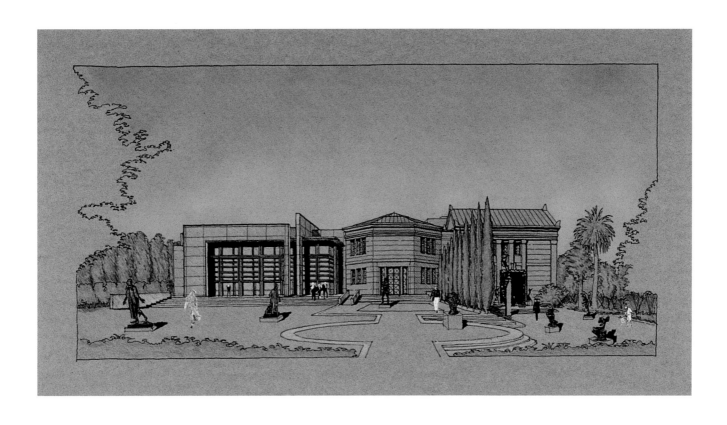

fig. 69 top
Polshek and Partners. Regulating lines, 1995.
CAD image.

ancient Greek method of the Golden Section. Although Olcott says he did not use the Golden Section, it does recall Le Corbusier's use of regulating lines in his architecture. In any event, the proportioning device ensures both a visually and psychologically integrated composition of parts. Even the dimension of the windows is governed by this mathematical ordering device. More obvious correspondences occur between floor levels, cornice lines, and string courses that are all carried over into the new wing (FEMA also urged such connections).

Seligman believes that one of the strengths of the new wing is its siting around and accessibility to garden and sculpture courtyards. The sculpture courtyard (figs. 70-71) between the two buildings as well as the sculpture gardens to the north and south, are transitional areas between the two buildings that help weave them into a unified compositional fabric, softening the edges of the museum precinct itself along the fringes of Olmsted's arboretum to the north and east. Garden courts offer soothing natural contrasts to the wing's interior spaces. The louvered, membranelike walls wrap round the building, opening it to the surrounding sculpture gardens and arboretum and blurring the distinction between indoor and outdoor galleries. The inner court's light and greenery and the marble strips that line its pavement and pass under the window wall of the addition (figs. 50, 72) entice visitors to circulate indiscriminately through sheltered and unsheltered spaces.

The garden courts exploit California's largely climate and reinforce the feeling of unimpeded circulation through the museum and its grounds. The cafe's fully glazed south wall offers a panorama of the Rodin Sculpture Garden, the campus behind it, and farther away, the drama of the sky and the foothills. The curving glass wall of the special-programs room invites light and views within, while the shifting qualities of the landscape are an integral effect of the gallery above, glimpsed through the opening between the drum's wall segments and the outdoor sculpture terrace (fig. 73). Nature's moods are further caught along the building's sun-catching louvers and glass walls lining many of the corridors feeding the galleries, defying the passivity of the older museum. The architects acknowledge a debt to Olmsted's landscaping, which was designed to take advantage of a Mediterranean-like setting. In fact, we might apply Olmsted's analogy between his New York Central Park and the "lungs" of the city to the garden courts of the museum. Their inclusion exemplifies the expansiveness of the new social vision of the museum to Stanford and its surrounding communities.

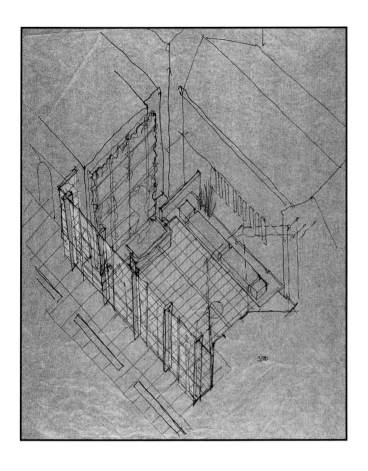

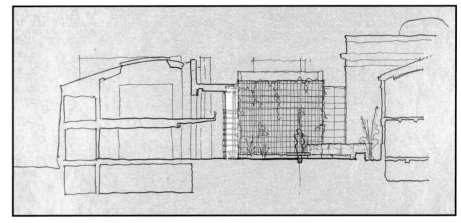

fig. 70 above left
Polshek and Partners.
Axonometric of the inner sculpture court, 1995.
Ink on tracing paper.

fig. 71 above right
Polshek and Partners.
Transverse section through the inner sculpture court, 1995.
Ink on tracing paper.

fig. 72 right
Polshek and Partners.
Perspective view from inner court to new wing, 1995.
Ink on paper.

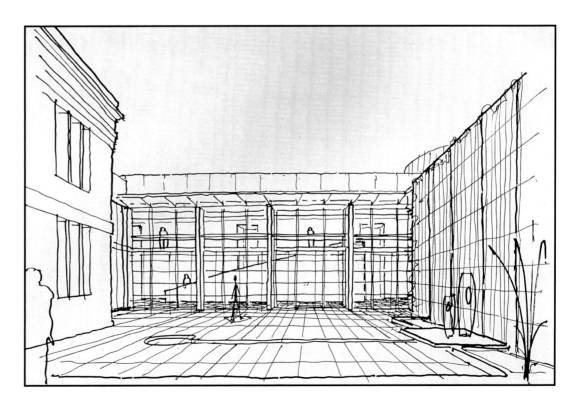

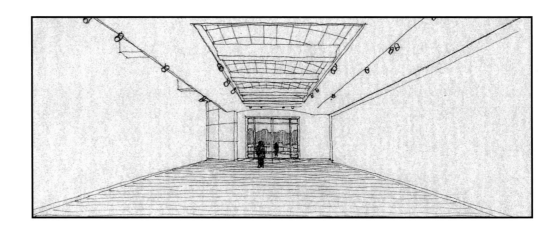

fig. 73 top
Polshek and Partners. View through new second floor gallery, 1995. Ink on paper.

fig. 74 a-c
Polshek and Partners. Studies for gallery skylights and roof monitors, 1994. Ink on paper.

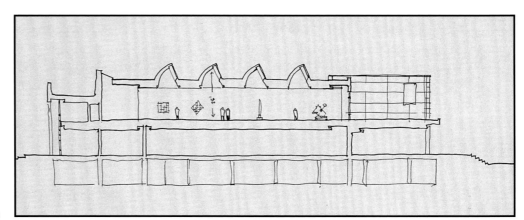

a

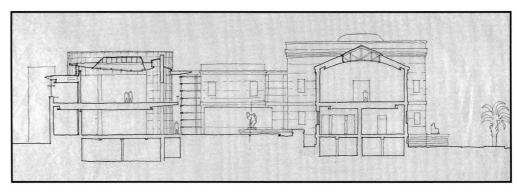

b

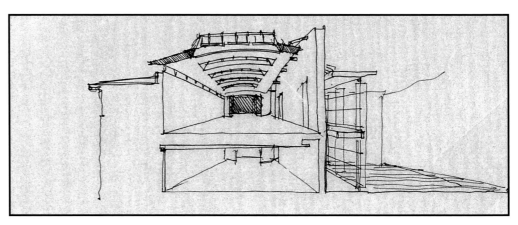

c

The wing consists of a variety of contrasting types of spaces that are a significant part of the allure of the new building. Like the special-programs room and outdoor sculpture terrace, they eschew the uniformity and the closed, boxy feeling that characterized the old museum. Indeed, Seligman refers to the first-floor galleries in the old museum as bowling alleys. Olcott said that his purpose was to create "beautiful, contemplative spaces," animated by such intangible elements as light washing down walls from above, continually refreshing the spaces within, or entering through apertures between walls, permitting views out of the galleries.

Olcott developed a variety of methods to bring light into the galleries through roof monitors (figs. 74 a–c). Kahn's influence is once again felt in some of the studies, recalling his Kimbell Art Museum (1972) in Fort Worth, Texas, with its curved, translucent deflectors suspended from vaulted ceilings. Each method of illuminating the galleries with natural light resulted in a different roof silhouette, which animated the external form of the museum from different perspectives (figs. 75-76). In fact, the light monitor became a sculptural object on the skyline, in one instance resembling a cooling tower (fig. 76), faintly reminiscent of Le Corbusier's light tower in the Assembly Building (1962) at Chandigarh, India. The light monitors provided a lively contrast with their curved hoods to the regular, unbroken roofline of the older museum (the skylights over the second-floor galleries are concealed behind the roof parapet). Unfortunately, the budget did not permit their realization, and track lighting was adopted in their stead.[176] This loss as well as that of the reinforced-concrete frame and concrete walls (a steel frame and stucco walls have been substituted), was less a significant blow to the aesthetic quality of the building than it was to its intellectual integrity and relation to the original museum.

Circulation routes effect a social spine through the museum buildings. How the museum reveals itself to the visitor was critical to the architects. According to Polshek, circulation stimulates "anticipation" and reinforces "memory" of the building and the art within its walls. Many of the early drawings for the museum were studies of potential routes linking the two buildings. The architects developed open-ended pathways that wove together a plan articulated by freestanding wall segments, working on the premise that the "things in space" are inseparable from the space itself.[177] Between the two buildings several levels of circulation of both a symbolic and prosaic nature were devised: a ceremonial route originating at the main lobby of the existing museum and passing through the Stanford family gallery immediately behind the lobby; two routes from the south, both passing through the Rodin Sculpture Garden and leading either to the cafe and bookstore and the first floor of the new wing or to the new reception area in the south rotunda; and a service route along the rear of the new wing, where the loading dock and administrative offices are located. The routes also had to satisfy the needs of security, conflicting public and curatorial uses of the spaces at various times, tours, and random visitors. Olcott looped the circulation spine through the two buildings, linking the addition by way of the south rotunda and the second floor of the main lobby, opening up the museum's dead-end galleries to the south. The distinct components of the two museum buildings become a single, cyclical, kinaesthetic experience.

The active, continually changing experiences of anticipation and memory forged by the circulation routes supersede, or complement, the static function of the old museum as a memorial. The memory of the museum in toto is constantly renewed as one moves from building

176 The purity and sanctity of the gallery spaces also required laborious detailing to conceal or make unobtrusive such functionally mundane fixtures as wall switches and plates, emergency and exit signs, sprinkler heads, and conduits for track lighting. At this level of minutia the design became an increasingly collaborative process, revolving around building codes and other state and federal regulations and involving project managers and university architects, museum curators and staff, the various contractors, the fire marshall, as well as the director and the principal architect.

177 Polshek, interview with the author, 26 October 1995.

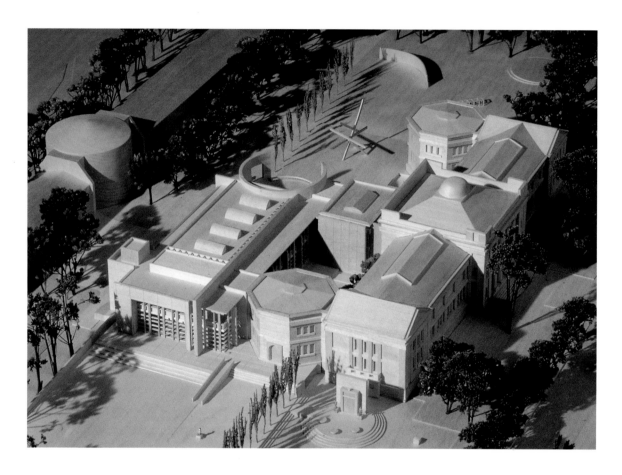

fig. 75 above
Polshek and Partners.
Model with roof monitors, 1995. Museum Archives.

fig. 76 right
Polshek and Partners.
South elevation, 1994. Ink on tracing paper.

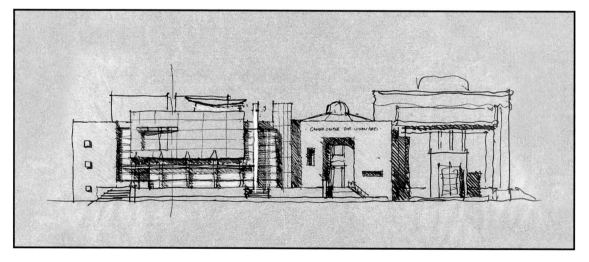

to building, space to space, or revisits spaces and experiences. Moreover, a human dimension is implied by the architects' creation of a social spine that elicits personal memory within a public institution. In contrast, the original museum bordered on a private memorial; memory was passive and static, reflected even in Jane Stanford's request that her arrangement of her son's memorabilia not be altered. Today's museum gives new life and purpose to the memory of the Stanfords and their collections.

The building as constructed is in many ways superior to the original competition model.[178] Less busy overall, it reflects a fruitful partnership and collaboration between the architects and the museum's director. Seligman said that he was looking for architects who were comfortable with his revising their drawings, and from the outset Polshek and Olcott were open to the needs and criticisms of their client. Indeed, they have given much credit to Seligman's direct involvement in and critique of every phase of the project, from its design, construction, and landscaping to the minutiae of its detail. This building history demonstrates that the successful museum today is rarely the product of a single mind or idea but is the synthesis of many partnerships. Although fraught with budgetary constraints and demanding functional considerations, the new wing is aesthetically inspiring and rewards continued study.

178 The museum's wing was constructed by Rudolph & Sletten.

CONCLUSION

THE IRIS & B. GERALD CANTOR CENTER FOR VISUAL ARTS AT STANFORD UNIVERSITY

In 1982 Helen Searing perceptively noted a trend in American museums (and it could have included those in Europe as well) toward buildings singular in style, a trend that has become commonplace since then.[179] The paramount consideration during this period has been a growing awareness of the museum's original isolation from its social context, and an effort to redress that imbalance has propelled museum design into one of the most vigorous and widely perceived arenas of architectural design. We have only to think of Meier's High Museum or his more recent Getty Center, Frank Gehry's Guggenheim Museum Bilbao, Arata Isozaki's Museum of Contemporary Art, James Stirling's Neues Staatsgalerie, and more locally, Mario Botta's San Francisco Museum of Modern Art to discover the museum's bewildering diversity. They have become popularly spectacular centers of social activity and, some would say, social construction, often eliciting comparisons to theme parks and shopping malls. Be that as it may, they demonstrate that art—and its architectural jacket—has moved closer to the center of public life, hopefully promoting deeper reflection on a broad range of social and historical issues and their cultural contexts.

The history of the university museum at Stanford, as told in this essay and accompanying exhibition, reflects the development of American museum design, from its late nineteenth-century penchant for classical types to the current fascination with individual architectural expression, an amplification of institutional identity partly driven by the changing demands of the art world, education, and competitive marketing strategies promoting augmented social programs. The museum speaks to its principles and aspirations, which are indelibly impressed in the plan. The fabric that houses those ideals is very much a statement of an institution's beliefs. At Stanford, Polshek and Partners have realized that challenge in an engaging addition that resonates strongly with the university's rich history and prepares a solid foundation for the museum's future.

Philip Johnson once wryly remarked that "museums have taken the place of churches in our culture."[180] The contemporary art museum and increasingly the university art museum is a social place that seeks to draw people to it. The expanded museum at Stanford makes strong connections with the university and the surrounding community through the continuity of traditions (i.e., memorial) and through architectural integration with the campus; the courtyards, galleries, and ancillary public areas represent a blueprint for effective social relations; and the open-ended circulation routes reinforce ideals of mobility and accessibility to cultural knowledge. Polshek and Olcott have achieved "memorable" and socially responsible spaces.

The restoration, the design, and the building process, however, have also brought forth some harsh and doubtless controversial realities (figs. 77–78). The university was founded in memory of Leland Stanford Jr. by his parents, and the museum was the other of two significant monuments they erected to commemorate his life, its achievements, and lost promise. When the museum reopens in 1999, it will no longer officially bear homage to the memory of a youth who

179 Helen Searing, *New American Art Museums,* exhibition catalogue (New York: Whitney Museum of American Art, in association with the University of California Press, Berkeley, 1982), 75-76.

180 Douglas Davis, *The Museum Transformed: Design and Culture in the Post-Pompidou Age* (New York: Abbeville Press, 1990), 196.

spawned such a fertile legacy. Rather, it will assume the name of significant donors and patrons of the arts with a long and generous connection to the museum and the art department, being rechristened the Iris & B. Gerald Cantor Center for Visual Arts at Stanford University. Nevertheless, there remains a history that cannot be erased in name, and indeed, is guaranteed by a vital, physical presence.

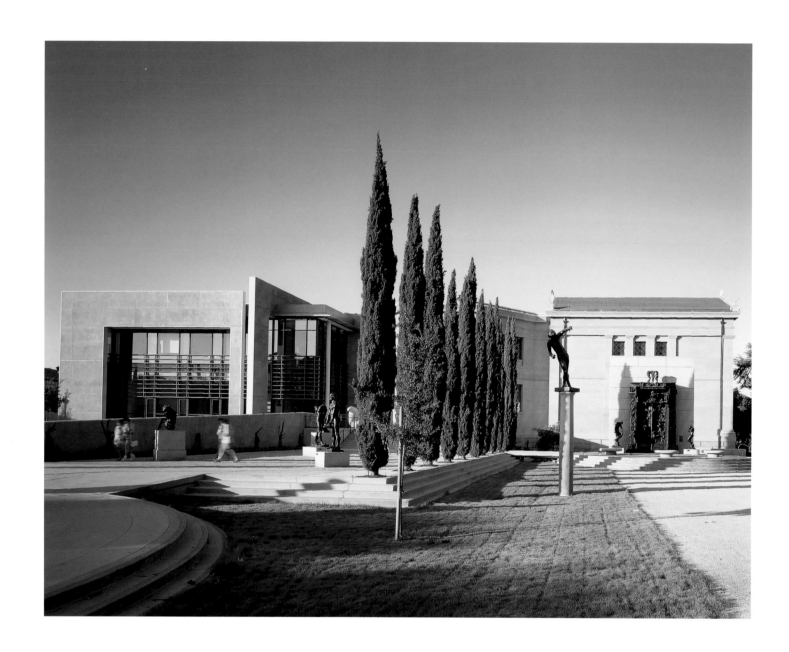

fig. 77
Polshek and Partners.
South elevation of the Iris & B. Gerald Cantor Center
for Visual Arts, 1998.
Photograph by Richard Barnes.

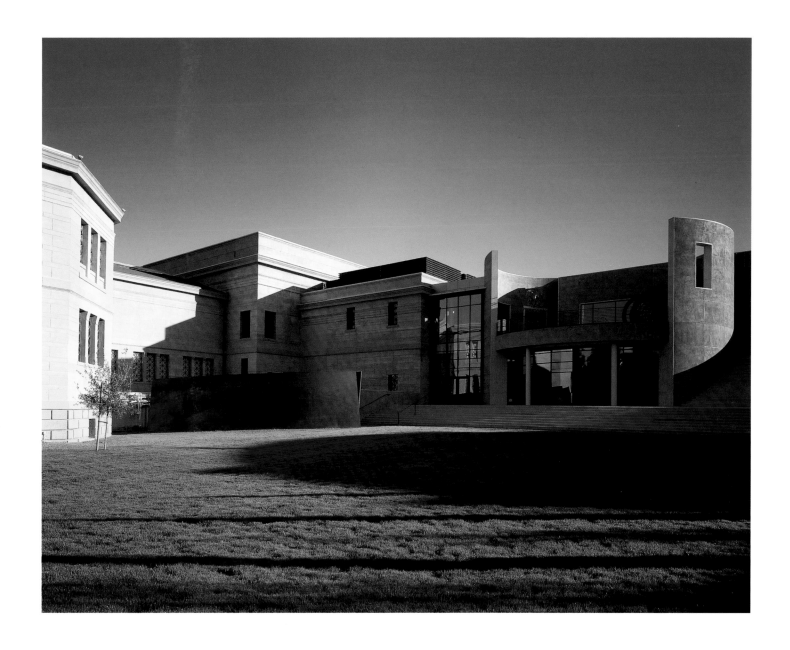

fig. 78
Polshek and Partners.
North elevation of the Iris & B. Gerald Cantor Center
for Visual Arts, 1998.
Photograph by Richard Barnes.

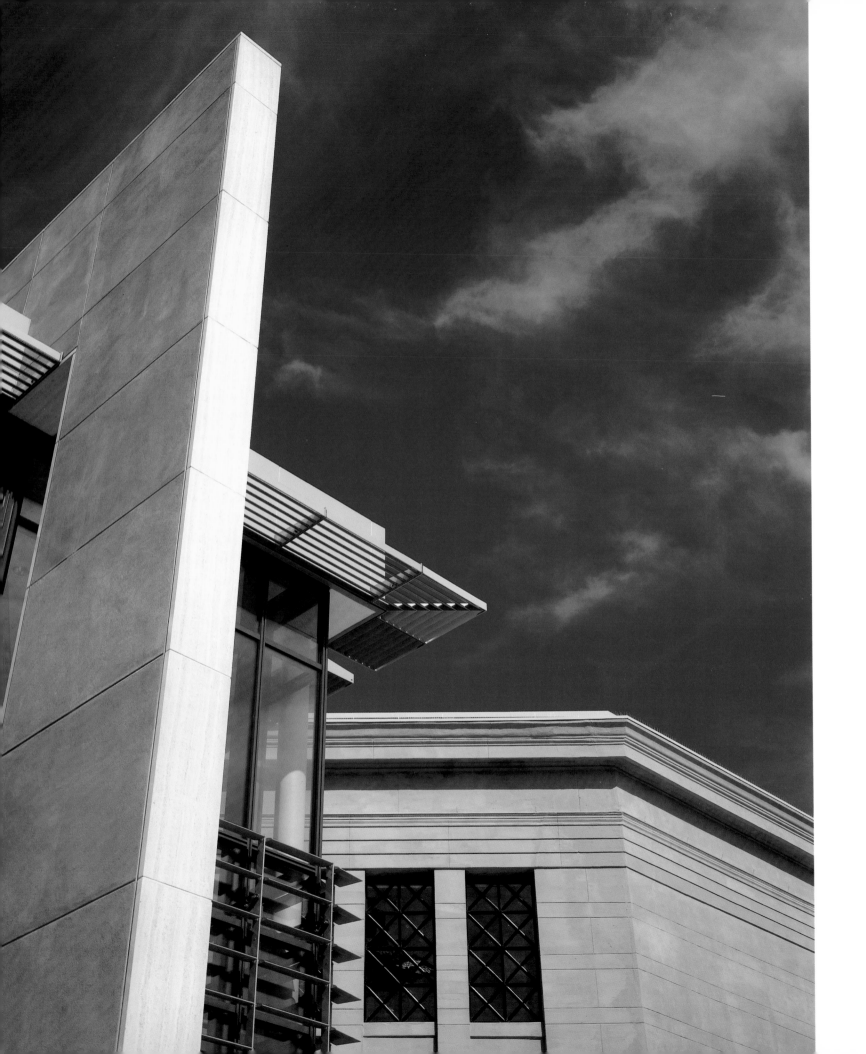

Architectural Portfolio

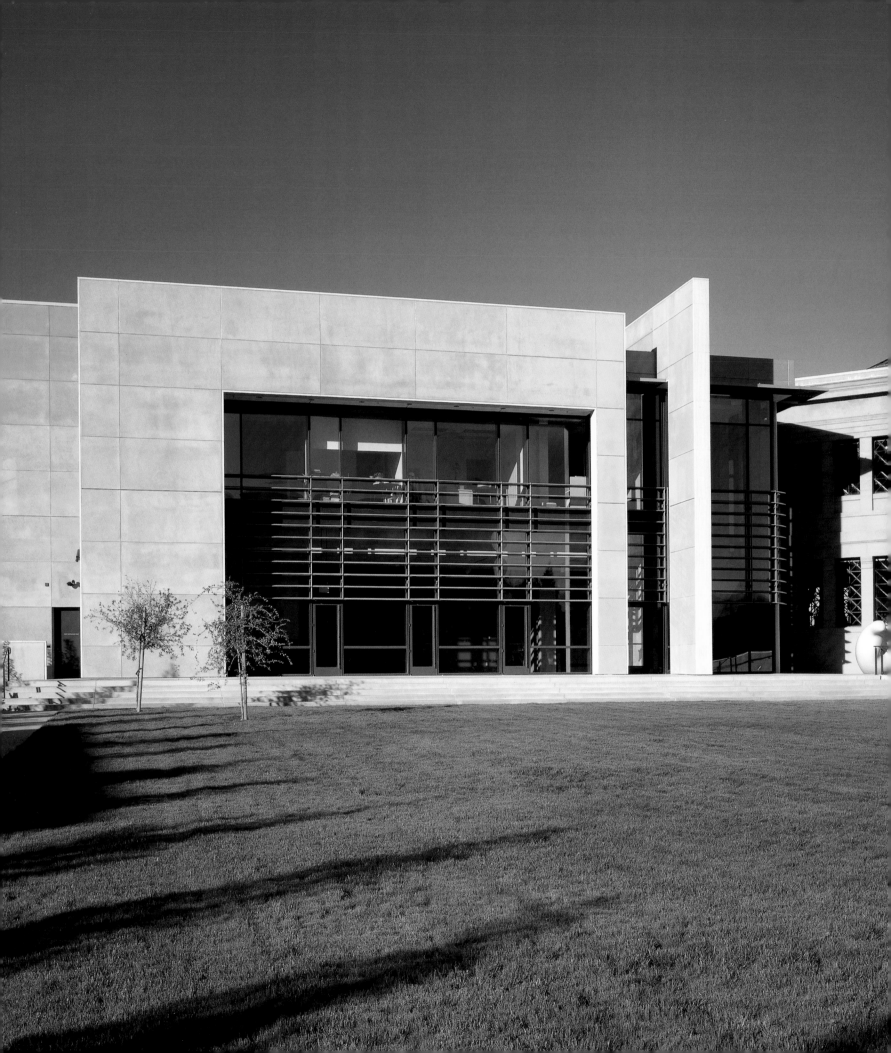

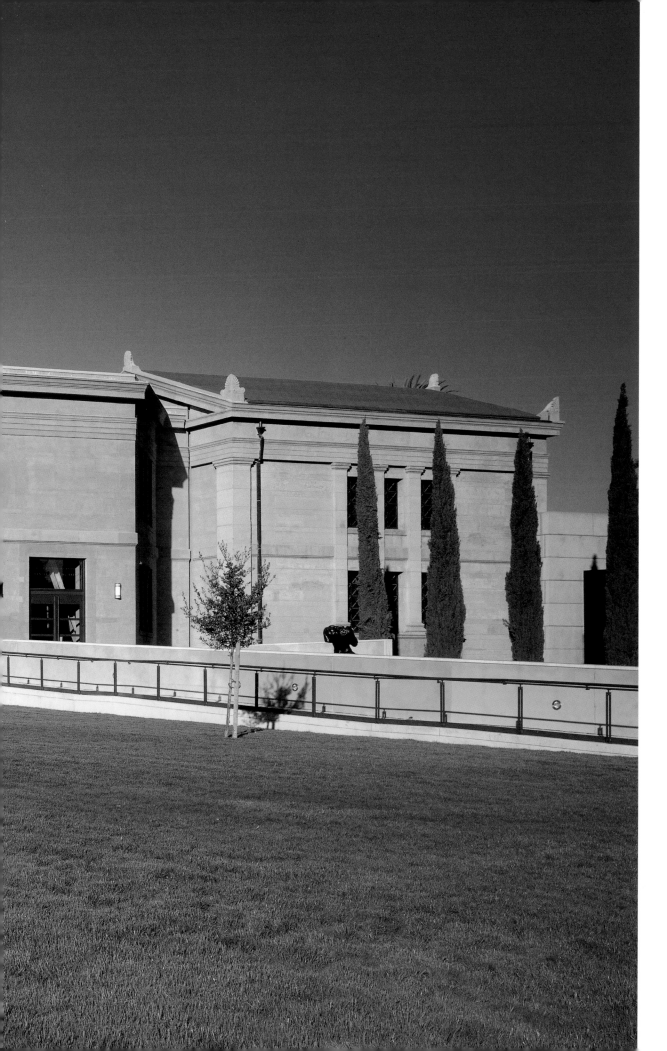

South elevation

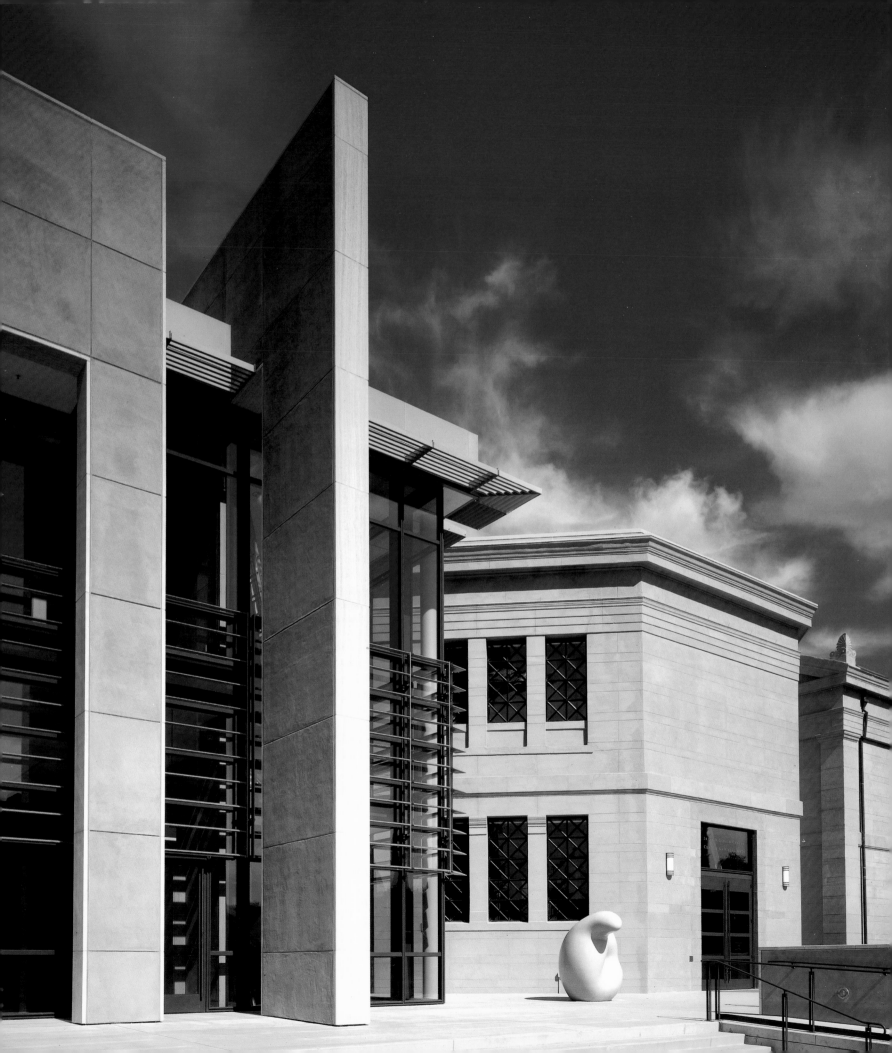

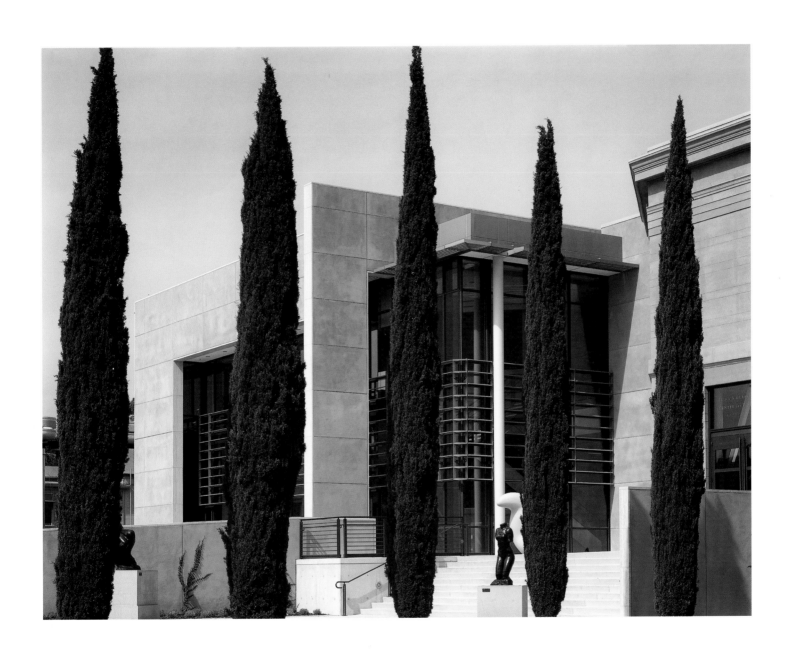

opposite
South elevation (detail)

above
South elevation from Rodin Sculpture Garden

following pages
South elevation (details)

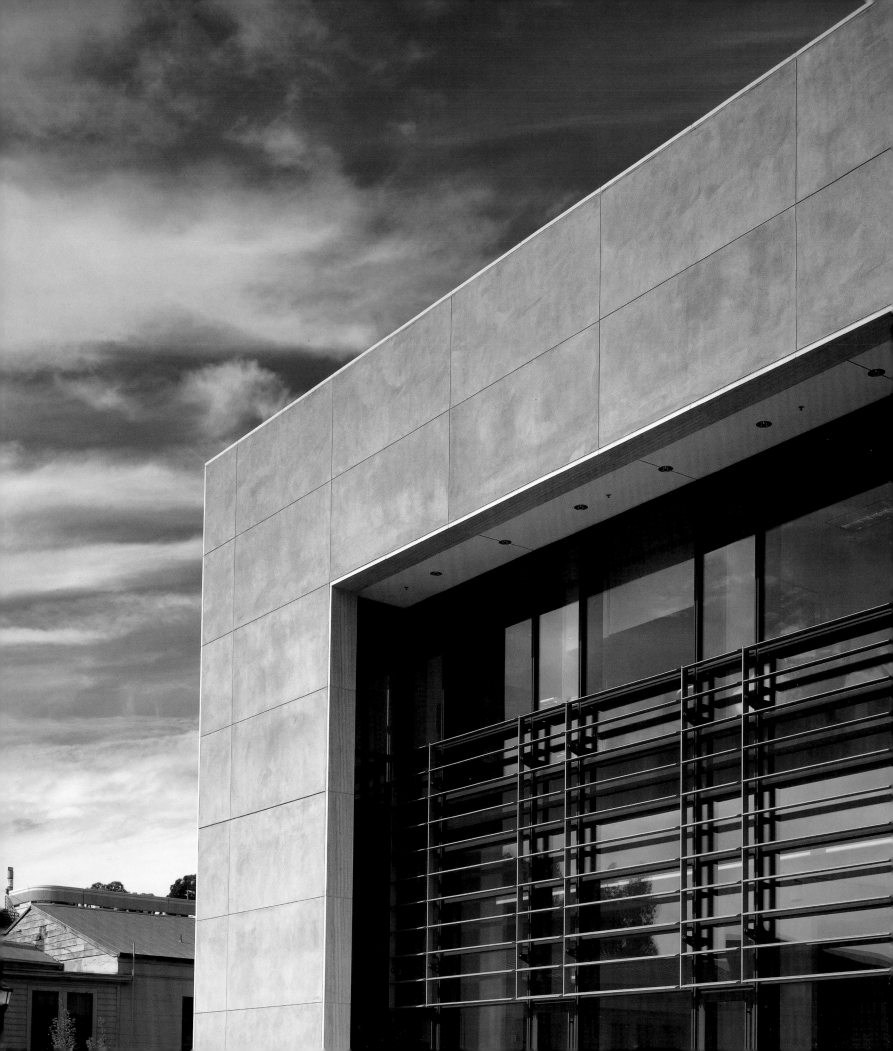

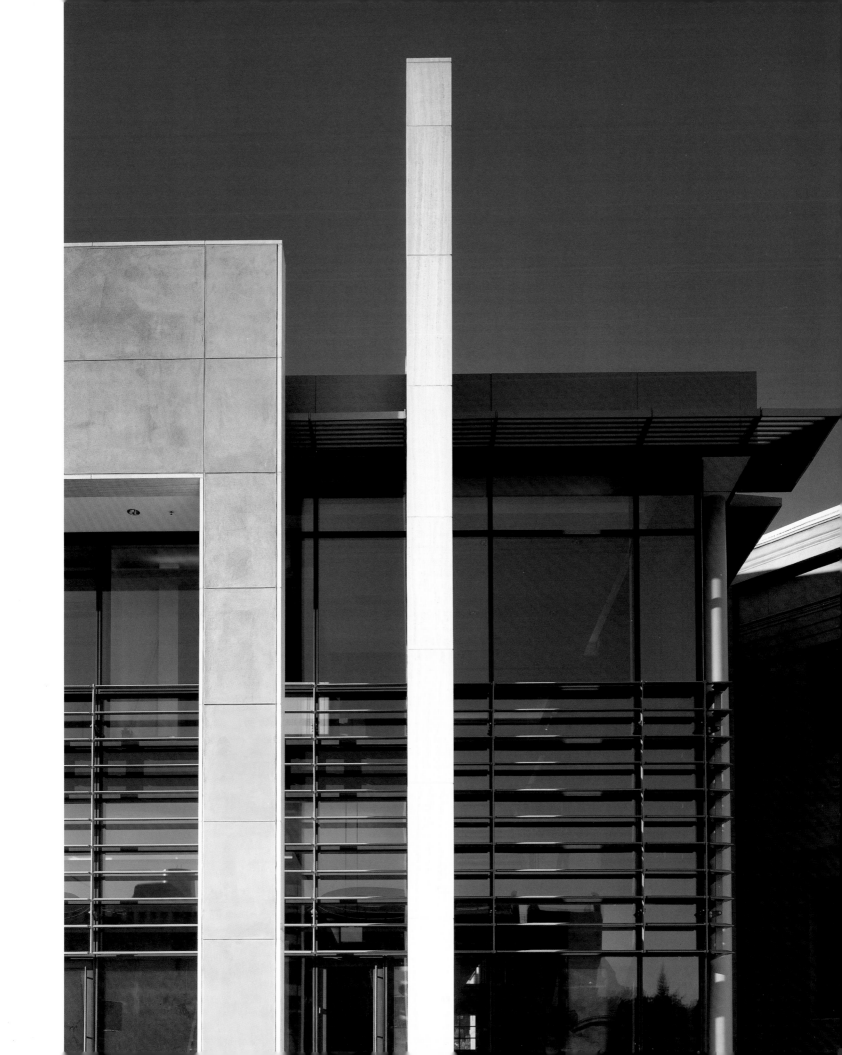

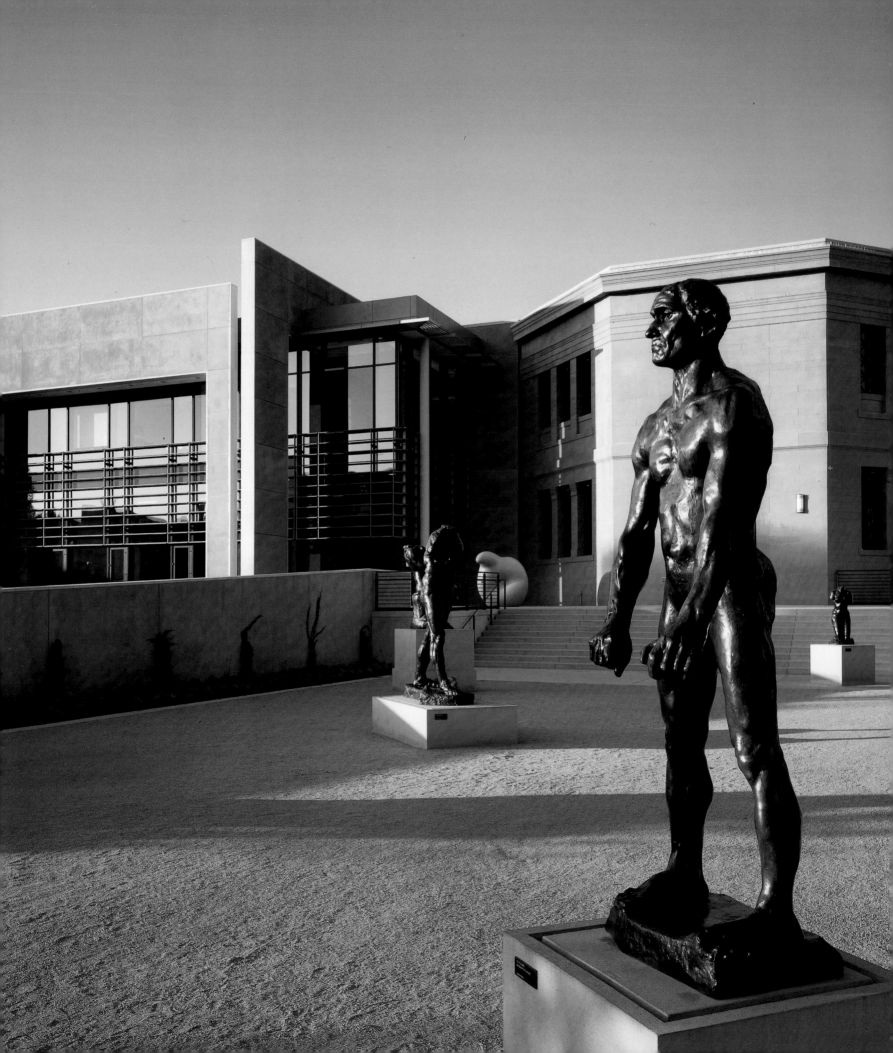

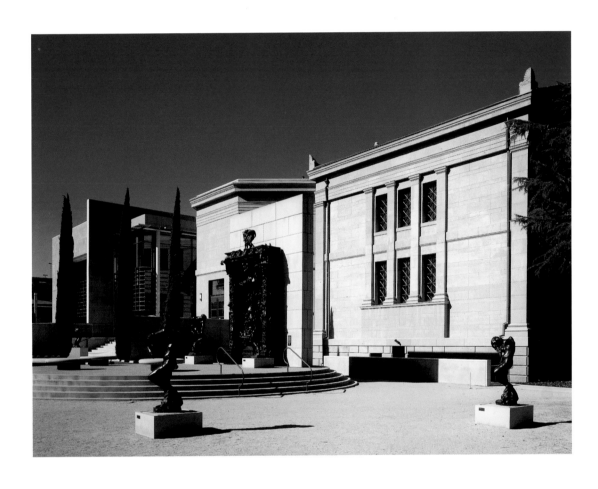

opposite and above
South elevation from Rodin Sculpture Garden

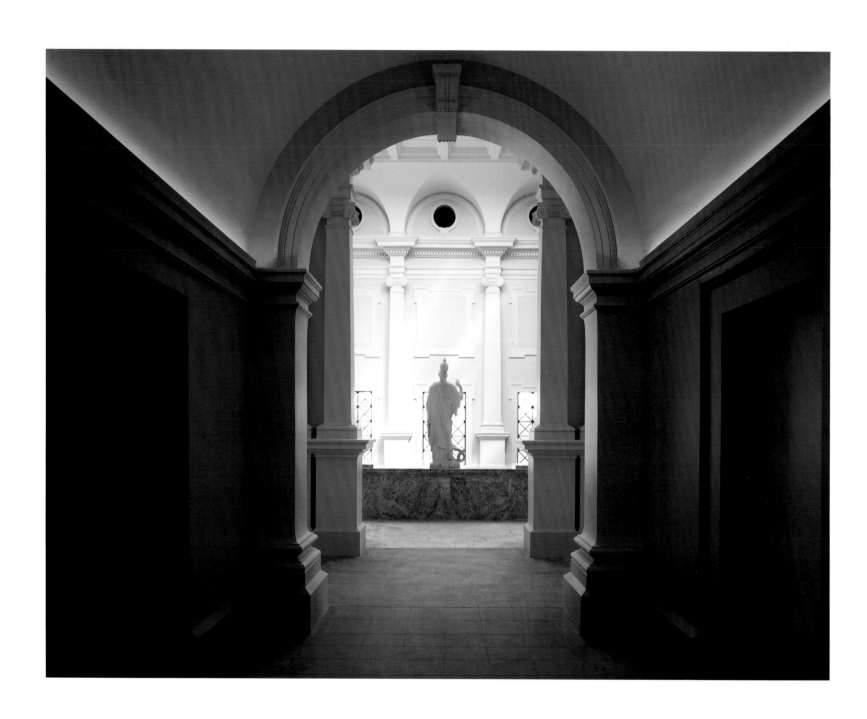

above
View to upper lobby

opposite
North rotunda interior

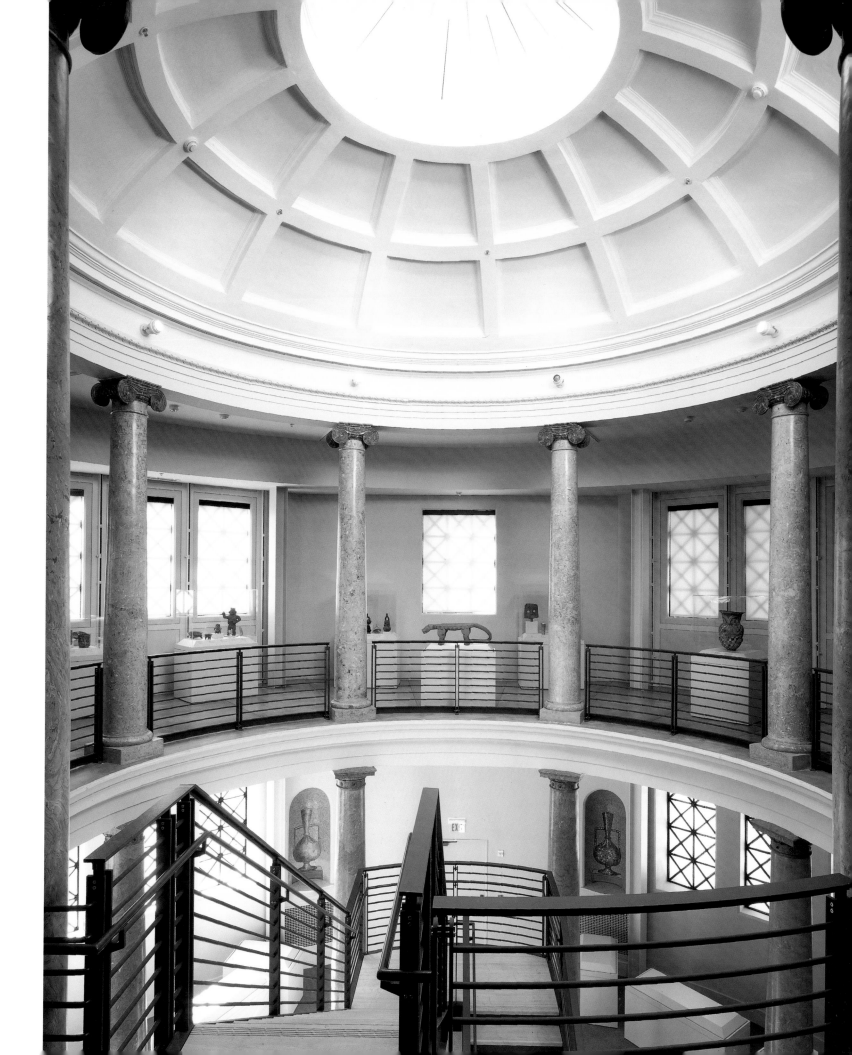

FREIDENRICH FAM

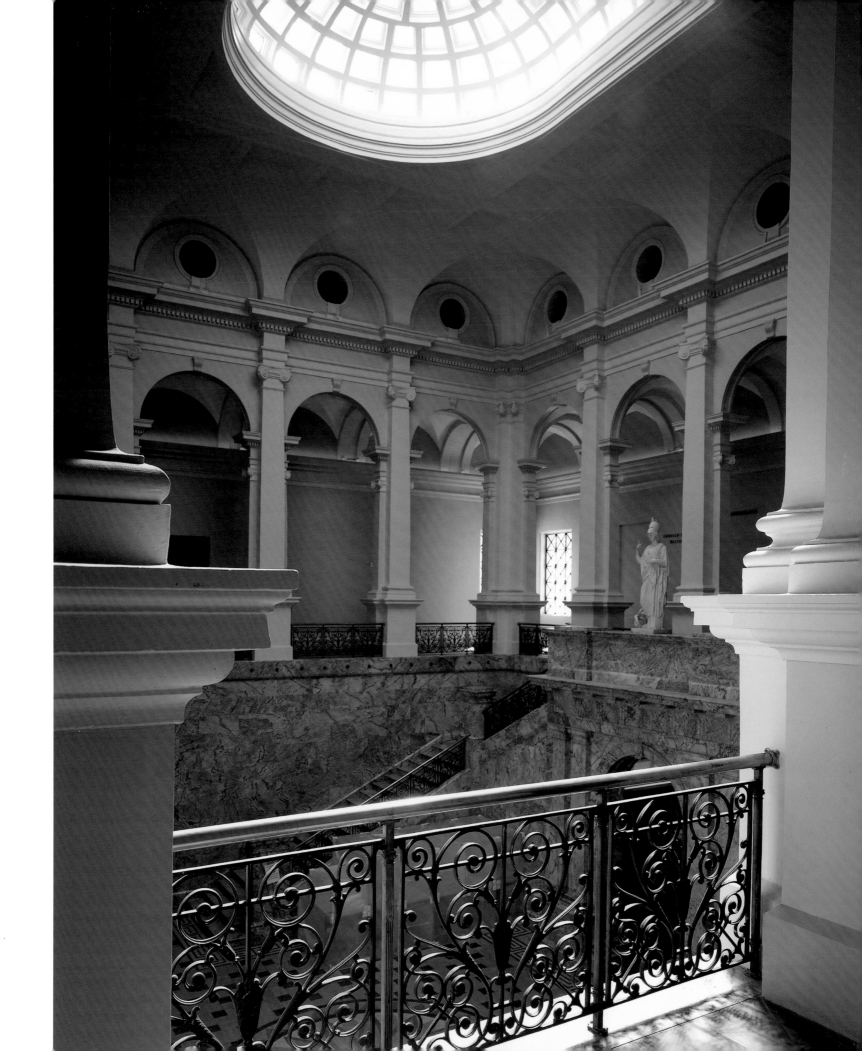

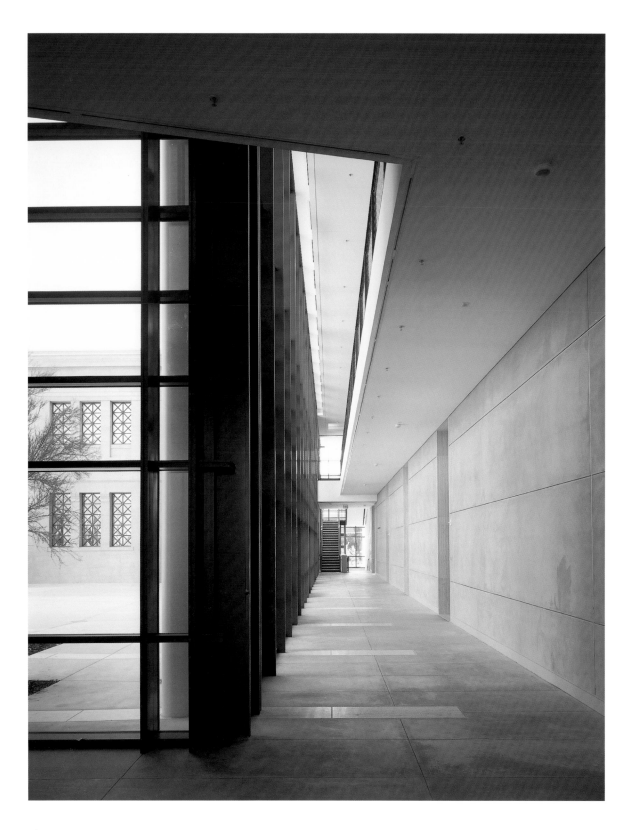

above
Galleria and window wall

opposite
View into Sculpture Garden

preceding pages
View into contemporary gallery (left)
Main lobby (right)

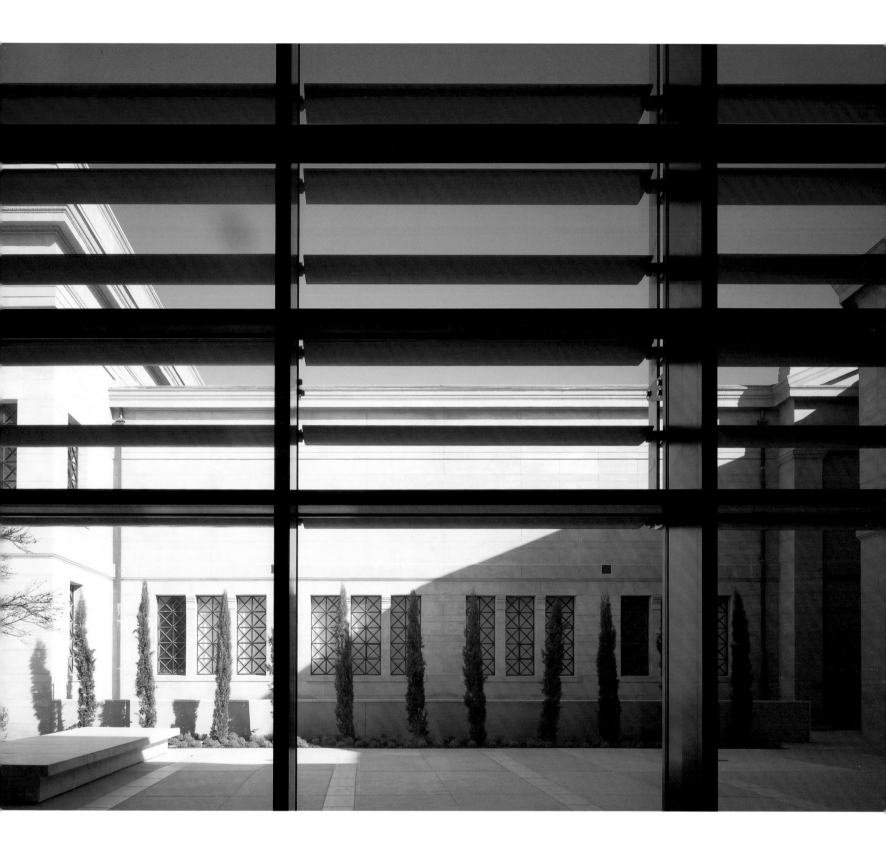

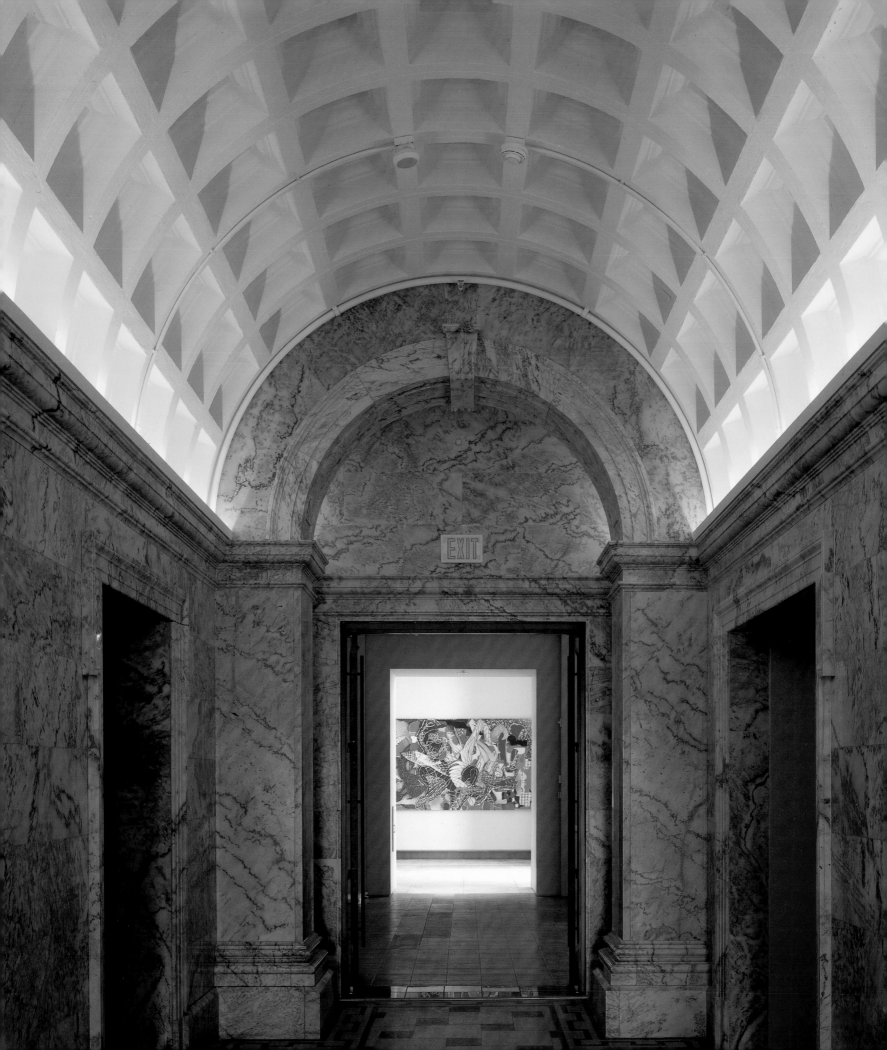

EXIT

opposite
View from lobby to auditorium

above
Interior (detail)

West elevation (detail)

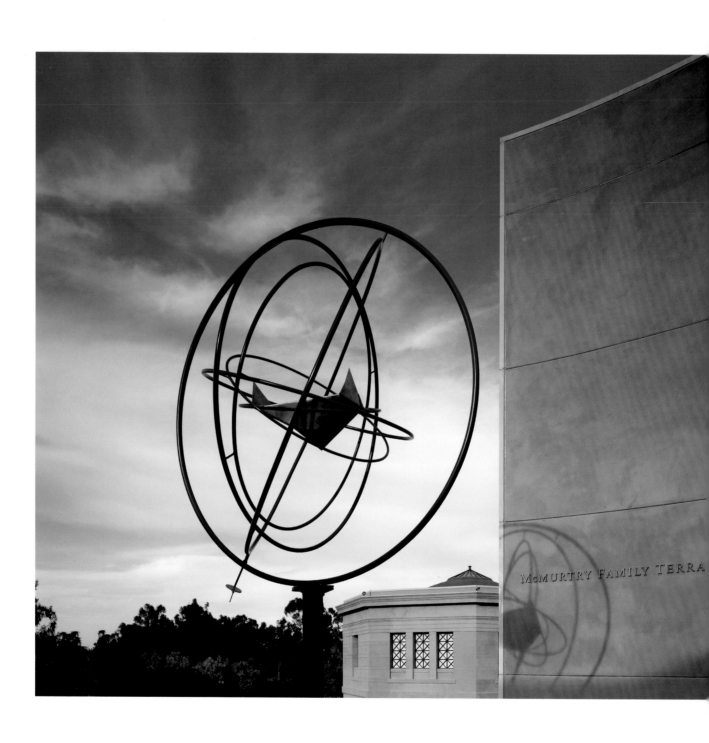

above
View from Sculpture Terrace

opposite
North elevation (detail)

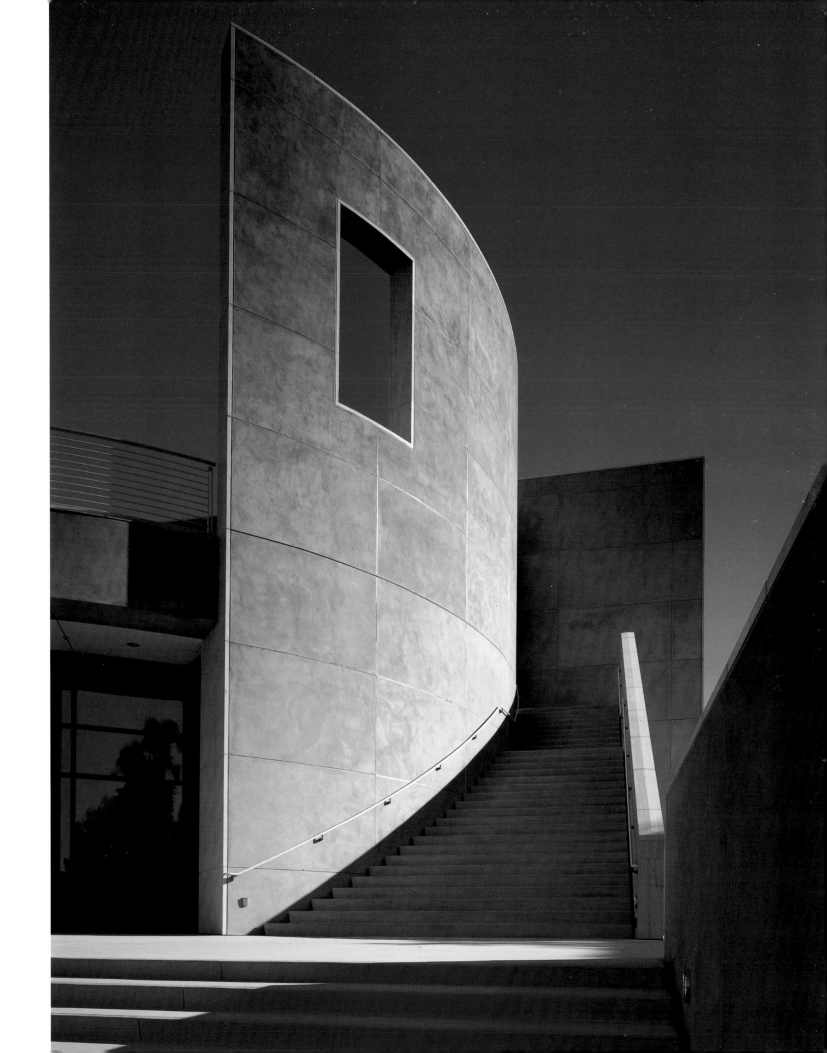

Museum and Building Project Chronology

1901 The first catalogue of the museum's collection is published.

1902-6 In its second expansion the museum is extended to form a quadrangle with additional connecting rotundas. The completed structure comprises almost 300,000 square feet, built mostly of ordinary brick and mortar, except for the original concrete central block.

1905 February 28: Jane Stanford dies.

April 18, 1906
The San Francisco earthquake destroys all but the original 1891 reinforced concrete building,

its adjoining rotundas, and a portion of the brick and mortar block behind it to the west. Much of the collection, estimated to contain 28,000 items, is also lost or damaged. Harry Peterson, the museum's curator, begins to survey the damage.

1884 March 13: Leland Stanford Jr. dies in Florence, Italy. His parents, Leland and Jane Stanford, resolve to found a university and an encyclopedic museum in memory of their only child. Later in the year they purchase 5,000 Cypriot antiquities from The Metropolitan Museum of Art's Cesnola collection for the new museum.

1924-25 The departments of botany, entomology, and zoology move into the museum's south wing.

1880 1890 1900 1910 1920 1930

Museum Directors

Jane Stanford 1893-1905

Harry Peterson *Curator* 1900-1917

Pedro deLemos 1917-45

1890 November 23: Ground is broken for the Leland Stanford Junior Museum.

1891 May 14: The museum's cornerstone is laid on Leland Jr.'s birthday. Percy & Hamilton Architects in collaboration with Ernest J. Ransome design the museum as a neoclassical building.

April 23, 1892

The museum building is completed.

The first structure built entirely of reinforced concrete, it contains 20,000 square feet and costs $200,000.

1893 June 21: Leland Stanford dies.

1894 The Leland Stanford Junior Museum opens to the public with Jane Stanford as director in all but name.

1898 In its first architectural expansion the museum gains north and south wings and two rotundas.

1911 Leland Stanford's brother, Thomas Welton Stanford, makes the university a substantial financial gift, which is eventually dedicated solely to the construction of a separate art gallery elsewhere on campus.

1917 The Thomas Welton Stanford Art Gallery is completed. Peterson submits his inventory to the university and subsequently resigns; Pedro deLemos is named as director.

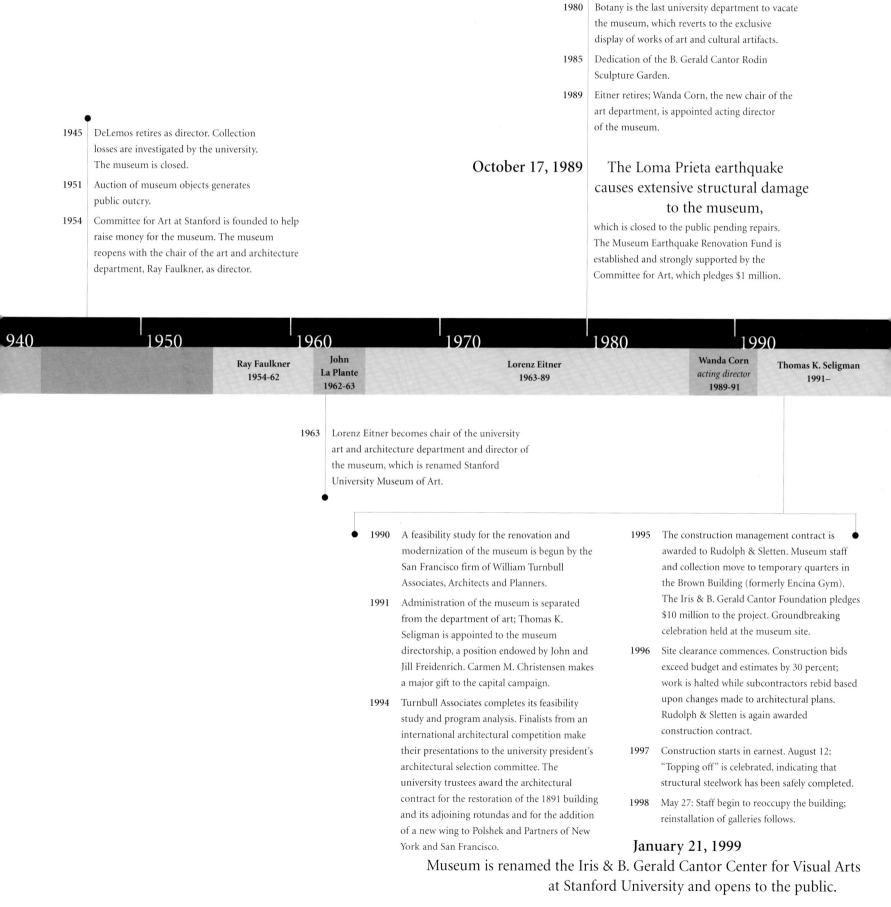

1945 DeLemos retires as director. Collection losses are investigated by the university. The museum is closed.

1951 Auction of museum objects generates public outcry.

1954 Committee for Art at Stanford is founded to help raise money for the museum. The museum reopens with the chair of the art and architecture department, Ray Faulkner, as director.

1980 Botany is the last university department to vacate the museum, which reverts to the exclusive display of works of art and cultural artifacts.

1985 Dedication of the B. Gerald Cantor Rodin Sculpture Garden.

1989 Eitner retires; Wanda Corn, the new chair of the art department, is appointed acting director of the museum.

October 17, 1989 — **The Loma Prieta earthquake causes extensive structural damage to the museum,** which is closed to the public pending repairs. The Museum Earthquake Renovation Fund is established and strongly supported by the Committee for Art, which pledges $1 million.

940 1950 1960 1970 1980 1990

Ray Faulkner 1954-62

John La Plante 1962-63

Lorenz Eitner 1963-89

Wanda Corn *acting director* 1989-91

Thomas K. Seligman 1991–

1963 Lorenz Eitner becomes chair of the university art and architecture department and director of the museum, which is renamed Stanford University Museum of Art.

1990 A feasibility study for the renovation and modernization of the museum is begun by the San Francisco firm of William Turnbull Associates, Architects and Planners.

1991 Administration of the museum is separated from the department of art; Thomas K. Seligman is appointed to the museum directorship, a position endowed by John and Jill Freidenrich. Carmen M. Christensen makes a major gift to the capital campaign.

1994 Turnbull Associates completes its feasibility study and program analysis. Finalists from an international architectural competition make their presentations to the university president's architectural selection committee. The university trustees award the architectural contract for the restoration of the 1891 building and its adjoining rotundas and for the addition of a new wing to Polshek and Partners of New York and San Francisco.

1995 The construction management contract is awarded to Rudolph & Sletten. Museum staff and collection move to temporary quarters in the Brown Building (formerly Encina Gym). The Iris & B. Gerald Cantor Foundation pledges $10 million to the project. Groundbreaking celebration held at the museum site.

1996 Site clearance commences. Construction bids exceed budget and estimates by 30 percent; work is halted while subcontractors rebid based upon changes made to architectural plans. Rudolph & Sletten is again awarded construction contract.

1997 Construction starts in earnest. August 12: "Topping off" is celebrated, indicating that structural steelwork has been safely completed.

1998 May 27: Staff begin to reoccupy the building; reinstallation of galleries follows.

January 21, 1999 Museum is renamed the Iris & B. Gerald Cantor Center for Visual Arts at Stanford University and opens to the public.

Building Components

New Wing

Exterior Wall Construction

Steel stud-framed Portland cement plaster consisting of 7/8 in. integrally colored Portland cement plaster on self-furring metal lath on 5/8 in. gypsum sheathing on 6 in. cold-formed metal framing (heavy gauge steel studs). The stud cavity is filled with R-11 foil-faced batt insulation and a vapor barrier. The interior surface of the wall is then finished with 5/8 in. gypsum wallboard.

Exterior Wall Stone

The planar exterior Portland cement plaster walls are trimmed in 2 in. nominal thickness (5 cm.), filled, and honed Eba Light Travertine from Tivoli, Italy. Each piece of vertical stone is supported by extruded aluminum shelf angles fastened to cold-formed metal framing. The Travertine coping stone is held in place with stainless steel dowels.

Exterior Window Wall and Window System

The exterior window wall is Kawneer Series 1600, with custom extrusions and custom fascia caps. Within each vertical mullion is a 2 x 10 in. structural steel tube spanning 33 feet from the first floor to the roof structure above. The glass is high performance, insulated vision units, Heat Mirror 88, Clear by Southwall Technologies. The system is designed to accommodate a maximum 3 in. of differential horizontal drift due to seismic events without failure or deterioration. The horizontal shade louvers attached to the window wall are 8 in. extruded aluminum Airfoil Blades by C/S Group Construction Specialties, supported by custom fabricated 1/2 in. steel plates.

The horizontal aluminum cornice grille assembly above the window wall is a custom fabricated aluminum frame with 4 in. extruded aluminum Airfoil Blades.

The doors are Kawneer Series 350 with oil-rubbed bronze Rockwood pulls, with the exception of the main doors to the south rotunda, which are Vistawall Series 375 within a Kawneer frame.

The window wall and louvers are finished with a custom color, fluorocarbon-resinous coating, Duranar, by PPG Industries. The aluminum panels, horizontal louvers, and aluminum cornice grille are finished with a Duranar XL.

The exterior Firetrol circular columns are finished with a polyurethane paint system by Tnemec.

Skylights and Loading Dock Canopy

The skylight over the twentieth-century gallery is Kalwall with a 12 x 24 in. Shoji pattern. The skylight over the loading dock canopy is Kalwall with a 8 x 24 in. Shoji pattern.

Roofing System

The roofing is a polyurethane foam with an elastomeric coating finished with ceramic granules. The foam roof is applied directly to the structural concrete roof slab. Copings are aluminum or Travertine depending on location.

Interior Finishes

Heating, Ventilating, and Air Conditioning (HVAC)

Computer-automated, centrally controlled system of steam and chilled water pneumatically regulated as required to maintain temperature and humidity control of 85% filtered air. The following temperature and humidity levels are maintained:

Galleries: 70° +/- 2°; 45%; relative humidity +/- 5%
Other public areas: 70° +/- 2°; N/A
Art storage: 68° +/- 2°; 45%; relative humidity +/- 5%
Office areas: 70° +/- 2°; N/A

Lighting

The primary lighting system used through the museum is the Lightolier two-circuit recessed track. The track is circuited to give the gallery a maximum flexibility.

The lighting control system was provided by Macro Electronics. The system controls all the track lighting throughout the galleries and downlights and other forms of architectural lighting in the building. In addition to intensity control the system limits voltage to the lamps and increases lamp life significantly.

Cove lighting throughout the galleries was provided by Elliptipar. This optically precise system provides a smooth wash of light on ceiling and wall surfaces throughout.

Floors

Galleries and other public areas
The predominant flooring is architectural concrete topping slab Colton Type II, with a rubbed, troweled, matte finish, with stone banding, 1.5 in. (3 cm.) nominal thickness, filled, and honed Eba Light Travertine. The Temporary Exhibit Gallery has a red oak parquet floor in a Haddon Hall pattern. The twentieth-century gallery and the auditorium have 2 1/4 in. wide 25/32 in. thick Natural White Maple tongue-and-groove strip flooring.

Office areas
Danbury carpet by Bentley Carpets in the office and work areas, and vinyl composition tile in kitchen and work areas.

Walls

Galleries and other public areas
The major walls are integrally colored veneer plaster on 1/2 in. Imperial Board, with color and finish to match the exterior Portland cement plaster, trimmed with Eba Light Travertine. Painted walls are 5/8 in. gypsum wallboard over 3/4 in. plywood on steel stud framing. Custom wood millwork is predominantly bookmatched, plain-sliced, Select White Maple veneer in the bookshop and main circulation areas. The cafe millwork also incorporates bookmatched, flat-cut, Figured Pearwood veneer with a natural finish, topped with Absolute Black granite.

Auditorium
In addition to the materials noted above for the public areas this area also incorporates curved acoustic wood wall panels, Quadrillo by Decoustics, with a custom Pearwood finish, with flitches matching the Pearwood veneer used on the audiovisual cabinet millwork at the opposite side of the room.

Curatorial areas
Painted gypsum wall board with Select White Maple veneer architectural millwork in the offices and plastic laminate casework in the kitchen and general work areas.

Restrooms
The public and private restrooms have 2 x 2 in. unglazed ceramic mosaic wall tile by American Olean, laid in a "no cut" pattern, with painted gypsum wall board above. The toilet partitions are brushed stainless steel by Masco Flush Metal Partition Corp. The accessories are by Bobrick. The lavatories are stainless steel set into Absolute Black granite countertops.

Ornamental Metal

Railings and stairs are custom fabricated with steel plates and shapes and finished with a polyurethane paint by Tnemic. Guardrail cables are stainless steel.

Doors

Wood doors are solid core with Select White Maple veneer. Doors that are not part of the window wall system are painted, hollow metal.

Ceilings

Public areas, restrooms and auditorium
Painted gypsum wall board ceilings with Decoustics Ceilencio acoustical ceiling panel system at the second-floor circulation gallery and in the auditorium.

Curatorial areas
Painted gypsum wall board ceilings at corridors, with 2 x 2 ft. and 2 x 4 ft. tegular acoustical ceiling tile.

Back-of-house areas and art storage areas
Painted, exposed ceiling construction.

Existing Building

Exterior Wall Construction

Vintage concrete walls repaired structurally, with major exterior cracks repaired and finished with an integrally colored cementitious slurry to match the original concrete finish. The interior surface of the historical concrete walls is coated with a vapor-retardant paint as a vapor barrier for humidity control.

New walls at the central annex and the walls connecting both rotundas to the main portion of the museum are steel stud framed Portland cement plaster consisting of 7/8 in. integrally colored Portland cement plaster on self-furring metal lath on 5/8 in. gypsum sheathing on 6 in. cold-formed metal framing. The stud cavity is filled with R-11 foil-faced batt insulation and a vapor barrier. The interior surface of the wall is then finished with 5/8 in. gypsum wallboard.

Windows

The exterior windows are reconditioned vintage windows with original glass.

Doors

The new aluminum interior and exterior doors are Kawneer Series 350 with oil-rubbed, bronze Rockwood pulls, except the main doors to the south rotunda, which are Vistawall Series 375, and the full-height glass doors at the main lobby, which are BlumCraft Series 1301 with US10B bronze finish.

The bronze entrance doors to the main lobby are the original doors reconditioned.

Skylights

The skylights over the second-floor galleries are Kalwall with an 8 x 24 in. Shoji pattern, in a completely new watertight assembly constructed directly over the original copper and bronze skylights.

The skylights over both rotundas are restored original frames with new laminated glass, California Series White Water Crystal by Southwall Technologies.

Roofing

The roofing is a polyurethane foam with an elastomeric coating finished with ceramic granules. The foam roof is applied directly over the existing historic metal roof, which was constructed directly over the original structural concrete roof at the gabled portions; the existing concrete slab roof over the main lobby and central annex; and over reconstructed wood roof at both rotundas. The concrete gutters were stabilized and lined with new copper. Downspouts are both new and existing copper downspouts.

Interior Finishes

Floors

Main lobby
The original terrazzo floor has been reconditioned. The second-floor balcony overlooking the main lobby is newly cast, integrally colored reinforced concrete floor, colored and scored to match the original concrete floor.

Galleries and rotundas
Where the original historic colored concrete floors were in acceptable condition, the original historic floors were left exposed. Where the floors were in poor condition, they were covered with Danbury carpet by Bentley Carpets. The second-floor galleries incorporate, along the perimeter walls, newly cast, integrally colored reinforced concrete floors, colored and scored to match the original concrete floors.

Curatorial, storage, and other work areas
Danbury carpet by Bentley Carpets in the offices and work areas and vinyl composition tile in kitchen and work areas. In the art storage areas the floors are sealed structural concrete.

Restrooms
The public and private restrooms have 2 x 2 in. unglazed ceramic mosaic tile, by American Olean, laid in a "no cut" pattern. The alcove areas off the public restrooms are tiled in 12 x 12 in. polished porcelain, Granitireali, Black Galaxy, by Graniti Fiandre.

Walls

Main lobby
The lower portion is the original marble, which has been stabilized. The upper portion is the original veneer plaster coat, reconditioned, repaired, and painted.

Galleries
The major planar walls are painted 5/8 in. gypsum wall board on 3/4 in. plywood (at all gallery walls) on steel stud framing. The gypsum wall board walls float off the historic concrete walls exposed at gallery entrances and at the ceiling planes.

Rotundas
Portions of the interior walls of the rotundas were entirely reconstructed with new three-coat gypsum plaster finished to match the historic plaster and painted.

Curatorial and art storage areas
Painted 5/8 in. gypsum wall board on steel stud framing. Interior casework is plastic laminate veneer by Formica.

Restrooms
Same as New Wing.

Ornamental metal
Newly constructed railings and stairs are custom fabricated with steel plates and shapes and finished with a polyurethane paint by Tnemic. The main lobby balustrades are the original historic railings. The south rotunda second-floor guardrails are the original historic balustrade relocated from the north rotunda.

Doors
Wood doors are original, reconditioned and refinished.

Ceilings
Main lobby and first-floor galleries
The lobby and first-floor galleries have the original coffered concrete ceilings, which have been reconditioned and stabilized.

Second-floor galleries
The ceilings are painted gypsum wall board configured to match the profile of the original plaster ceilings.

Rotundas
The first-floor ceilings are painted original ribbed concrete, with a circular, painted gypsum wall board soffit. The second-floor ceilings are painted gypsum wall board, fastened directly to the original wood-trussed roof, to match the original plaster ceiling.

Public areas and restrooms
Painted gypsum wall board ceilings.

Curatorial areas
2 x 4 ft. tegular acoustical ceiling tile.

Back-of-house and art storage areas
Painted exposed ceiling construction.

Landscape

Planting
Trees
Carpinus betuluys "Fastigiata"/European horn beam (screening western edge of site); Cupressus sempervirens/ Italian cypress (interior courtyard and along west side of north lawn); Cercidium floridum/ blue palo verde (interior courtyard); Nyssa sylvatica/ black tupelo (north sculpture court accent tree); Pinus halepensis/Aleppo pine (along Roth Way); Pinus pinea/Italian stone pine (entry court on Roth Way); Quercus agrifolia/coast live oak (tree for non-lawn areas around existing museum); Quercus virginiana/ southern live oak (lawn areas on south and north sides of new building).

Shrubs and groundcovers
Arctostaphylos densiflora "Howard McMinn"/manzanita (main entry and along Roth Way); Carpenteria californica/ bush anemone (north sculpture court); Hedera helix "Hahnii"/ Hahn's English ivy (east and north sides of existing museum); Heteromeles arbutifolia/toyon (screen at north end of north lawn); Ligustrum japonicum "Texanum"/privet (hedging along western edge of site and at trash enclosure); Rhamnus alaternus/Italian buckthorn (hedging in interior court and north sculpture court).

Perennials and vines
Lavandula x intermedia "Provence"/lavender (Cypress Terrace and interior courtyard); Parthenocissus tricuspidata/ Boston ivy (Cypress Terrace); Salvia leucantha/Mexican sage (south end of south lawn).

Courtyard perennial bed
Achillea tomentosa/wooly yarrow; Erigeron glaucus "WR"/beach aster; Eschsholzia californica/California poppy; Iris douglasiana/Pacific Coast iris; Penstemon centrathifolius/scarlet bugler; Penstemon gloxinioides "Sour Grapes"/sour grapes border pensetemon; Stachys "Silver Carpet"/lamb's ears; Thymus praecox arcticus/ creeping thyme; Hesperaloe parviflora/red yucca; Verbscum olympicum/mullein.

Paving
Architectural concrete paving (north and south terraces, Cypress Terrace, Roth Way entry plaza); architectural concrete paving with travertine marble inset (interior courtyard and existing museum entry plaza); asphaltic concrete paving (sidewalk along Roth Way and Lomita Drive); decomposed granite paving (Rodin Sculpture Garden, Cypress Terrace); gravel paving (north sculpture court).

Walls
CMU wall, with 5/8 in. parging and 2 in. travertine coping and end facings (landscape walls on south, west, and north sides of new and old buildings); architectural concrete retaining wall (at edges of ramps and plazas without landscape wall, see above); 6 in. architectural concrete curb wall (on building side of new ramp and stair entries to existing museum at west side of north rotunda, south basement entry, basement entry on south side of main entry); 10' architectural concrete curb wall (building side of entry stairs on north side of the north rotunda).

Building Dimensions

			square feet	square meters
Dimensions (gross)		Site	200,600	18,643
		Old Wing	75,000	6,970
		New Wing	42,000	3,903
Space Allocation by area (net)		*Interior*		
		galleries (including 2 circulation galleries)	44,142	4,102
		auditorium (including green room)	1,595	148
		classrooms (2 in basement and docent library)	1,840	171
		conservation	1,440	134
		art handling/storage (including dock/packing)	18,026	1,675
		bookshop	735	68
		cafe	975	91
		offices	6,120	569
		main lobby (including balcony)	3,248	302
		Exterior		
		sculpture courtyard	3,489	324
		sculpture terrace	2,084	193
		north terrace (not including stairs)	2,592	240
		south terrace (not including stairs)	2,990	278
		south garden (Rodin and new, including stairs)	65,100	6,050
		north garden (w/in project, including stairs)	21,600	2,007
Exterior building heights		Existing building (main lobby dome)		68'+/- and 54' at end gables
		New wing (highest)		45'9"
Interior clear spaces		*Existing building*		
		First floor:		17'0" max
		Second floor:		26'0" max
		New wing		
		First floor:		15'2" max
		Second floor:		17'2" max

Miscellaneous Facts

4,250 cubic yards of concrete
590 tons of structural steel
180 tons of reinforcing steel

Architecture

Client
Stanford University and Stanford University Museum of Art

Competition and Design Team (New York office)
James Stewart Polshek, FAIA, design principal
Richard M. Olcott, FAIA, design principal
Thomas Wong
Amanda Martocchio
Minsuk Cho
John Fernandez
Darius Sollohub
Lawrence Zeroth

Design Team (San Francisco office)
C. David Robinson, FAIA, partner-in-charge
Richard Kosheluk, AIA, project manager, project architect,
 specifications and construction administrator (1996-98)
Stefan Hastrup, AIA, project architect (1994-96)
Joanne Hermance
Kenneth Ong
Roberto Sheinberg
Thomas Silva
Andrew Tyley

Consultants

Structural engineers
H. J. Degenkolb Associates, Engineers
Chris Poland, Evan Reis

Landscape architects
SWA Group
John Wong, Cinda Gilliland

Architectural lighting
PHA Lighting Design
Paul Helms

Historic preservation
Architectural Resources Group
Steve Farneth, David Wessel

Mechanical, electrical, and plumbing engineers
Flack & Kurtz
Mark Belgarde, Jeff Sacks, Peter Samaras,
Alda Licis, Victoria Duggan

Civil and geotechnical engineering
Rutherford and Chekene Consulting Engineers

Security
Steven R. Keller and Associates, Inc.

Hardware
DHC (Door + Hardware Consultants)

Acoustics and audiovisual
Charles M. Salter & Associates, Inc.
David Schwind, Ken Graven

Architectural concrete
Reginald D. Hough
Architect

Signage and graphics
Madeleine Corson Design

Cost estimation
Oppenheim Lewis, Inc.

Project Team

Stanford University
Thomas K. Seligman, museum director
Olivier Pieron, project manager
Maggie Burgett, construction manager
Patricia Douglas, project intern
Warren Jacobsen, assistant project manager
Jean Barnes, FEMA contracts
David Neuman, university architect
Ruth Todd, assistant university architect
Laura Jones, campus archaeologist
Judy Chan, associate director, planning
Craig Comartin, consulting engineer
Mike Tsuchimoto, facilities operation
Charles Mann, facilities operation
Joseph Leung, fire marshall
Steven Riggs, fire protection engineer

Federal, state, and county
Sandro Amaglio, FEMA Region IX
Eric Rekdah, FEMA Region IX
Pat Dunn, FEMA Region IX
Cherilyn Widell, State Office of Historic Preservation
Steade Craigo, State Office of Historic Preservation
James C. Yee, Santa Clara County Building Department
Tom Walsh, Santa Clara County Building Department

General contractor
Rudolph and Sletten, Inc.
Bob Olson, project manager
Mickey Skelson, senior project superintendent
Arash Azarkhish, project engineer
Mike Conroy, project engineer

Principal Subcontractors

Architectural millwork
Mission Bell Manufacturing, Inc.

Fire sprinkler
Allied Fire Protection

Stone
Carrara Marble Co.

Site concrete
Casey-Fogli

Roofing
Central Coating Co.

HVAC
Critchfield Mechanical

Plumbing
Design Mechanical

Structural steel
Gayle Manufacturing Co.

Scagliola repair
Griswald Associates

Demolition
Iconco, Inc.

Landscape and irrigation
Jensen Corporation

Drywall, plaster, fireproofing
Frederick Meiswinkel, Inc.

Exterior restoration
Rainbow Waterproofing

Mosaic restoration
Leslie Bone

Structural steel
Romak Iron Works

Electrical
Rosendin Electric, Inc.

Glazing
Royal Glass Company, Inc.

Ceiling molding
Patrick J. Ruane, Inc.

Ornamental metal
C. E. Toland

Museum Staff

Since October, 1989

Administration

Acting Director
Wanda M. Corn, 09/89–07/91

John and Jill Freidenrich Director
Thomas K. Seligman, 08/91–

Associate Director/Chief Curator
Carol M. Osborne, –09/93
Bernard Barryte, 09/93–

Associate Director/
Director of External Affairs
Mona Duggan

Museum Administrator
Martha L. Drickey

Operations Manager
Kathleen Baldwin

Assistant to the Director
Evelyn Gandara, 09/91–03/98
Laura R. Janku, –08/98
Ada Afanasieff, 08/98–

Member Services Manager
Rachel Hull, 10/96–05/98
Nicole Grosvenor, 08/98–

Public Relations Manager
Jill Osaka, 11/94–

Administrative Assistant
Veronica Salgado, 12/97–

Curatorial Department

Robert M. and Ruth L. Halperin
Curator of Modern and
Contemporary Art
Hilarie Faberman

Curator of the Arts of Africa,
Oceania and the Americas
Ruth K. Franklin

Curator of Prints and Drawings
Betsy G. Fryberger

Curator of Asian Art
Patrick J. Maveety

Curator of American Art
Diana Strazdes, 09/93–08/97

Curator for Education
Patience Young

Educational Services Coordinator
Gerry Gilchrist, –04/91
Judy Barber, –07/96
Lani K. Meilgaard, –01/98
Lyn Cox, 01/98–

Honorary Curators
Albert E. Elsen, –02/95
Joel Leivick, photography
Dwight Miller, –08/95

Curatorial Assistant
Minoti Pakrasi, 06/96–11/97
Laura R. Janku, 08/98–

Guest Curators
Richard Joncas
Caroline Jones
Roxanne Nilan
Claire Perry
Phillip Prodger
Denni Woodward

Anthropology Collection
John Rick, curator
Rosa Rick, assistant curator

Registration and Facilities

Head, Registration and
Conservation
Susan Roberts-Manganelli

Associate Registrar
Dolores F. Kincaid
Cinthia Kung, 11/92–01/94

Assistant Registrar
Katie Clifford
Noreen Ong

Collections Assistant
Alicja T. Egbert

Academic Technology Specialist
Leslie Johnston

Preparators
Jeffrey L. Fairbairn
Frank W. Kommer
Don Larsen
Larry J. Lippold

Matting and Framing Assistant
Glenn Young

Gallery Attendants
Marilyn Calvey, –10/97
Rebecca Hackemann, 08/95–12/96
Maribel Kilmartin, –12/97

Curatorial and Registration
Interns and Volunteers
Judy Amsbaugh
Dina Basalyga
Eva Brockmann
Pauline Brown
Alice H. Chiu
Dana Claudat
Pru Cleary
Alexis Comacho
Christopher Connell
Susan Dennis
Jeanie Dolin
Jeff Donaldson
Elise S. Effmann
Alicja Egbert
Keith Eggener
Dr. Goodwin "Bud" Elliott
Michael Gaudio
Arlene Gray
Eve Gribi
Elizabeth Guffey
Evelyn Hankins
Barbara Hanson
Betty Hostetler
Elizabeth Hutchinson
Molly Hutton
Elizabeth Idleman
Betty Jaedicke
Tracy Johnson
Branden Joseph
Belinda Kan
Jordan Kantor
Brigitte Kolloch
Jennifer Knuth
Grayson Lane
Karyl Lin
Heather Lind
Amy J. Liu
Beth Mangini
Adi Mannor
Judy Maxwell
Elizabeth McLain
Kerry Morgan
Therese Mulford
Jamie Muse
Isabelle Pafford
Christine Page
Phillip Prodger
Lindsey Rinder
Les Roberts
Mary Salzman
Carolyn R. Samuels
Kristin Schwain
Kathryn Shefren
Mary Smith
Susana Sosa
Judithe Speidel
Kristie Stout
Preston Thistle
Natalie Williamson
Letitia Yang
Sylvia Yu

External Relations and
Office Assistants
Gilbert Borrego
Elizabeth Chien
Charla Cooper
Susan Murray Dennis
Darin Furukawa
Natasha Johnson
Stephen Johnstone
Ceri R. Jones
LaHoma Lee
Carlo Libaridian
Maya McMillin
Sujatha Meegama
Alicia Miller
Lauren Neefe
Cherry Pradipnathalang
Christopher Seligman
Timothy Seligman
Diane Wood

Packers
Gilbert Borrego
Dean Burton
Christopher Clark
Jim Hunter
Laurel Hunter
Christopher Jack
Daniel Meltsner
Timothy Ryan
Colin E. Stinson
Stephen Streng
Vernon E. Trindade
Leonard Vasquez

Outdoor Sculpture Maintenance
Thai Quoc Bui
Lisa Carroll
Isabel Farnsworth
Stephen Wesley Hendee
Melanie Klein
Wing See Lai
Christina Mueller
Joe Norman
Elizabeth Tremante

Donors

REFOUNDERS
Iris and B. Gerald Cantor
Carmen M. Christensen

DISTINGUISHED DONORS
An Anonymous Donor
The Committee for Art at Stanford
Jill and John Freidenrich
Burt and Deedee McMurtry
The Pigott Family
The President's Fund

JANE STANFORD CIRCLE
John and Susan Diekman
Doris F. and Donald G. Fisher
The Geballe Family
Lynn and Jim Gibbons
Jean Haber Green
Ruth and Robert Halperin
The Estate of John M. Houser, Jr.
Mr. and Mrs. Patrick Maveety
Linda and Tony Meier
Mr. and Mrs. Albert Moorman
Palo Alto University Rotary Club
The Joan Pearson and
 John D. Leland Family
Barbara and Ken Oshman
Patricia S. and Rowland K. Rebele
Madeleine H. Russell Fund of the
 Columbia Foundation
Mr. and Mrs. Charles Schwab
Charles and Mary Tanenbaum
Melitta and Rex Vaughan
Mr. and Mrs. Jack Wheatley

DIRECTOR'S CIRCLE
An Anonymous Donor
Mr. and Mrs. William A. Campbell
The Evelyn and Walter Haas, Jr. Fund
Charles Haber
Jane B. Miller
John A. and Rosemary Young

CURATORS' CIRCLE
Jane Foster Carter and
 Robert Buffington Carter
Mrs. Clement Chen, II
Gil Ellenberger, in memory of
 Sally Ellenberger
Jo Ann Schaaf and Julian Ganz, Jr.
Paul Helms
Mr. and Mrs. Roger Mertz
Doris McNamara
Mr. and Mrs. Kenneth Sletten

DONORS' CIRCLE
Mr. and Mrs. Robert R. Augsburger
Mr. and Mrs. John M. Black
Mimi and Sheldon Breiner
Mr. and Mrs. George Cilker
Carol L. and Russell Collier
Phyllis Diebenkorn
Jane Farmer
Charles and Marian Huggins
Patricia S. Jacobson
Mary Ann and Stan Kaisel

Carol Ackerman Kilner
Emily M. Leisy
Carol and Hal Louchheim
Mr. and Mrs. Robert P. Mann
Doreen D. Marshall
Samuel C. Miller
Warren and Barbara Poole
Marjorie and Jack Power
Mary Carroll Scott
William P. Scott III
Donovan and Geri Thayer

FRIENDS' CIRCLE–TIER I
Mahmea Alton
Allen and Judith Amsbaugh
Dr. and Mrs. Clayton W. Bavor
Mrs. Anne K. Berry
Bernard and Sybil Ann Brennan
Kenneth D. Brenner Family
Nathan and Harriet Brenner
Pauline Brown
Mrs. Hervey P. Clark
Community Foundation Silicon Valley
Ginger Glockner
Greater Bay Bancorp Foundation
Margaret R. Haneberg
Eileen Barbara Hultin
The David and Lucille Packard Foundation
Sandra and Wilcox Patterson
Dr. and Mrs. Paul Reinhardt
H. Ed Robison
Marjorie N. Rossi
 (Rossi Family Foundation)
Jean and William Schuyler
Mrs. Nancy F. Seeley
Margaret Sowers
Mr. and Mrs. Hugh Taylor
Noel and Roberta Thompson
Walter L. Weisman
Joseph and Phyllis Willits
Mr. and Mrs. Victor Zurcher

FRIENDS' CIRCLE–TIER II
An Anonymous Donor
Jeanne H. and Richard E. Abbott
Barbara and Karl Agre
American Airlines
Barbara Anne Ames
Hunk and Moo Anderson
Richard Lynn Anderson
Charlotte and Robert H. Anderson
Mr. and Mrs. Peter Arnstein
Marion and Burt Avery
Dr. and Mrs. William Ayer
Dr. and Mrs. Richard R. Babb
Mr. and Mrs. Richard T. Baker
Mr. and Mrs. Melvin R. Bennington
Roger Boas
Robert Minge Brown
Steve and Gayle Brugler
Richard I. Buckwalter
Mrs. Darrell H. Carey
Jane M. Chai
Elizabeth G. Chamberlain
Stan and Carol Chapman

Mrs. Kenneth C. Christensen
George and Dona Clark
Prudence and Mansfield Cleary
Nancy Patricia Coe
Joseph and Wanda Corn
Anne Dauer
Mr. and Mrs. Robert W. Davies
John and Dagmar Dern
Mr. and Mrs. Stephen Docter
Mrs. Ralph I. Dorfman
Joseph and Meri Ehrlich
Dr. and Mrs. Goodwin C. Elliott
Mr. and Mrs. Robert Eustis
Mr. and Mrs. William R. Farrar
Mr. and Mrs. Charles D. Field
Edith Sears Finch
Mrs. Thomas A. Gonda
Peter B. and Ann M. Gregory
GTE Sylvania Corporation
Lucille Lanza Hagstrum
Professor and Mrs. Walter A. Harrison
Stephen Peter Hass
Evelyn Cary Hassbaum
Thomas E. Haven
Dr. and Mrs. George F. Hexter
Frances L. Hoffman
Marilyn A. Hohbach
Don and Betty Hostetler
Dr. and Mrs. Francis Howard
Mrs. J. K. Hutchinson
Dr. and Mrs. Bill Karras
Joelle Moira Kayden
Harry and Kathleen Kellogg
Mr. and Mrs. Richard Owen Kelson
J. Burke Knapp
Mr. and Mrs. Albert J. Kurtzon
Sarah Parker Landels
Gertrude Levison
Elise S. and George A. Liddle
William L. Lowe
Mr. and Mrs. Edward Mansfield
Dr. and Mrs. Charles W. McGary
Jack W. and Amy McKittrick
Charles and Nancy McLaughlin
Jane Austin Milne
Charity and Charles Morse
Dorothy Nash
Merrill and Alicia Newman
James and Barbara Newton
Mr. and Mrs. Karl Nygren
Mr. and Mrs. John C. O'Keefe
Mr. and Mrs. Cap Offutt
Peat Marwick Main and Company
Peninsula Stanford Club
Barbara Preuss
Mary C. Radin
Dr. Jack S. Remington
LaLa Richards
Cynthia Kaiser Roberts
Elizabeth R. Rothschild
Fred and Ethel Schaaf
Lilian M. Scherp
Mrs. Elizabeth Schieffelin

Dr. and Mrs. Jud Scholtz
David and Dee Dee Schurman
Dr. and Mrs. Eugene Segre
Joseph and Peggy Seligman
Thomas K. Seligman and Rita Barela
Joyce and Jerry Shefren
John Dickerson Smith
Mrs. Edward J. Soares
Dr. Ralph J. Spiegl
Stanford Club of Palos Verdes
Mr. and Mrs. Stewart Steere
Mr. and Mrs. Robert J. Stewart
Sally Stout
Mrs. Jane Strubbe
Time-Warner
Mr. and Mrs. M. J. Van Loben Sels
Dr. and Mrs. Henry D. Von Witzleben
Mr.and Mrs. Keith G. Wadsworth
Mr. and Mrs. Robert B. Walker
Constance B. and Robert E. Ward
Mrs. James T. Watkins, IV
Watkins Ward Travel Association, Inc.
Sam and Kim Webster
Nancy K. and Robert Weeks
Betty D. White
Mrs. Allen C. Wilcox, Jr.
Dr. Margaret C. Winston
Mr. and Mrs. James P. Young

FRIENDS' CIRCLE–TIER III
Dr. Bernard S. Aarons
Anne D. Ackerman
James L. Agnew, Jr.
Judith Ainbinder
Kay Alexander
Allied Arts Guild
Allied-Signal, Inc.
Margaret Amara
Mrs. Alice E. (Betty) Anderson
Marjorie J. Anderson
Clara S. Andrews
Mrs. Alan V. Andrews
Mrs. John J. Antel
Susan Arbuckle and Steve Schneider
Mrs. George Stanleigh Arnold
AT&T Foundation
Helen H. Athey
Ruth W. Bacon
Katheryn H. Baggott
Mr. and Mrs. Schuyler Bailey
Elizabeth A. Baker
Harriet Baker
Jessica Baker
Norman and Patricia Baker
North Baker
Beverly S. Balanis
Mr. and Mrs. Albert Bandura
Margaret A. Barnard
Andrew Barnes
Mrs. Edward Basile
Mr. and Mrs. Bernard Bayuk
Elizabeth J. Beckman
Mr. and Mrs. William H. Beeger
Mrs. Adron Beene
Mr. and Mrs. Richard G. Beidleman
Stephen and Darline Bellumori

Paul and Mildred Berg
Eric and Polly Bergtraun
Charlotte and Carl Berney
Joanna R. Berry
Robert Hunt Berry
Carole A. Bettencourt
Mr. and Mrs. A. D. Bickell
Dr. Elizabeth S. Bing
Mr. and Mrs. Steven Blasberg
Arnold and Barbara Bloom
Margaret K. Boothe
Mr. and Mrs. Thomas W. Borden
Bonnie Brae
Mrs. Richard P. Brennan
Donald P Brewster
Pauline Brown
Carl Brown, Jr.
Patti Brown
Bill and Ann Bryson
Joyce Bryson
Lee C. Buck
T. E. Burke
Sara Burrows
Mr. and Mrs. Herbert J. Cabral
Mildred L. Cage
Mrs. John Edward Cahill
Mr. and Mrs. Donald Campbell
Theodore F. and Barbara Carter
Mr. and Mrs. George Cator
J. O. Centers
Elizabeth N. Chapman
Dr. and Mrs. Robert A. Chase
Chevron Corporation
Susan and Robert L. Christiansen
Mrs. Juliet Clark
Bill Tom Closs
Professor and Mrs. Wendell Cole
Betty Wing Concannon
Continental Caterers
Elizabeth Ann Coombs
Mrs. William Corbus
Nancy Costales
Jane Nora Coughran
Mrs. James A. Cox
Marcia S. Cox
Mr. and Mrs. Robert Crawford
Constance Crawford
Mrs. Harriet B. Crawford
Evelyn M. Cuna
Mr. and Mrs. John M. Curtin
Mr. and Mrs. William H. Curtiss, Jr.
Ruth Cushner
Mr. and Mrs. Kenneth Cuthbertson
Lorayne R. Daly
Mr. and Mrs. William Dana
Mrs. Ralph Davies
Virginia B. Davison
Dexter and Jean Dawes
Mrs. Fred De Sibert
Mr. and Mrs. Joseph Dearing
R. Oulton Decius
Mrs. Barbara P. Dee
Mr. and Mrs. Hunter L. Delatour, Jr.

Joanna Despres
Jean T. Dickson
Margaret S. Dilg
Jim and June Diller
Ann G. Ditz
Mrs. Arthur J. Dolan, Jr.
Mr. and Mrs. Sanford M. Dornbusch
Pearl Draheim
Dr. Kirk Alan Duncan
Patricia Potter Duncan
Mr. and Mrs. Charles Park Eddie
John and Beth Edwards
Mr. and Mrs. Ronald S. Edwards, Jr.
Norma and Geoffrey Egan
Jon and Eileen Eisenson
Joel Eisinger
Frances Elgan
Amy Sara Ellison
Dr. and Mrs. Leonard Ely
Molly Hurlbut Engelbrecht
Shiela E. Erickson
Charlotte Ernst
Karen Vik Eustis
Moya and Fred Eyerly
Bob and Judy Falconer
Mrs. William S. Falkenberg
Mr. Merritt David Farren
Mr. and Mrs. Warren W. Faus
Mr. and Mrs. George Fern
Ian Ross Field
Virginia F. Field
Tom and Nancy Fiene
Mrs. Reginald Fischer
Caroline E. Fisher
Ann Fisk
Mr. Michael C. Fitzgerald
Patricia Flanagan
Mr. and Mrs. Eugene J. Flath
Laura Marie Fleming
W. D. Fletcher
John and Doris Fondahl
Dr. and Mrs. Joel P. Friedman
Inger Friis
David and Betsy Fryberger
William E. Frye
George Gaber
Mr. and Mrs. Jerold Henry Gard
Trisha Siemon Garlock
Lillian and Harold Garner
Jessie C. Gaspar
General Electric
Gloria G. Getty
Dr. Clive F. Getty
Hellen Grube Gifford
Gerry and Joseph Gilchrist
Paul Bernard Goldstein
Mr. and Mrs. Eugene S. Goodwin
Mrs. Duncan E. Govan
Natalie and Bill Graham
Kathy R. Graham
Mr. and Mrs. Charles Gravelle
Barbara K. Gray
Joan S. Gray
Robert A. and Rose S. Green
Gertrude B. Greenberg

Dr. and Mrs. Alan E. Greenwald
Mr. and Mrs. Albert G. Gregory
Eve Gribi
Marian C. P. Grim
Mrs. Sydney G. Griswold
Judith E. Halley
Walter A. Haluk
Dr and Mrs. John Hanbery
Mr. and Mrs. E. William Hancock
John Hancock/
 Mutual Life Insurance Company
Margaret P. Haneberg
Dorothy A. Harney
Robert B. Harrison
Harry E. Hartzell
Albert and Barbara Hastorf
Karen Kari Haubrich
Mrs. Melvin Hawley
Dr. and Mrs. Charles Heaton
Shirley Heiman
Mrs. Addis Herd
Mrs. W. R. Heslop
Ernest R. Hilgard
Robnett and James Hill
James and Dawn Hill
Mary A. Hirsch and H. Ross MacMichael
Mrs. Beth Lazear Hitchcock
Carolyn S. Hofstetter
George and Ann Hogle
Mr. and Mrs. George H. Holder
Robert H. and Lisetta P. Horn
H.C. and June Hubbard, Jr.
Jeannette P. Huff
Carol B. Hughes
Helen Hunt
Fredericka H. Hunter
Ginevra M. Hunter
Marjorie W. Hyman
IBM
Carol Kanoelani Ihara
Murray Innes, Jr.
Setsuko Ishiyama
Karen Woodruff Jackson
Doris Jacoby
Mr. and Mrs. Gustave Jamart
Mr. and Mrs. Myron Jarman
Arthur Jenni
Mr. and Mrs. J. Cyril Johnson
Mr. and Mrs. Robert R. Johnson
Mrs. William L. Jones
Nancy Jorgensen
Norma Justman
Betty Kaplan
Joseph Karger
Stephen Kasierski
Stina and Herant Katchadourian
Judith S. Kays
Norbert Lee Keller
Michael Kerry Kellogg
Sean and Laurie Kelly
Betty Hawley Kelso
Jeannette D. Kennedy
Mrs. Richard R. Kennedy
Dr. Leo and Mrs. Marlys Keoshian

Nancy Hunt Kiesling
Doris V. Kingman
Grace D. Kirk
William T. Kirk, Jr.
Rosanne Kirkpatrick
Mike and Wendy Kirst
Jean Klein
Mr. and Mrs. David Knowles
Etty Korengold
Phoebe Korn
Dr. Marcus A. Krupp
G. David Kuhlman
Mary Ann Lally
Mr. and Mrs. Andrew S. Lanza
Mr. and Mrs. James G. LaPlante
Mr. and Mrs. Kenneth Larkin
Cheryl and Bern Beecham Lathrop
Dr. Esther M. Lederberg
Dr. Marion Lee
Elaine Livingston
Mrs. Paul H. Louie
Shirley S. Lutes
Charles and Linda Lynch
William Lyons
Martha R. Macdonald
Mrs. John L. Madden
Mr and Mrs. J. Keith Mann
Joan M. Mansour
Gloria and Vito Marchi
Eleanore H. Marcus
Mr. and Mrs. Raymond A. Marks
Lynn L. Marks
William E. Matthews
Jody Maxmin
Ann J. and Dennis Maxwell
Esther Mayer
Sharon and Wynn McClenahan
Peter Nevins and Jacqueline K. H. McCook
Anita Derby McCreery
Florence McDonald
Mrs. Ernestine D. McGovern
Dr. J. Ian McNeill
Olga W. McNemar
Mary W. Means
Leslie Rugg Meehan
Dr. and Mrs. James R. Meier
Joan Merchant
Julia S. Meyer
Mrs. Glenn L. Milburn
Roberta Miller
Geoffrey Miller
Mrs. William A. Miller
Rupert G. Miller, Jr.
Myrna E. Mitchner
John and Isabel Moll
Patsy and Henry Moore
Mr. and Mrs. Brian Moore
Dr. Bertha A. Moseson
Dena Mossar and Paul Goldstein
Motorola Corporation
Madeline F. Muller
Martha J. Myers
Hasso Naito

Ruth E. Nardi
Mr. and Mrs. John Naylor
Mr. and Mrs. Robert Neill, III
Mrs. J. P. Nevin, Jr.
Richard Newberger
Sharon and Donald Niederhaus
North American Philips
Laura Novick
Bea and Phil O'Donnell
Mrs. Janet B. Oakford
Elizabeth Offield
Mrs. Thomas Ohliger
Dr. Linda W. Olin
Anne M. Olson
Sharon L. Olson
Mrs. Jane Sammis Ord
Carol M. Osborne
M. Shepard Paponis
Virginia Patterson
M. Elizabeth Patton
Mrs. William G. Paul, Jr.
Mrs. R. Fabian Pease
Mrs. Jill Marion Pease
Templeton Peck
Pepsi Cola Bottling Co.
Pepsico Inc.
Kathleen M. Petry
Virginia A. Pfeifle
Norma H. Pollock
Borden and Jeanne Polson
Elizabeth R. Pomeroy
Mr. and Mrs. F. Harvey Popell
Ralph and Elsa Preminger
Ted and Pat Purcell
Frances Ragno
Mary Alice V. Ralls
Alice Janet Ramsay
Shirley and Robert Raymer
Dr. and Mrs. William A. Reeves
Carolyn and Bill Reller
Dr. and Mrs. Robert Rempel
Research-Cottrell, Inc.
Flora Elizabeth Reynolds
Jean A. Rice
H. W. and Margaret Richards
Jill Richmond
Mr. and Mrs. Robert J. Roantree
Kenneth and Cynthia Roberts
Evelyn B. Robin
Penelope L. Rock
Mrs. Grace F. Rockwell
Mrs. Edward Roesler
Jacqueline Roose and John Flather
Eva Ross
Mr. and Mrs. D. P. Rozenberg
Sally Harris Rub
David and Shulamith Rubinfien
Mr. and Mrs. Glen Ruffner, Jr.
Dr. and Mrs. George M. Rugtiv
Mrs. Karl B. Rusch
Edna Bonn Russell
Robert and Virginia Saldich
Hans and Nancy Samelson

Doris Coplen Santana
Pomona M. Sawyer
John P. and Mary Carey Schaefer
Ralph W. Schaffarzick
Mrs. Elizabeth Schilt
Charles M. Schlossman
Alfred and Marjorie Schuchard
Mrs. Henry Schwager
Anne A. Scitovsky
Monica L. Seghers
Maxine M. Sehring
Randee and Joe Seiger
Shari Selover-Fors
Marshall M. Seymour
Theodore M. Shaner
W. Robert Shaw
Sonia G. Shepard
Joan A. Shields
Flora I. Shreve
Sides Travel Service
Donna W. Silverberg
Mrs. Davida C. Simon
Virginia B. Simoni
Frampton E. Simons
Walter and Patricia Skees
Judith M. Sleeth
Phil and Meg Sloan
Mrs. Louis Sloss
Mary Penney Smith
Marion McGill Smith
Martha Vaughan Smith
Dr. and Mrs. Carl L. Smith
Ann J. Sonnenberg
Tom Sousa
Mrs. Griffiths Sox
Mr. and Mrs. Donald Spencer
William E. Sprague
Bonnie M. Stafford
Jerre Ann Stallcup
Peter Stansky
State Farm Auto Insurance Company
Winifred Steiner
Eileen Stevens
Marion C. Stewart
Daniel E. Stone
Ruth Tinsley Storey
Rita M. Stull
Ann Swanson
Marilyn Swartz
Synoptics Communication
Kasten and Diane Tallmadge
Mary Kay Lyon Tannebring
Tig and Marilyn Tarlton
Marjorie Taylor
Virginia M. Taylor
Barbara and Lewis Terman
Mr. and Mrs. D. K. Thackery
Mr. and Mrs. Robert H. Thede
Mrs. William P. Thomas
Olga Thomson
Pauline B. Tooker
Virginia A. Townsend
Dr. Ralph W. Tyler
Charlotte H. Upton
Ursula S. Van Anda
Dr. Elizabeth L. Van Dalsem

Carvel Van Der Burch
Dr. and Mrs. F. J. Van Rheenen
Colonel and Mrs. C. Vansiclen, Jr.
Marc Verzani
Oswald and Barbara Villard
Mr. and Mrs. Everett B. Walker
Mr. and Mrs. John K. Walker
Dr. and Mrs. Yueh-Ming Wang
Alan and Loretta A. Waterman
Jean Baker Watkins
Mr. and Mrs. Chick Wattenbarger
Anna Wu Weakland
Mimi Webb
Suzanne Weeks
Joel Adam Weinthal and Patrice
Badstubner
Muriel Casper Weithorn
James G. Wendel
Westinghouse Education
June C. Whipple
Edith M. Whitaker
Dr. Susan Lee Wickes
Mary C. Wilbur
Margaret Wilkins
Marilyn S. Wilson
Mr. and Mrs. Ben A. Wilson
Ellen V. Wilton
Virgilia Short Witzel
Elizabeth and Hans Wolf
Miriam E. Wolff
Margaret Davis Wolff
Peter and Judith Wolken
Art and Wilma Wong
Enid Wood
Nancy K. Woodward
Mr. and Mrs. William H. Woolsey
Marion M. Worthington
Dr. Caryl Elizabeth Yanow
Paula and Bill Young
Lynn W. Young and Scott H. Cummings
Morris and Bernice Zelditch

Bibliography

Bazin, Germain. *The Museum Age.* Trans. Jane van Nuis Cahill.
New York: Universe Books, 1967.

Burt, Nathaniel. *Palaces for the People.* Boston: Little, Brown, 1977.

Cantor, Jay. "Temple of the Arts: Museum Architecture in Nineteenth-Century America."
Metropolitan Museum of Art Bulletin 28 (April 1970): 331-354.

Coleman, Laurence Vail. *The Museum in America.* 3 vols.
Washington, D.C.: American Association of Museums, 1939.

Darragh, Joan and James S. Snyder. *Museum Design: Planning and Building for Art.*
New York: Oxford University Press, 1993.

Davis, Douglas. *The Museum Transformed: Design and Culture in the Post-Pompidou Age.*
New York: Abbeville Press, 1990.

Forster, Kurt W. "Shrine? Emporium? Theater? Reflections on Two Decades of American Museum Building,"
Zodiac 6 (March/August 1991): 30-75.

Fox, Daniel. *Engines of Culture: Philanthropy and Art Museums.*
Madison: State Historical Society of Wisconsin, 1963.

Nash, Herbert. *The Leland Stanford Junior Museum: Origin and Description.* 1886.

Osborne, Carol M. *Museum Builders in the West: The Stanfords as Collectors and Patrons of Art.*
Stanford: Stanford University Museum of Art, 1986.

Pevsner, Nicholas. *History of Building Types.* Princeton: Princeton University Press, 1976.

Searing, Helen. *New American Art Museums.* Exhibition catalogue.
New York: Whitney Museum of American Art, 1982.

Trachtenberg, Alan. *The Incorporation of America: Culture and Society in the Gilded Age.*
New York: Hill and Wang, 1982.

Turner, Paul V. et al. *The Founders and the Architects: The Design of Stanford University.*
Stanford: Stanford University, Department of Art, 1976.

Vidler, Anthony. "Losing Face: Notes on the Modern Museum." *Assemblage* 9 (June 1989): 41-57.

Wallach, Alan and Carol Duncan. "The Universal Survey Museum." *Art History* 3, (December 1980): 448-469.

Weil, Stephen E. *Rethinking the Museum and Other Meditations.*
Washington, D.C.: Smithsonian Institution Press, 1990.

Wilson, Richard Guy et al. *The American Renaissance 1876-1917.* Exhibition catalogue.
New York: Brooklyn Museum, 1979.